Drawing in Early Renaissance Italy

Drawing in Early Renaissance Italy

FRANCIS AMES-LEWIS

Yale University Press
New Haven and London
1981

To Christabel

Designed by Faith Brabenec Hart
Filmset in Monophoto Bembo and
printed in Great Britain by
Jolly & Barber Limited, Rugby

Published in Great Britain, Europe, Africa,
and Asia (except Japan) by Yale University Press,
Limited, London. Distributed in Australia and
New Zealand by Book & Film Services, Artarmon,
N.S.W., Australia; and in Japan by Harper & Row,
Publishers Tokyo Office.

Library of Congress Cataloging in Publication Data

Ames-Lewis, Francis, 1943–
 Drawing in early Renaissance Italy.

 Bibliography: p.
 Includes index.
 1. Drawing, Italian. 2. Drawing, Renaissance —
Italy. I. Title.
NC255.A44 741′.0945 81–40434
ISBN 0–300–02551–3 AACR2

Preface

MORE OFTEN than is generally realised, drawing was for the fifteenth-century artist a means of exploring new problems. In tandem with his investigations of these problems, the artist developed many new ways of making and using drawings. The subject of this book is therefore essentially exploratory: and so is the book itself, for I hope that the approach that I take to the subject will stimulate others to explore further, and to augment and improve on my ideas. This book is intended to be no more than a 'primer' in Early Renaissance drawing: it is inevitably limited in scope since the subject is immense and the complexities are legion. I cannot hope to raise or confront all these complex issues in a book of this length. By considering some of them in the context of the practice and preoccupations of the quattrocento artist, however, I hope to cast fresh light on the role played by drawing in the development of Renaissance art, and on the value of the study of drawing to our understanding of the Early Renaissance.

Three major themes run through the main sections of this book. Firstly, I offer practical explanations for the development of new types of drawing and drawing techniques. Secondly, I discuss changes in the uses to which drawing was put as a result of new needs and opportunities which artists encountered during the quattrocento. And thirdly, I hope to illustrate the stimulating effects on artistic practice brought about by these changes, and their relationships with developments in formal and pictorial pre-occupations during the fifteenth century. The quattrocento was a period of immensely vigorous change in Italian artists' attitudes and perceptions, and the dramatic growth in the practice and exploitation of drawing was of fundamental importance in providing artists not only with the wherewithal to grapple with these changes but also with new opportunities for investigation and experiment. It is impossible to say which came first, the new opportunities offered by developments in drawing and drawing techniques, or artists' needs to break out from the conventions of earlier practice by finding and exploiting new modes of drawing. The two developed in parallel during the century, in different ways depending on the artistic traditions and concerns of different regions, each stimulating the other in a highly productive symbiotic relationship.

Since the early sixteenth century, when drawings began to become collectors' items, the study of drawing has for the most part been the connoisseur's province. Very little systematic attention has been paid to the ways that drawing was used by the quattrocento artist. The bias of the connoisseur's interest is towards a judgement of the quality and

authorship of a drawing, and towards the history of its attribution and ownership. He tends to abstract the drawing from its context and to judge it as a unique object without regard to the external factors which may have influenced its production. In this book, however, nuances of quality or fine questions of attribution are relatively unimportant. What matters here is not whether, for example, a particular Florentine silverpoint nude study was made in the circle of Botticelli, Ghirlandaio, Filippino Lippi or another of their contemporaries, but how it was made and what artistic problem the draughtsman was investigating. I have therefore come to decisions on attribution in some hotly debated cases without having space to justify my position. In such cases my decisions have generally been reached through judgements of the artist's concerns rather than on assessments of graphic style. There is still plenty of room for disagreement, and debate will, I hope, continue undiminished. Reconsideration of the purpose of a drawing, and the way that the draughtsman handles his technique in pursuit of his artistic goal, may, however, help to place it within the range of interests of one artist rather than of another.

A word of explanation should be added here about the exclusion of any discussion of fifteenth-century drawing outside Italy. This is essentially for reasons of compactness. Many absorbing problems are raised by Italian drawing, interdependent problems which can be examined and elucidated together. Except at the beginning of the century, when 'International Gothic' pressures generated a relative uniformity of artistic endeavour and hence of drawing practice throughout Europe, the aims and preoccupations of fifteenth-century artists north and south of the Alps were for the most part fundamentally different. Consequently the purposes to which drawing was put in the north, and the techniques and graphic styles which were developed, were also different: so different, indeed, that comparisons between drawing practice in Italy and Northern Europe seldom help to throw light on either the one or the other. In proportion to the extent of artistic activity in the fifteenth century, substantially fewer Northern drawings survive than from any region of Italy, and generalisations are therefore even less secure. Because of these contrasts and imbalances, this book is restricted to a discussion of drawing in quattrocento Italy. Our subject provides a relatively homogeneous block of material from which deductions can reasonably be drawn without too much fragmentation into separate discussions of independent regional characteristics.

There is a bias in favour of Central Italian, and especially Florentine, drawings in the main sections of this book. This is unavoidable, although it is regrettable that as a result only too little space can be devoted to North Italian drawings. The reasons are threefold. Firstly, a number of treatises written by Tuscan artists and theorists help to clarify the techniques and functions of Central Italian drawing in the fifteenth century, and in turn this clarification guides and stimulates deduction from the drawings themselves. For Venetian and North Italian artistic practice, however, there is scarcely any comparable source material. Secondly, far more Central Italian drawings survive: the ratio of extant Florentine to Venetian drawings, for example, is in the order of seven to one. Consequently a much clearer pattern of their role in Central Italian quattrocento artistic practice emerges. And thirdly, the changes in the ways that Central Italian artists used drawings are more fundamental than appears to be the case in North Italy; and because they survive in greater numbers, Central Italian drawings can be related more closely to

major changes in artistic preoccupations. Even though relatively few drawings survive from North Italy, and despite the less dramatic changes in usage than further south in the peninsula, drawing in North Italian artistic practice needs to be considered both to provide a perspective against which to illuminate the major developments in Central Italian drawing practice and to clarify its individual characteristics and development.

Many of the general problems outlined in the opening chapter, 'Some General Considerations', are examined in more detail or contribute to further discussion in later sections of the book. It is important, however, to consider them at the outset, in order to gain some awareness of the limits of the information available to us about quattrocento drawing and draughtsmen. The material which has survived over the last five centuries is thin and unevenly spread. It will become clear that many of my deductions are inevitably speculative, based as they must be less on hard evidence as on the character of surviving drawings. The reader should keep the caveats raised in the first chapter constantly in the front of his mind when following the discussion in the rest of the book.

My thanks go to more friends, colleagues and students than can be named here who, often unknown to themselves, have stimulated my thoughts and ideas by chance observations or by giving me the benefit of their views in discussions of particular issues. For special thanks I would pick out Nigel Konstam, who guided me to a clearer understanding of how and why the sculptor draws, and Joanne Wright, who read an early draft and made innumerable invaluable suggestions on both content and organisation. The staff of many museums, print rooms and photographic studios have responded patiently and generously to my requests for photographs and for other assistance. I am sincerely grateful for grants from the British Academy towards the research for this book, and from Birkbeck College towards the costs of the photographs. While errors of fact or interpretation are entirely my responsibility, the typescript would have been less polished had it not been for the rigorous criticism of John Nicoll and Faith Hart of Yale University Press, and especially of my wife, the dedicatee, who not only read and greatly improved the text, but also gave me constant encouragement while suffering with equanimity the disruption that writing this book caused to our normally relatively tranquil domestic life.

Contents

Photographic Acknowledgements

Bergamo, Wellsfoto 32, 33
Berlin, Staatliche Museum Preussischer Kulturbesitz Kupferstichkabinett (Jörg P. Anders) 3, 119, 136, 143
Boston, Courtesy Museum of Fine Arts (Gift of Henry Lee Higginson) 20
Cambridge, Fitzwilliam Museum 8
Cambridge, Mass., Courtesy of the Fogg Art Museum, Harvard University (Bequest – Charles A.
 Loeser) 121
Darmstadt, Hessisches Landesmuseum 122
Düsseldorf, Landsbildstelle Rheinland 77, 163, 164
Florence
 Archivio Fotografico della Soprintendenza per i Beni Artistici e Storici di Firenze (AFS) 1,
 2, 6, 11, 15, 17, 18, 19, 57, 59, 69, 73, 74, 79, 98, 99, 100, 101, 102, 108, 114, 125, 126,
 135, 139, 141, 149, 151, 153, 159, 170
 Alinari 10, 144, 146, 154, 155
Haarlem, Teylers Museum 34
Hamburg, Kunsthalle 29
Lille, Musée des Beaux-Arts 27, 64, 75, 76, 127
London
 Anthony Hamber 16
 By courtesy of the Trustees of the British Museum I, II, V, VIII, 9, 24, 30, 31, 35, 37, 38, 41, 62,
 71, 82, 84, 92, 93, 94, 103, 107, 109, 110, 112, 118, 124, 133, 134, 137, 150, 152, 157, 162, 168,
 179
 Courtauld Institute of Art
 (Devonshire Collection, Chatsworth. Reproduced by permission of the Trustees of the
 Chatsworth Settlement) 25, 58, 138, 156, 160
 (Trustees, Home House Society) 90
 Sotheby Parke Bernet 158
 Victoria and Albert Museum (Crown Copyright) 117
Madrid, José de Prado 49
Milan, Ambrosiana 44, 45
Munich, Staatliche Graphische Sammlung 106, 132
New York
 Courtesy of Cooper-Hewitt Museum, the Smithsonian Institution's National Museum
 of Design 72
 The Metropolitan Museum of Art (Harris Brisbane Dick Fund, 1949) 116
Nottingham, Tony Holmes 22
Oxford
 Ashmolean Museum 46, 47, 66, 120, 123, 128, 180, 181
 The Governing Body, Christ Church III, VI, 4, 26, 36, 68, 83, 165
Paris
 © Arch. Phot. Paris/S.P.A.D.E.M. 12, 13, 14
 Bibliothèque Nationale 7
 Cliché des Musées Nationaux
 (Musée du Louvre, Cabinet des Dessins) IV, 5, 21, 39, 40, 42, 43, 48, 50, 51, 52, 53,
 61, 63, 65, 78, 81, 86, 87, 89, 96, 97, 105, 111, 113, 129, 130, 131, 167, 169, 182
 (Musée du Louvre, Collection Edmond de Rothschild) 54
 (Musée Bonnat, Bayonne) 80, 95, 166
 Fondation Custodia (Coll. F. Lugt), Institut Néerlandais 91
 Giraudon (Musée Condé, Chantilly) 115, 176
Rome, Oscar Savio (Accademia Nazionale dei Lincei, in deposito presso l'Instituto Nazionale per la
 Grafica – Gabinetto Nazionale delle Stampe) 147, 148
Rotterdam, Museum Boymans-van Beuningen (Frequin-Photos) 55, 56, 142
Stockholm, Nationalmuseum 60
Uppsala, Universitetsbiblioteket 140
Venice, Osvaldo Böhm 104, 172
Vienna, Lichtbildwerkstätte 'Alpenland' 23, 70, 85, 145, 173, 175, 177, 178
Windsor, Royal Library (reproduced by gracious permission of Her Majesty Queen Elizabeth II) VII,
 28, 67, 88, 161, 171, 174

CHAPTER I

Some General Considerations

WRITTEN SOURCES

FIFTEENTH and sixteenth-century writers on the arts provide us with various kinds of source material for drawing in Central Italy, and especially in Florence, but pitifully little for North Italian drawing. The variety of the sources for Tuscan drawing is in itself instructive, and valuable in providing coverage of different aspects of the subject. Since these writings are fairly extensively quoted in the later sections of this book, a brief review of the major sources is a useful way of introducing the material and the problem.

Early in his *Commentarii*, Ghiberti is absolutely clear in his certainty about the fundamental importance of drawing as the origin and theoretical basis of sculpture and painting, although he is characteristically repetitive and impossible to translate exactly:

> [Per] lo scultore e 'l pittore il disegno è il fondamento e teorica di queste due arti . . . tanto è perfetto scultore quanto è perfetto disegnatore e così è il pittore; detta teorica è origine e fondamento di ciascuna arte.[1]

Paradoxically, only one drawing by Ghiberti survives (85), but his written belief in the primacy of drawing in the early Renaissance justifies the investigations pursued here, and echoes with increased emphasis Cennino Cennini's earlier declaration that 'the basis of the profession, the very beginning of all these manual operations, is drawing and painting'.[2]

Cennino's *Il Libro dell'Arte*, almost entirely a technical manual for the craftsman–painter, is the earliest treatise of the century. His discussions of the preparation for, and execution of, paintings in various mediums are very detailed, but his book is totally lacking in theoretical or critical comment. Probably written in Padua at about the beginning of the quattrocento,[3] Cennino's treatise codified the strict, limiting traditions of trecento artistic practice. His view was of course yet unaffected by the theoretical and formal concerns of the early Renaissance, which had a crucial effect on quattrocento drawing. But Cennino's discussions of materials, techniques and procedures are fundamentally important to our understanding of fifteenth-century drawing, for they hold good with relatively little change throughout the century. This technical information is later amplified in manuals like the Introduction to the first edition of Vasari's *Lives*.[4]

A similarly technical slant underlies Leonardo da Vinci's remarks on drawing in his *Trattato*, although he does not discuss practical procedures, perhaps taking for granted conventional methods and materials of drawing.[5] But writing towards the end of the

century and in the early cinquecento, Leonardo was of course deeply influenced by Renaissance intellectual ideas, and these are reflected in his discussion of the range of possibilities offered by drawing to the exploring mind of the creative artist. Early Renaissance theoretical viewpoints which often impinge on drawing practice are extensively considered by Leon Battista Alberti in his *de Pictura* of 1435, even though drawing itself is only occasionally touched on, and never in basic technical terms.[6] Parallels can often be drawn between Alberti's theoretical ideas, and his suggestions for their practical fulfilment, and the uses of drawing developed by Central Italian artists of the succeeding generations. These fifteenth-century theoretical texts can sometimes throw light on the aims of artists in their exploratory drawings which might otherwise be hard to account for.

Sixteenth-century theorists add some further information to the quattrocento sources on drawing technique and practice, but the major contribution of cinquecento writers is in providing critical, historical and biographical information. Here, Vasari's *Lives* are of course the major source.[7] Vasari's anecdotes sometimes give a vivid idea of painters' workshops in action, from which we may be able to glean more about the role of drawing in quattrocento workshop practice. His critical discussion of artists' works and styles often refers to their drawings, partly because like Ghiberti he regarded drawing as the foundation-stone of the art of painting,[8] but not least because he possessed one of the largest collections of quattrocento drawings ever assembled by a private individual, and to this he frequently refers in his biographies.[9] It is only in this last category of source material, artists' biographies or descriptions of cinquecento collections, that anything comparable exists for Venetian and other North Italian drawing, and even here references are few and far between. Quattrocento Venice produced no writers on art, and no sixteenth-century Venetian critic had Vasari's zeal as a collector, or wrote artists' biographies with Vasari's sensitivity as historian and connoisseur. Without Vasari's writings we would be almost as ill-informed about Tuscan quattrocento drawing as regrettably we are about the history of drawing elsewhere in the peninsula.

The Status of Drawing in the Quattrocento

That the written sources are almost exclusively concerned with the history and practice of drawing in Central Italy is matched by a similar imbalance in the number of drawings which survive. One of the reasons for this imbalance is that quattrocento artists and patrons in different parts of Italy accorded a different status to the art of drawing, and this contributed significantly to regional variations in the types, the functions and probably (as a result) the numbers of drawings produced. The idea that a drawing was not merely a disposable stage in workshop procedures, but could be seen as an object worth preserving and admiring for its own artistic and aesthetic qualities, seems not to have developed in Central Italy until around 1500. Before this individual drawings had not been commented on by writers, who saw them as having practical uses only, and very few are dated, signed or even inscribed with the draughtsman's name. When they are, it was probably for a special reason rather than from a general sense of the prestigiousness of

drawing: Pollaiuolo's drawing of a *Nude man seen from front, side and back* (81) was a famed exemplar of the representation of anatomy, and Leonardo's *Arno landscape* (1) was dated 5 August 1473 as a purely private record of when it was made.

In 1501, however, the Florentine crowds flocked to Leonardo da Vinci's studio to admire his cartoon of the *Virgin and Child with St. Anne*,[10] and Michelangelo's *Battle of Cascina* cartoon attracted so much attention in 1504 that Benvenuto Cellini described it as 'a drawing-academy for the whole world'.[11] These are the earliest recorded examples of drawings being admired by the lay public, and reflect changing attitudes at the turn of the century to the artistic qualities of a drawing, marking the birth of the modern notion of the drawing as a revelation of the artist's creativity. At just this time, furthermore, Leonardo made the earliest recorded 'presentation' drawing, of *Neptune* for his friend Antonio Segni,[12] and Signorelli produced a series of highly polished black chalk and watercolour replicas after figures in his Orvieto frescoes, apparently as souvenirs of a much-admired virtuoso performance in the representation of the nude.[13]

The production of the 'presentation' drawing, in lieu of a painting but with the same aesthetic value, had evolved rather earlier in North Italy. The growing consciousness of the artistic worth and autonomy of a drawing had always been stronger in the North than in Central Italy. In about 1395 the Bergamo model-book was inscribed 'iohininus de grassis designavit':[14] this may mean merely that the book was the property, and represented the traditions, of Giovannino de Grassi's workshop, but it might equally

1. Leonardo da Vinci, *Arno landscape*. Florence, Uffizi, 8P. Pen and ink on paper; 19.6 × 28.7 cm. Dated 5 August 1473.

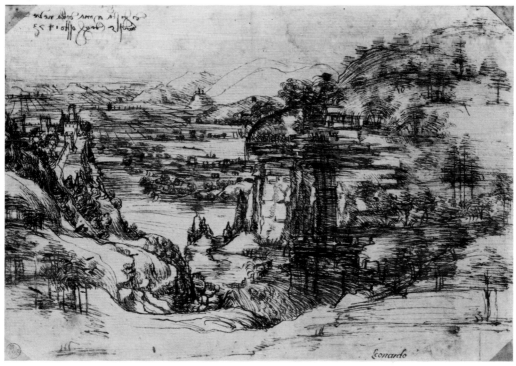

imply that the drawings should be recognised as having the same status as finished paintings. A later parallel to this inscription is the uniquely elaborate signature and date of 1491 added by Mantegna to his *Judith* (2), a brush drawing technically so polished that it is intentionally comparable in finish and artistic value with monochrome paintings like his London *Samson and Delilah*. The concept that the finished drawing is a precious object, a work of art in its own right, underlies the character of Jacopo Bellini's two books of drawings. Lying between Giovannino's model-book and Mantegna's *Judith* in date, Jacopo's compositional drawings were not made as preparatory designs for paintings but as completed statements of artistic intention and achievement (111–13). This is indicated by the important place held by Jacopo's books in the wills of his widow and his elder son Gentile: Anna Bellini, for example, bequeathed to Gentile 'all . . . drawn pictures and all books of drawings . . . which belonged to the late Master Jacopo Bellini'[15] – the concept of the 'drawn picture' recalls Mantegna's *Judith*. Not only painters attached such value to drawings in North Italy: reference is made in the will of the Paduan humanist Felice Feliciano in 1466 to 'drawings and pictures on paper by many excellent masters of design'.[16] The only Central Italian sheets which merit the label 'drawn pictures' are Lorenzo Monaco's *Journey of the Magi* and *Visitation* (3). These are highly sophisticated brush drawings on vellum, and the *Visitation* is even provided with a painted frame. They are in fact best seen as miniature panel paintings, deriving from the manuscript illumination tradition in which Lorenzo Monaco was trained rather than from the tradition of drawing in Tuscany. The manuscript tradition was less strong in Central than in North Italy where it exerted an important influence, through the model-book form, on the establishment of drawings as aesthetically viable works of art.

In the North Italian tradition, therefore, drawings were frequently finished, preservable objects, whereas in Central Italy the establishment of exploratory drawing as a standard quattrocento practice may have delayed the acceptance of drawings as works of art which merited preservation. This North Italian tradition may, in part, explain why fewer drawings were apparently made there than for instance in quattrocento Tuscany, and why the exploratory possibilities of drawing were seldom exploited. Exemplified by Jacopo Bellini's books of drawing, the tradition gave rise to the new type of highly finished portrait drawing, probably made on commission in the late quattrocento Venetian workshops of the Bellini (4) and Carpaccio (colour plate VIII) amongst others, and presumably less expensive than a painted portrait. Bellini's superbly refined use of black chalk may have influenced Leonardo da Vinci in his use of chalk for studies of Apostles' heads in the *Last Supper* (174, colour plate VII). Evidently following the North Italian tradition, Leonardo's portrait of Isabella d'Este made in Mantua in 1500 is a drawing for which he developed a novel technique of colouring in pastels (5), whereas his Florentine portraits were painted. There is no evidence of the independent portrait drawing in Central Italy before Michelangelo's 'presentation' portraits of the 1520s: portrait drawings like Ghirlandaio's (160–1) were made in preparation for paintings, although they may subsequently have been given to (and hence preserved by) the sitter. It is also possible that highly finished drawings like Leonardo's early silverpoint *Bust of a warrior* (colour plate I) were given as presents to friends or patrons, but the primary function of this and similar sheets was as apprenticeship exercises in the handling of the

2. Andrea Mantegna, *Judith*. Florence, Uffizi, 404E. Brush and wash, slightly heightened with white, on paper; 38.8 × 25.8 cm. Signed and dated February 1491.

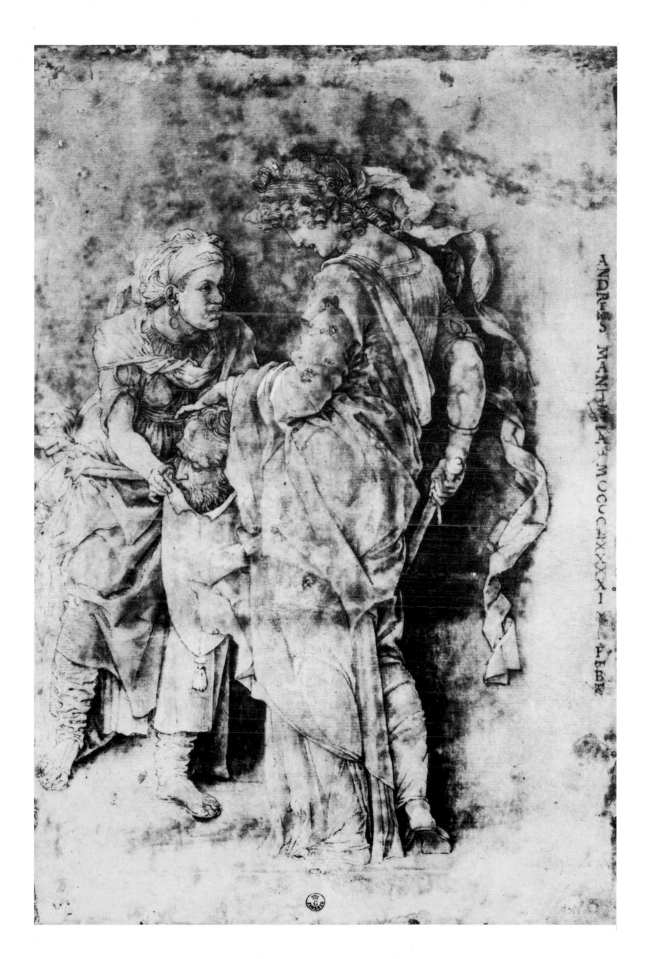

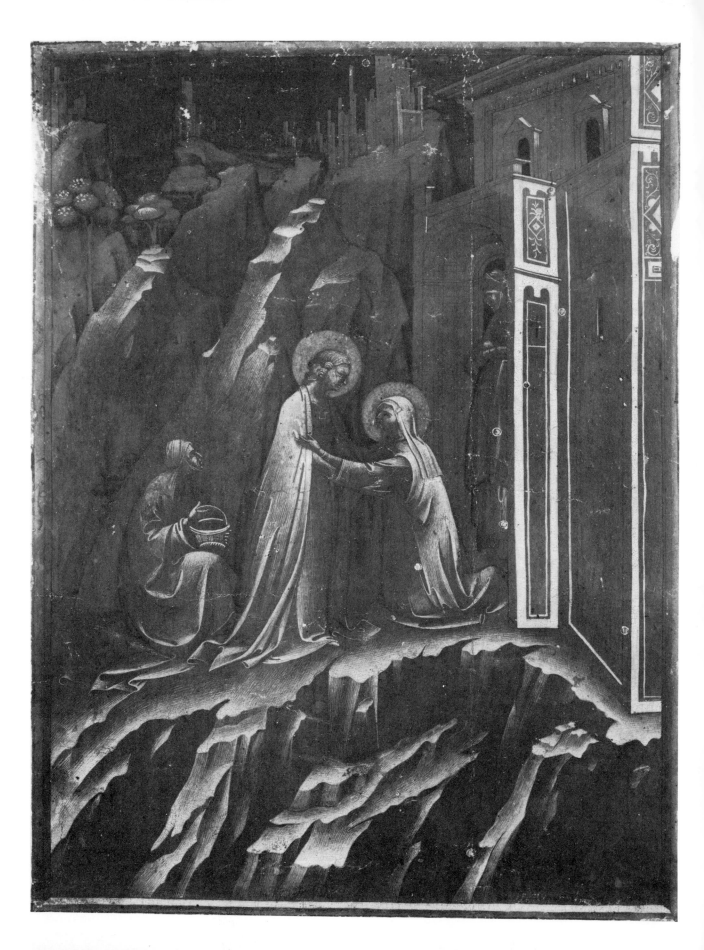

silverpoint. Only after the major changes and developments at the beginning of the sixteenth century was the concept, long current in North Italy, of the drawing as an autonomous work of art accepted in Central Italy, leading to a rapidly growing recognition of the value of drawing as an expression of artistic imagination. From this time onwards these new ideas were fast accepted by patrons and collectors, a development of crucial importance to the survival of quattrocento drawings to the present day.

SURVIVAL OF DRAWINGS

The Problem

There can be little doubt that the sample of surviving quattrocento drawings is in various ways not balanced: we must therefore be wary of generalisations which do not seem to take enough account of losses over the centuries. Unfortunately it is extremely difficult to define how, and how seriously, the sample is distorted. It is thus correspondingly difficult to assess what allowance should be made for imbalances between the proportions of drawings produced in different centres, at different stages of the fifteenth century, which have not survived. Some general points can be made about this problem, however, which may help in correcting some of the distortion, or at least in alerting us to areas of ignorance.

Certain types of drawings were made to be preserved, and have therefore survived in greater number than ephemeral drawings made in the same workshops. Model-books were handed down through the generations of a workshop, increasing their chance of surviving into a period when drawings began to be collected as records of artistic practice. No doubt, though, many model-books did not survive the rapid changes in quattrocento artistic practice which soon made them redundant in the workshop. Very few drawings made during the early stages of designing a specific work, or made for purely experimental purposes, have survived from early in the century. Of purely short-term function, such drawings had no value to the artist beyond that function. They were probably usually made on reusable surfaces, prepared wooden tablets which were scraped down as soon as the drawing's immediate purpose had been fulfilled. Lorenzo Monaco's drawing (6) probably made in preparation for the London *Coronation of the Virgin* altarpiece is a rare survivor, but we cannot assume that it was equally rare at its time as a stage in the design process. Indeed, its survival should alert us to the probability that it is an uncommon representative of a normal phase in the evolution of an early quattrocento composition. We should perhaps assume that many artists worked out their designs, at any rate for important or unusually taxing compositions, through such drawings, rather than that they did not use drawing as a creative medium.

The evidence for the use of drawing at the experimental stage of design is meagre, but drawings at the final stage survive in greater number. This is partly because the 'contract' drawing, approved by the patron and often the basis of a legal contract of commission, had to be on a durable surface like paper or parchment, and partly because it had the status of a legal document which increased the chances of its survival in an archive. These

3. Lorenzo Monaco, *Visitation*. Berlin, Kupferstichkabinett, 608. Pen and ink, with white heightening, yellow and blue pigments, on parchment; 25.6 × 18.8 cm.

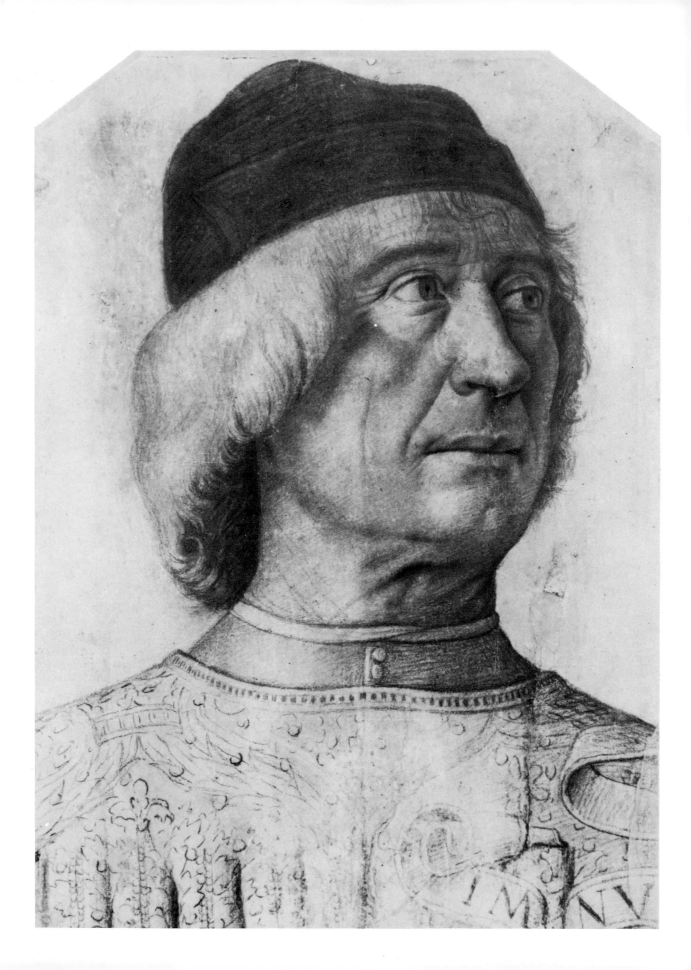

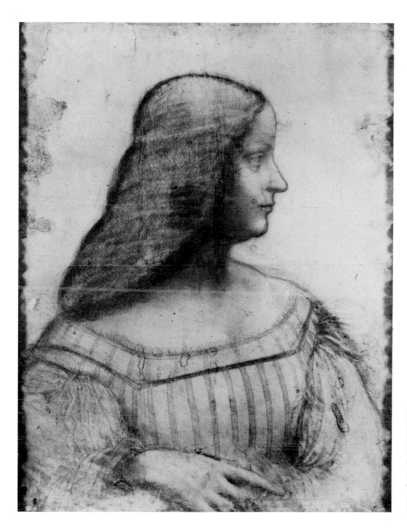

5. Leonardo da Vinci, *Portrait of Isabella d'Este*. Paris, Louvre, M.I.753. Black chalk and pastel colours on paper, pricked for transfer; 63.0 × 46.0 cm. Documented January–February 1500.

differences in status and materials between preparatory and final design stages create an imbalance in survival which makes the assessment of how drawings were used in early quattrocento compositional design extremely difficult.

This imbalance is somewhat redressed later in the century when paper was used more frequently for all types of drawing, including those which had previously been made on reusable surfaces, with the result that many more drawings survive. But this in itself introduces another distortion in the extant material: the evidence about drawing practice is far richer at the end than at the beginning of the fifteenth century. Increasing availability of paper later in the century clearly stimulated artists to new patterns of creative thought and expression in the development of their ideas, but it is very unlikely that these patterns were unprecedented. Conventions of workshop practice were remarkably strong throughout the century, and therefore evidence deduced from late quattrocento drawing practice may reasonably be referred back and checked against the few surviving representatives of early quattrocento drawing. The role of drawings in, for example, Ghirlandaio's preparatory process for the Tornabuoni Chapel frescoes in Sta. Maria Novella in Florence can be reconstructed with some certainty. It would be pure guesswork to state that Masaccio, in the Brancacci Chapel, or Gentile da Fabriano, in the

9

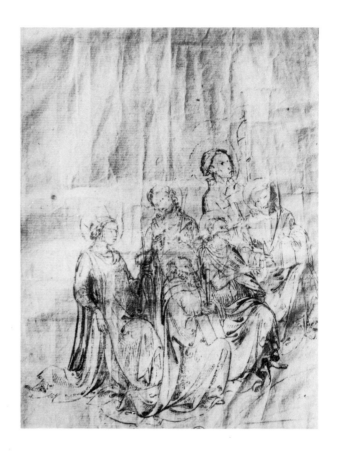

6. Lorenzo Monaco, *Six Saints*. Florence, Uffizi, 11E. Pen and ink on pink-tinted paper; 24.5 × 17.5 cm.

Doge's Palace, worked through a design sequence comparable with Ghirlandaio's, but it would be equally dangerous to assert that they did not. The differences are more likely to be of degree, of the number and range of drawings made in preparation for compositions of comparable complexity, rather than of principle.

Regional Differences

Another critical distortion in the surviving sample of quattrocento drawings is a regional one. Drawings by North Italian quattrocento artists are substantially rarer than those by Tuscans, except in special cases like Pisanello's sketch-books or Jacopo Bellini's books of drawings. Several model-books probably made in Lombardy early in the century survive, but pitifully few single sheets which were not made with preservation in mind now exist, compared with a relatively sizeable group from Tuscany. Verona, the background to Pisanello's remarkable innovations in drawing, is exceptional, for an unaccountably large group of early quattrocento Veronese drawings can be assembled. Only a handful of extant Venetian drawings, however, certainly predate Jacopo Bellini's two great books of drawings of the 1450s. To judge from the numbers of drawings which survive from later in the century, drawing was less freely practised in Venice than

in Florence, and this is also probably true of other North Italian centres like Padua or Ferrara. There is no North Italian parallel to the range and quantity of, for instance, drawings from Filippino Lippi's Florentine workshop, and the number of surviving Titian drawings is a fraction of the size of the Michelangelo corpus, despite Michelangelo's habit of destroying his drawings once their immediate usefulness was past. Survival cannot, of course, be taken as an exact reflection of production, but these imbalances may in general terms indicate that drawing had varying regional functions dependent on the usefulness of the practice in the pursuit of particular regional artistic interests.

Sixteenth-century theorists claim that whereas Central Italian painters were primarily concerned with *disegno*, Venetian art was dominated by a preoccupation with *colore*. This regional polarisation was to some degree a theoretical exaggeration caused by Tuscan writers' admiration for Raphael, Michelangelo and other Central Italian draughtsmen who made major contributions in the field of *disegno*. Inevitably these attitudes affected the balance of the collections of the sixteenth-century Tuscan connoisseurs, and thus created a bias in favour of the survival of Central Italian quattrocento drawings. This bias also reflects an imbalance in production. Not only the relative numbers of surviving drawings, but also the styles, techniques and, by implication, the status and purposes of quattrocento drawings show regional variations. The polarisation between *disegno* and *colore* was exaggerated by chauvinist polemic, but none the less the underlying theoretical proposition has some value for the quattrocento as for the cinquecento. The possibilities offered by drawing for the investigation of anatomical form and movement, for example, were not pursued as vigorously in Venice as in Tuscany; and if Venetian painters tended towards a stronger interest in colour, drawing could offer them fewer opportunities for exploration and experiment.

Collecting

As drawings gradually increased in status and in value as representatives of an artist's style and creative abilities, they became objects worthy of being collected by artist and connoisseur alike.[17] The preservation of quattrocento drawings has depended to a crucial extent on the value accorded to them by cinquecento connoisseurs and collectors as works of art in their own right. Without the development of collecting as a hobby, a passion, and even a necessity for anyone who wished to be seen by his intellectual peers as a discriminating connoisseur, a large proportion of surviving quattrocento drawings might well have been lost to us over the intervening centuries. The scene for this development was set by the artists themselves. In the quattrocento, many drawings were preserved and bequeathed within a family workshop for the practical purpose of sustaining and passing down an artistic tradition. Drawings also circulated amongst workshops and were collected by artists as exemplars or patterns for workshop copying. Benvenuto Cellini writes of Antonio Pollaiuolo that 'he was such a great draughtsman that not merely did all the goldsmiths use his most beautiful drawings, which were of such excellence, but also many sculptors and painters, and I speak of the most accomplished in these arts, also used his designs, and through them achieved the greatest

honour',[18] and Francesco Squarcione, Mantegna's Paduan master, is known to have possessed a Pollaiuolo *cartone* in 1474.[19] Pinturicchio obtained drawings from the Gentile Bellini workshop which he used as patterns in his frescoes, and Raphael arranged an exchange of drawings with Francesco Francia in 1508 and sent a sample of his work to Dürer in 1515 in order to increase communication of interests and styles between himself and contemporary draughtsmen.[20] Leonardo da Vinci seems self-consciously to have gathered up many of his drawings, and to have left them to assistants and friends in the hope that they would thus be preserved for posterity. The developing realisation early in the sixteenth century of the value of drawings as representatives of spontaneous creativity and personal inventive imagination led Michelangelo periodically to destroy drawings in his studio. He wished, it seems, to conceal his creative procedures from the inquisitive eyes of the connoisseur and the historian, perhaps feeling that his drawings revealed more than he was prepared to make public about the workings of his imagination.

These developments led to an increasingly widespread interest among laymen in the formation of collections of drawings at about the beginning of the sixteenth century. Because of the higher status enjoyed by drawings in Northern Italy, it was Venetians who, following the lead of intellectuals like Felice Feliciano, first realised the value of drawings as collectors' items. Jacopo Bellini's London book of drawings belonged early on to Gabriele Vendramin, whose collection of drawings is the earliest recorded in the hands of a patrician connoisseur; and Taddeo Contarini, also a Venetian, was an early collector of drawings as well as paintings by Giorgione.[21] This new desire to collect drawings may have been due in part to the high cost and rarity of finished works by major painters, and indicates that drawings were acceptable substitutes for expensive or unobtainable paintings. Vasari's great collection of drawings was formed as the only feasible way of assembling a reasonably representative collection of works by the Tuscan masters of the previous three hundred years. Without his collection, which survives in large part, and without the spirit of enthusiasm for collecting which he both reflected and encouraged, we would lack a substantial proportion of the material on which this book is based. Furthermore, Vasari was perhaps the first collector to have had an artist's intuitive appreciation of the aesthetic merits of drawings and their superiority over finished works in demonstrating the creative processes at work in artists' minds. As this attitude became more general, the survival of the remaining quattrocento drawings was virtually assured: after the mid-sixteenth century few can have been considered worthless and consequently discarded.

However, these new attitudes which led to the formation of numerous cinquecento collections were once more regionally biased in nature. Gabriele Vendramin collected only Venetian drawings; Timoteo Viti preserved only those of the Umbrian painters.[22] The great collectors of the cinquecento, notably Vasari, concentrated on Central Italian drawings: since Vasari's collection was intended partly as a visual complement to his *Lives* it naturally followed the prejudice shown in his biographies in favour of Central Italian, and especially Tuscan, artists. Furthermore, drawings by local artists were of course easier for him to find. Imbalances in the regional activities of cinquecento collectors inevitably helped to create a bias of survival which favoured Tuscan quattrocento drawings.

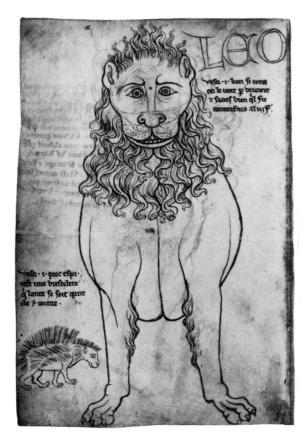

7. Villard de Honnecourt, *Lion*. Paris, Bibliothèque Nationale, MS. fr. 19093, f.24 verso. Pen and ink on parchment; 24.0 × 16.0 cm.

Even bearing in mind all the imbalances and distortions discussed in the last few pages, it is probably reasonable to assume that the range of types of surviving drawings more or less reflects the relative importance of those types in each region or workshop. It is therefore possible, with some reservations, to make comparisons between regions of the importance of certain artistic problems and of how drawing was used to investigate them. Such comparisons will form a significant part of the discussion in later chapters, for comparison can best throw light on the growing versatility of drawing practice and the increasing exploitation of drawing styles and techniques.

THE ORIGINS OF DRAWING

Another fundamental problem with which many writers have grappled is how drawing emerged as an autonomous activity. This question has been artificially polarised, between a search for the origins of drawing either in manuscript illumination or in monumental wall painting, because insufficient account has been taken of the imbalances in survival.[23] Drawing practice was never restricted to these two fields: from an early date drawings were used in different ways to suit different needs. Developments which can be deduced from surviving trecento and early quattrocento drawings do not mark

the emergence of a totally new medium of expression, although the possibilities already hinted at in earlier centuries were certainly progressively more widely and more vigorously exploited.

Surviving medieval drawings tend to be carefully wrought, with inflexible, 'closed' outlines and little concern for form rendered through hatching. This is because they are almost all either 'contract' drawings, finished compositional sketches (mainly in preparation for manuscript illumination or wall painting), or precise pattern-book records for later reference. In other words, almost all surviving medieval drawings had a formal purpose, and that is why they survive. Villard de Honnecourt claims in the inscription to his drawing of a lion (7) that it was 'made from the life',[24] but not only did he schematise the lion's appearance to correspond with the structure of the human head, which he was accustomed to drawing, but he also tamed the wild vitality of the animal by reproducing it in the dry, expressionless pen lines, uniform in emphasis and texture, which characterise all the record drawings in his pattern-book. To contrast this drawing with one by Pisanello (colour plate IV) is to realise the extent to which draughtsmen evolved over a century and a half in their responsive observation of nature and in their technical ability to reproduce their observations faithfully. This evolution was a gradual one, running alongside newly developing attitudes to natural form and its representation seen in painting and sculpture during the later thirteenth and the fourteenth centuries.

Villard's pattern-book was the ancestor of the International Gothic model-book, which in form and graphic style is comparable to the illuminated manuscript. Derived from the manuscript tradition, the model-book in turn gradually evolved, in response to new artistic pressures in the fifteenth century, into the increasingly informal drawings of the sketch-book form. Manuscript illuminations are, however, by definition illustrative: they cannot have the freedom of exploratory sketches, although free sketches probably frequently contributed to the development of the finished design for illumination. Drawing as an autonomous activity evolved from illumination, via the model-book, only in the technical sense. The fundamental stimulus to the emergence of new types and freedom of graphic expression was the growing assumption, on the part of quattrocento theorists, painters and patrons alike, that artists should seek above all to imitate and even to surpass the forms and rhythms of nature.

The ability of draughtsmen to record faithfully their new perceptions of nature must have been increased through small-scale study, perhaps generally in preparation for commissioned works, perhaps purely experimental. We now have only a vague, general idea of the character of these studies, since unfortunately very few survive. Clarification may perhaps be provided gradually by the underdrawings for wall paintings which are being revealed in ever-growing number: the opportunities offered by large areas of wall may have been an invigorating stimulus to experimental drawing. But as will be seen later, wall surfaces have significant limitations for draughtsmen, which inevitably restrict their value for the development of graphic freedom and the pursuit of artistic interests. Underdrawing probably contributed little to the remarkable range of graphic expression which is already shown in the handful of experimental drawings surviving from the beginning of the fifteenth century. Before an underdrawing could have been made, whether on the wall, on panel, or on parchment in preparation for illumination,

experimental sketches must normally have been made. Early on, these sketches may generally have been monotonous, relying on 'closed' outlines and lacking in graphic freedom. They provided, however, the context from which drawing could, and did, emerge as a medium for experimentation and individual expression in the hands of draughtsmen responsive to its possibilities and stimulated by the new demands of early Renaissance artistic ideas.

DRAWING IN WORKSHOP TRAINING

The graphic freedoms which already existed by the beginning of the quattrocento were not, however, identified by Cennino Cennini among the positive benefits of drawing. Indeed, Cennino's discussion of the techniques and uses of drawing entirely fails to comment on its potential for exploratory or individual, expressive purposes. When not directly associated with the preparation of a painting, drawing was for Cennino essentially the means by which artistic tradition and skill could be communicated to a new apprentice. Once the materials had been prepared, Cennino instructed the apprentice to 'start to copy the easiest possible subjects, to get your hand in . . . using a model',[25] by which he implies another drawing, preferably by the master; and to 'take pains and pleasure in constantly copying the best things which [you] can find done by the hand of great masters'.[26] The best apprentices 'come to want to find a master; and they bind themselves to him with respect for authority, undergoing an apprenticeship in order to achieve perfection',[27] but

> if you undertake to copy after one master today and another tomorrow, you will not acquire the style of either one or the other, and you will inevitably, through enthusiasm, become capricious, because each style will be distracting your mind . . . If you follow the course of one man through constant practice, your intelligence would have to be crude indeed for you not to get some nourishment from it.[28]

Cennino's discussion shows clearly the primary role of drawing in early quattrocento workshop training. Early in the century the model-book played a fundamental part in ensuring that the young apprentice inherited the conventions and style of the workshop. The model-book gradually lost importance as progressively more stress was placed on individualisation, but it was succeeded by less formal 'pattern' drawings which continued throughout the century and into the next to play a vital part in communicating the workshop style to apprentices. Pollaiuolo's sheet of studies of a *Nude man seen from front, side and back* (81) evidently acquired some fame as a 'pattern' for copying, since a contemporary added the inscription 'This is the work of the excellent and famous Florentine painter and outstanding sculptor Antonio, son of Jacopo. When he depicts man, look how marvellously he shows the limbs', and it served as the prototype for several surviving drawings from the Pollaiuolo workshop.[29] This seems almost paradoxical, since copying a two-dimensional pattern appears to contradict the primary purpose of the drawing, which was to study three-dimensional anatomical form. None the less, Pollaiuolo's apprentices followed closely the precept of Leonardo da Vinci who,

15

returning to Cennino's theme late in the century, wrote that 'the painter ought first to train his own hand by copying drawings from the hands of good masters, and when this has been done under the guidance of his teacher, he should represent objects well in relief',[30] and he further advises the apprentice to 'copy work after the hand of a good master, to gain the habit of drawing parts of the body well'.[31] Leonardo himself used the refined techniques of silverpoint drawing (colour plate I) and brush-drawing on linen for drapery studies (30) current in Verrocchio's workshop during his apprenticeship; and Raphael's earliest drawings are often difficult to distinguish from Perugino's, probably because many of them copy workshop exemplars.

The practice of copy-drawing in the training of the young painter was so well known that it was quoted as an example by laymen. In 1420 the humanist Gasparino Barzizza suggested that schoolmasters should learn from the methods used for training apprentices:

> whenever something is to be learned from the master, before they have got the theory of painting, they are in the habit of handing them some very good figures and pictures, as models of this craft, and, taught by these, they can progress a bit by themselves.[32]

In a sermon in 1493 Savonarola compared apprentice copying with man's desire to imitate God:

> What does the pupil look for in the master? I'll tell you. The master draws from his mind an image which his hands trace on paper and it carries the imprint of his idea. The pupil studies the drawing, and tries to imitate it. Little by little, in this way, he appropriates the style of his master. That is how all natural things, and all creatures, have derived from the divine intellect.[33]

In North Italy the same practice was used in workshop training. Just as International Gothic model-books were duplicated by copying, so also the large corpus of Pisanello drawings includes many apprentice copies of autograph exemplars. Several sheets of figure studies made in Carpaccio's studio at the end of the fifteenth century are rather unaccomplished copies of the master's originals (66). To distinguish between the master's and his pupils' drawings requires subjective judgements of relative quality; but the evidence is clear enough to confirm the instructional role played by model-books or portfolios of drawings kept in North Italian workshops.

Copying was for Cennino a means of ensuring the continuation of the trecento traditions in which he was trained. By the later quattrocento a stronger belief in the value of individuality had developed, and the idea that artistic tradition should be perpetuated was less strongly followed. It was, however, still necessary to ensure a high degree of stylistic consistency, especially in the collaborative works produced in the large work-shops which developed towards the end of the century, and in the replicated versions of a prototype designed by the master and issued from the workshop over his signature. Copy-drawing was the ideal way to channel heterogeneous artistic talents and incli-nations in a relatively uniform direction. It was also, of course, the most practical and inexpensive way for the young apprentice to acquire the manual skills he needed. For Cennino, Ghiberti and Leonardo da Vinci drawing was the declared foundation-stone of the artist's training, and control of the silverpoint and the pen was best learned by copying the master's drawings line for line.

DRAWING IN ARTISTIC EXPLORATION

More and more often as the fifteenth century progressed, drawings make manifest types of artistic activity which earlier had only seldom been attempted on paper. Experimental drawings become gradually more numerous, whereas earlier draughtsmen had been inhibited by cost from exploiting paper for experiments in graphic handling, in observation of the model, or in the formulation of pictorial compositions. During the fifteenth century conventional compositions and figure-types needed more and more to be reconsidered according to the new tenets of early Renaissance realism, so artists were stimulated to develop the scope of drawing which came to be seen as the natural medium for investigating new problems. The growing need for artistic exploration made draughtsmen more prepared than before to use paper. Whereas, for example, early quattrocento studies from the nude model are (and probably always were) rare, they are innumerable by the end of the century, and the range of technique and handling is as wide as the range of specific anatomical problems investigated.

No group of drawings which can be associated with a single project survives from the early quattrocento. By the end of the century, however, we can begin to trace the stages through which the artist worked in the exploratory evolution of a design and in the solution of formal problems which he encountered in the process. The model-book stock of motifs ready for transfer into a painting gives way to loose sheets of rapidly recorded observations and alternative solutions to problems of form, foreshortening or expression. Such studies were not intended for reuse in paintings. Primarily a record of artistic and creative activity, they could be reviewed at a later date by the artist when tracing the progress of his thoughts on the problem under scrutiny.

Draughtsmen also became increasingly confident in handling their tools and techniques, and consequently developed more clearly personal graphic styles and modes of expression. The master's workshop style was no longer absolute, but served as a springboard for independent graphic activity. Increasing awareness of the advantages, and also of the constructive limitations, of different techniques is also apparent as the quattrocento progresses. Certain draughtsmen concentrated on particular techniques which offered the widest scope for the exploration of their individual preoccupations. Pollaiuolo used pen and ink almost without exception, while Filippino Lippi almost always made his life studies in silverpoint and white heightening. Carpaccio used a range of techniques, but concentrated on developing and exploiting a very personal technique of brush-drawing on blue paper. Leonardo da Vinci exploited all available techniques, and pioneered some new ones, for the potential inherent in each, carefully choosing his technique in response to the demands of the problem he was tackling. These developments are the principal subjects for consideration in the following chapters. During the quattrocento, drawing as a medium of artistic exploration and expression emerged rapidly from a background (as far as one can reconstruct it) of only tentative steps beyond a tradition in which drawing was inflexible and impersonal, serving essentially as a workshop record. By the end of the century the exploitation of the immense potential of drawing for the investigation of artists' problems, and for the expression of their growing creative self-consciousness, provided a firm foundation for the achievements of the great draughtsmen of the High Renaissance.

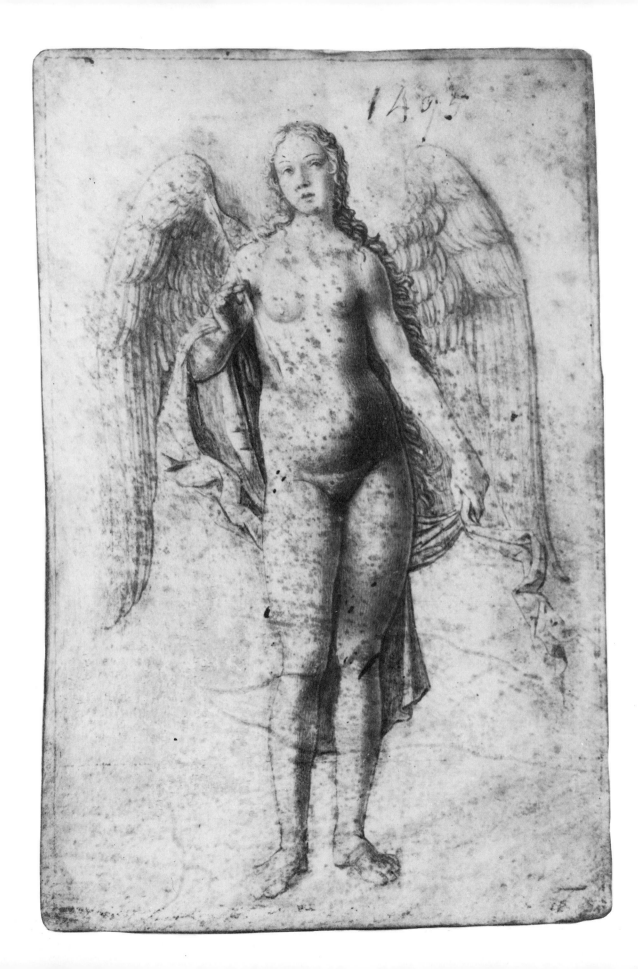

Drawing Surfaces

PARCHMENT AND OTHER SMALL-SCALE SURFACES

BEFORE regular supplies of high-quality paper were available to the draughtsman, parchment or vellum were often used as surfaces for drawing. Parchment, prepared from the skins of sheep or goats, and especially vellum (made from very young animal skins, at first calf-skin), were significantly more expensive than paper, and surviving drawings on parchment are almost all formal, highly detailed and well finished. It was, for example, an appropriate material from which to make a model-book, which needed to survive long-term workshop use, especially at a time when the reliability of paper was in doubt. Parchment is clearly much more durable than paper, and less prone to wear and tear. One of the results of preparing paper for stylus drawing was a more durable surface, slowing down the anticipated deterioration of the paper: this surface was sometimes used as an alternative to parchment in later model-books. As the model-book gave way to the sketch-book, the activity of drawing became progressively more informal and experimental; for this to be technically and economically feasible the less substantial, less expensive and more versatile paper was increasingly needed. After the middle of the fifteenth century, drawings on parchment become much rarer, despite the special qualities of the surface due to its smoothness, colour and high absorbency. The use of parchment and touches of bodycolour on a fine pen drawing of a *Winged female figure* (8) suggest that this late fifteenth-century sheet belongs in the North Italian tradition of a drawing standing as a work of art in its own right. It has closer parallels than most drawings of its date with the model-book tradition and perhaps like Lorenzo Monaco's *Visitation* (3) was intended to be seen as a miniature panel painting.

The careful detail and use of colour in these two drawings, similar to the controlled style and handling of model-book pages, immediately suggest a parallel with manuscript illumination. Drawings made in preparation for illumination in vellum books probably stimulated the growing use, into the early quattrocento, of parchment as a surface for model-book drawings (32–3) and for formal 'contract' drawings (116–17). During the preparatory stages of illumination, the painter transferred his compositional ideas onto the vellum page as careful drawings ready for colouring. Model-book drawings were similarly transferred by copying into manuscript illuminations, and this process could easily have promoted the practice of drawing on parchment for record purposes. Furthermore, record drawings in model-books were to be preserved in the same way, and in the same format, as texts written and illustrated on the pages of a book. Just as

8. North Italian draughtsman, ca. 1500, *Winged female figure*. Cambridge, Fitzwilliam Museum, 2622. Pen and ink, with wash and touches of pink bodycolour, on parchment; 31.4 × 20.8 cm.

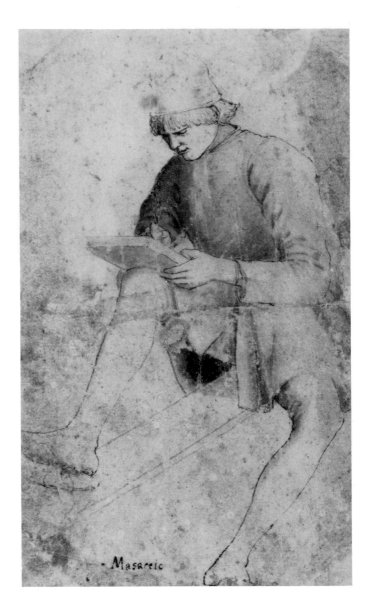

9. Workshop of Pollaiuolo (?), *Youth drawing*. London, British Museum, 1895–9–15–440. Pen and ink with wash on paper; 19.2 × 11.4 cm.

miniatures required an immaculate small-scale technique, so also a model-book drawing had to be highly detailed and accurate. The quality of the smooth parchment sheet to take, indeed to encourage, a very fine line which is none the less tonally rich due to the sheet's high absorbency is an advantage much exploited by the model-book draughtsman. But since the availability of parchment was controlled by the economics of the livestock market, production could not be rapidly increased to meet growing demands. Nor could production costs be radically reduced, because the base costs of rearing the animals and suitably preparing the skins for refined drawings were high. For economic reasons, therefore, parchment was appropriate only for this type of drawing, and not for more spontaneous, exploratory drawings.

Before paper was widely available and commonly used, other materials were at hand for experimental drawings. Normally there was no reason for such drawings to be preserved; indeed, it may often have been preferable, especially in the case of apprentices'

drawings, that they should be destroyed at once. They were therefore made not on parchment or paper, but on a reusable surface. Cennino Cennini writes of the use of figwood or boxwood tablets, prepared with a thin layer of ground bone, for the apprentice's first experiments with the silverpoint, and he specifically notes that this has the advantage that the tablets can be scraped down and reused.[1] The close-grained hardness of boxwood is ideal for this purpose: little of the surface would be lost in scraping off the preparation and only after much reuse would the tablet become so uneven as to need to be replaned. Reusable prepared tablets were very satisfactory for stylus drawing, but not for pen drawing, for which paper or parchment was needed. This is one reason why Cennino recommended that the apprentice should start his training with silverpoint drawing and graduate to the pen only after much practice. A Florentine pen-and-ink drawing (9) shows an apprentice, perhaps in Pollaiuolo's workshop, engrossed in drawing on a wooden tablet, still used late in the quattrocento even when many studies were made on paper. Other surfaces, each having particular disadvantages, which could have been used for rapid sketches of no permanent value are wax tablets, slates, or even the dust on the workshop floor. From the historian's point of view all these surfaces suffer from the crucial disadvantage that the drawings on them were made with the intention of being destroyed. As a result a huge number of drawings, indeed almost the entire production of one type of drawing, are lost, and our knowledge of early quattrocento drawing practice is significantly the poorer.

PAPER

Throughout the fifteenth century, paper was a costly material. Early in the century it was generally too expensive and in too short supply for draughtsmen to be prepared to afford it for experimental drawings. Most surviving drawings from the first half of the century were therefore made either for workshop preservation or for formal, contractual purposes. Although the cost remained relatively high, paper became more freely available later in the century, and this stimulated artists to make more use of it for experimental drawing. Furthermore, draughtsmen became more aware of, and more ready to exploit, the benefits of experimental drawing for the exploration of artistic problems. The pen has a flexibility and versatility of movement which makes it the most appropriate instrument for this kind of drawing: the rapid increase in sketching with the pen led to a corresponding growth in the use of paper.

The growing demand of mid-quattrocento artists for larger supplies of paper for experimental drawing was fortunately matched by a vigorous development of the paper industry.[2] Paper had been manufactured in Italy for well over a century before the beginning of the quattrocento, and had been imported into Europe for several centuries before that. There were paper-mills at least as early as 1276 in Fabriano, where conditions for the industry were unusually favourable due to plentiful clean water, windmills available for conversion to drive the paper-mills, and an expanding textile industry to supply the raw materials. By 1330 Fabriano was the leading European centre of the industry, with about twenty mills providing paper both for home consumption and for

export. Expansion was slow, however, for paper was considered very inferior for manuscript books, and too fragile and prone to deterioration for legal or constitutional documents. Until the fifteenth century paper lacked prestige, and it neither presented clear enough advantages nor was it manufactured in large enough quantities to replace parchment.

The invention of printing by movable type, and the establishment of printing presses throughout Europe, created a huge new demand for paper. Once the mechanical problems in printed book production had been solved, the possibilities of rapid communication to a new, middle-class, educated élite which could not afford many parchment manuscript books were quickly realised. An edition of 250 or 300 copies of a printed book could be produced faster, more accurately and more cheaply than a single copy of the same text handwritten on parchment. This sudden development put enormous demands on the paper industry, and required a matching expansion of paper manufacture to supply the voracious presses. There was probably plenty of paper-making capacity in Europe at the time of the early development of printing, for the growth of the paper industry was one of the significant economic results of the Council of Basel (1431–49). Indeed, the ready availability of paper probably acted as a stimulus to the initial development of printing, which might otherwise not have evolved so soon or so fast. None the less the demands of the presses soon exceeded the capacity of existing papermills, and there was a rapid growth in the manufacture of paper from about 1450 in Northern Europe. Printing presses were established in Rome in 1467 and all over the peninsula during the early 1470s: in response, the Italian paper industry also expanded rapidly in the last third of the century.

The stimulus of the development of printing to the manufacture of paper had important consequences for draughtsmen, for just at the time when artistic practice needed more paper for drawing it became more readily available. Paper also probably rose in quality and dropped somewhat in price, since it was produced in greater quantity for a rapidly growing consumer. With improvements in paper manufacture, fears about the durability of paper probably lessened. For both technical and economic reasons, in any case, paper was the most satisfactory surface to print on, and parchment production could not possibly expand to keep pace with the demands of the presses. That paper should have been used in increasing quantities for drawing is as natural an outcome of the expansion of the industry as it is of the developing requirements of drawing practice.

Paper could not, however, drop so much in price that it could be used as freely as it is today. The production of paper from wood-pulp was a development of the early eighteenth century. From the time that the industry was established in Europe, paper was manufactured from cloth – the best paper from linen, lower quality paper from cotton or rags. The process was laborious and time-consuming, and required special sites with plentiful clean water for washing the paper in the course of manufacture. Although output increased dramatically in response to new demand, cloth-paper was never cheap by modern standards. In the fifteenth century good quality paper cost about one-sixth the price of parchment: it was therefore much more expensive than is generally assumed. The cost of the paper was a surprisingly high proportion of the total cost of book production. For the edition of 1,025 copies of Ficino's translation of the complete works

of Plato, printed in Florence in 1483, the paper cost between 120 and 160 florins, whereas all the printing costs came to only 90 florins. The cheapness of paper compared with parchment was commented on by late fifteenth-century writers, but it was none the less still a commodity of significant cost to the artist. It was the greater currency and wider use of paper, rather than a substantial drop in price, which stimulated the late quattrocento draughtsman also to use it more freely.

Increased supplies of raw materials could be obtained more easily for paper than for parchment manufacture. None the less, the rapidity of expansion of the paper industry put great pressure on these supplies. Late in the fifteenth century new laws were passed to prevent the export of cotton rags from Venetian territory, and equally stringent efforts were probably needed elsewhere to collect the materials needed by the industry. This probably involved the reuse of used paper itself, and the loss of many quattrocento drawings may be attributed to the appetites of the paper-mills. This might be true especially of cartoons which, since they were finished drawings for a single purpose, could seldom have further use in the workshop, but would be especially suitable for recycling because of the size and thickness of the paper used. The survival of quattrocento cartoons is therefore particularly fortuitous, depending perhaps on a precocious recognition of artistic quality, or on the attachment to a cartoon of a personal value, in the case, for example, of Ghirlandaio's portrait cartoon for the Tornabuoni Chapel *Birth of the Virgin* (160).

The increase in the use of paper for drawing was one of the crucial developments in quattrocento drawing practice. Despite the appetites of the paper-mills for waste there is a large increase in the number of drawings surviving from the last third of the century. Furthermore, the use of paper allowed the draughtsman much greater inventive and exploratory freedom, and gave him the opportunity to review the progress of his ideas or skills over a group of drawings collected together. In this way, paper both provided for and stimulated the growing consciousness of artistic expression of the early Renaissance draughtsman.

'SINOPIE' AND CARTOONS

The surfaces so far considered were appropriate only for small-scale drawings, for both practical and economic reasons. The early quattrocento artist also had opportunities for drawing on a larger scale, through which he could have explored artistic problems in greater detail. Occasionally he might have gained a commission for a stained-glass design, for which a full-scale drawing had to be made: 'you will take as many sheets of paper glued together as you need for your window; and you will draw your figure first with charcoal, then fix it with ink, with your figure completely shaded, exactly as you draw on panel.'[3] No such full-scale drawing survives, so we cannot know how painters may have made use of the opportunity, but Cennino's description suggests that these drawings were careful and dry, lacking in graphic freedom. This is to be expected, since they functioned essentially as a guide both to the glass master in his cutting of the coloured glass and to the painter himself when working on the glass. As the above

quotation suggests, Cennino recommends the same technique of fixing in ink a charcoal underdrawing when setting out a design in preparation for painting on panel. What can be seen of underdrawings of fifteenth-century panel paintings, especially of thinly glazed oil paintings viewed under infra-red light, tends to bear out Cennino's words. A formal, precise drawing as a guide to painting, rather than exploitation of a chance for large-scale experiment, is appropriate to the context.

Over the past few decades techniques have been developed by which during the conservation of fresco paintings the *sinopia* underdrawings have been revealed.[4] Although standard in the preparation for mural painting at least from the mid-thirteenth century, the practice of making these underdrawings declined in popularity with later quattrocento painters in favour of the use of full-scale cartoons. This important change reveals much about how artists used drawings and realised the benefits of new aspects of drawing practice, just as *sinopia* drawings tell us a lot about how draughtsmen exploited the opportunity for drawing on a large scale.

Before the introduction of cartoons on paper to transfer a design, or part of a design, to the wall for painting, the final stage of preparation for mural decoration was the *sinopia* drawing. This name derives from the red-earth pigment sinoper, traditionally used for these underdrawings, which was applied with the brush over a rough preliminary charcoal drawing on the wall to be painted.[5] *Sinopia* drawing may in some respects have had a significant role to play in the development of graphic freedom, but it is important to note at once that *sinopie* could only be brush drawings. Analogous in technique to the execution of the finished fresco, they had rather little in common with the handling of the silverpoint or the pen. Although they might be exploited in the consideration of artistic concerns, in technical terms they could have made only a limited contribution to the development of drawing as an autonomous medium.

As preparation for mural painting, the *sinopia* had obvious practical functions. It also had one major drawback: the underdrawing was inevitably concealed by the patch of fresh plaster applied for each day's fresco work. The *sinopia* alone could not provide the painter with detailed indications of the form to be painted. In practical terms, therefore, the *sinopia* did not need to be more than an outline drawing, to show the painter the boundaries of the patch of plaster to be laid on the wall. Before painting began gradually, patch by patch, to conceal it from view, the *sinopia* showed the complete composition on the wall. This was important to the painter who was concerned with the effect created by the scale of his composition, but this advantage was often limited by the location of the wall to be decorated. The *sinopia* painter had none of the flexibility of the draughtsman working on the small scale, who could carry his paper or prepared tablet wherever he wished to draw. Seldom could he stand back to judge the overall compositional effect of his *sinopia*, since the wall was generally obscured by scaffolding. These disadvantages were overcome by some artists under certain conditions, but they limited the potential value of the wall as a surface for large-scale exploratory drawing.

The problem of the location of the wall to be painted also arose in the transfer of a small-scale design. The system of 'snapping' onto the wall-surface a series of vertical and horizontal lines, around which the composition could be drawn, may have evolved in response to these difficulties. A thick string dipped in sinoper and held taut between two

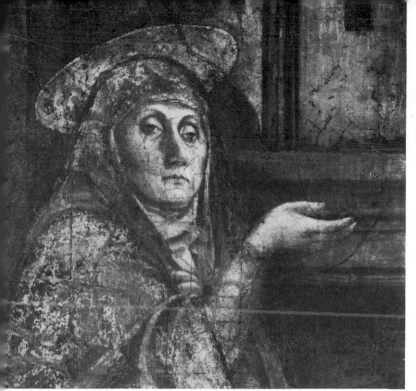

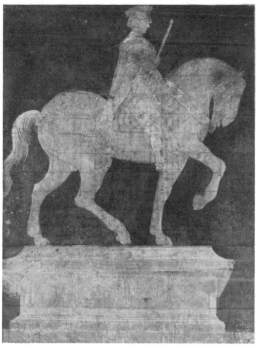

10. Masaccio, *Trinity*, detail: Virgin Mary. Florence, Sta. Maria Novella.

11. Paolo Uccello, *Design for monument to Sir John Hawkwood*. Florence, Uffizi, 31F. Silverpoint with white heightening on light green prepared paper, the background coloured dull red with the brush; 46.0 × 33.2 cm. Documented mid-1436.

points was snapped against the wall to leave a straight line of pigment. This process could have been the initial stimulus behind the development of the method of enlarging a design from a squared drawing, although this was apparently not in Cennino's mind when he wrote his rather opaque discussion of snapping.[6] As early as the mid-1420s, however, Masaccio painted the head of the Virgin in the *Trinity* in Sta. Maria Novella, Florence, over an incised grid (10), which presupposes that he was working from a careful, squared study for this subtly foreshortened head. The earliest surviving squared drawing is Uccello's study for the Hawkwood Monument (11) painted in the Florentine Duomo in 1436, but no other squared drawings date before the late quattrocento. Designs for large-scale works were probably normally still transferred by rule of thumb, using snapping as a guide in the case of wall painting.

Masaccio's incised grid and Uccello's squared Hawkwood Monument drawing are analogous to Alberti's *velum* or 'veil'. 'A veil loosely woven of fine thread . . . divided up by thicker threads into as many parallel square sections as you like, and stretched on a frame . . . affords the greatest assistance in executing your picture, since you can see any object that is round and in relief, represented on the flat surface of the veil',[7] which is 'set up between the eye and the object to be represented'. Alberti advises the painter to use a veil when drawing or painting from a model, advice which may reproduce an accepted technical practice in the circle of Brunelleschi and Masaccio. The writer further suggests that 'it will help to divide our models into parallels, so that everything can then be transferred, as it were, from our private papers and put into correct position in the work'.[8] The use of a squared drawing is particularly valuable when a painter who, like Masaccio (10), demands absolute realism of form tackles a difficult problem of fore-

25

shortening. These attitudes are significantly different from painting conventions at the very beginning of the fifteenth century, when frescoes often show precisely the sort of compositional discontinuities that one might expect from the transfer of a small-scale design by the relatively arbitrary process of snapping. By the end of the century it had been realised fully that only the use of squared drawings could adequately compensate for the lack of opportunity of seeing the composition as a whole until painting was finished and the scaffolding had been removed.

For various practical reasons, then, most trecento and early quattrocento *sinopie* are very simple, evidently intended as no more than a guide for plastering. This may suggest that the painter would regularly have used 'auxiliary cartoons', finished drawings of details (especially perhaps of heads) which he could follow carefully when working up important passages in a fresco. Evidence for this practice might perhaps be deduced from some model-books which contain a stock of patterns for heads. But these models are very different in scale and technique: it is most unlikely that they were related to the particular problems of fresco painting. The earliest surviving drawings that may have served in part as auxiliary cartoons date from the late quattrocento: an example is the portrait cartoon for Ghirlandaio's Tornabuoni Chapel *Birth of the Virgin* (160). Earlier on, painters worked from established formulae for the faces of religious figures, varying them only slightly to suit the expressive demands of the scene. They worked essentially from memory of other painted representations and from traditional workshop procedures such as Cennino recommends, rather than from a detailed drawing made especially for the occasion.[9] Elaborate preparatory studies, such as Leonardo da Vinci's for the heads of Apostles in the *Last Supper* (173–4, colour plate VII), were unnecessary at a time when painters were not stirred to reconsider stock types or to develop new individual characterisations, but were content to work from memory patterns.

Not all *sinopie*, however, even of the fourteenth century were simple outline drawings. Despite its limitations, *sinopia* drawing sometimes gave draughtsmen otherwise very rare opportunities for making detailed monochrome studies on the monumental scale. An excellent example of the way that these chances could be grasped and exploited to the full is the series of underdrawings made by Simone Martini for his two frescoes on the main portal of Notre-Dame-des-Doms in Avignon.[10] For these frescoes Simone produced two sets of underdrawings, both much more detailed than was usual in the fourteenth century. The initial drawing for the *Blessing Christ with Angels* (13) was made on the bare stone of the tympanum, using charcoal applied in thick, bold lines. Since this was subsequently entirely covered by the first layer of plaster, it was evidently a full-scale preliminary design to be revised in the *sinopia*. Indeed, changes were made to this drawing itself, showing that Simone was using the wall to work out the figure group composition, rather than simply transferring an already established design. For the *Madonna and Child with Angels* lunette a *sinopia* study of the Madonna and Child group alone (14) was laid over the initial charcoal underdrawing. The entire surface was then plastered over, and a full *sinopia* (12) was drawn in preparation for fresco painting. These *sinopie* are not mere outline drawings: they are finely finished studies of form, of drapery patterns and of expressive types. The modelling of faces, hands and details like the curls of the angels' hair is thoughtfully considered, with more in mind than the production of a

12. Simone Martini, *Madonna and Child with Angels*. Avignon, Palais des Papes (formerly Notre-Dame-des-Doms). Sinopia on plaster.

13. Simone Martini, *Blessing Christ with Angels*. Avignon, Notre-Dame-des-Doms. Charcoal underdrawing on wall.

14. Simone Martini, *Madonna and Child*. Avignon, Palais des Papes (formerly Notre-Dame-des-Doms). Sinopia on plaster.

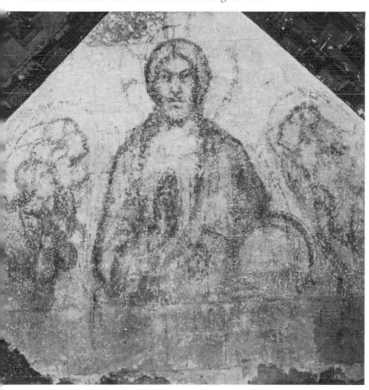

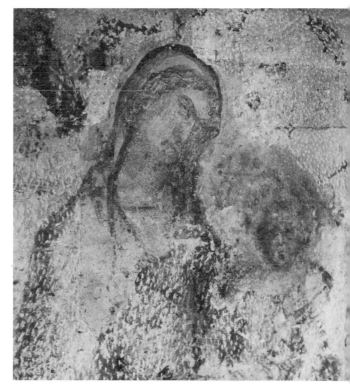

drawing to assist in the execution of the fresco. Simone took full advantage of the scale of his drawings to explore problems in the representation of three-dimensional form which can better be studied in terms of tone than colour.

Too few *sinopie* have yet been recovered to allow broad generalisations about how they were used for artistic experiment. If Simone's procedure appears unusual in the trecento, the opportunities that he realised *sinopia* drawing could offer were more often taken up in early quattrocento Florence, where artistic consciousness of problems of form, and the scope of drawing for investigating them, developed more strongly than elsewhere. None of Masaccio's frescoes has yet been removed from the wall to reveal the *sinopia*, but his underdrawing practice may be reflected in Masolino's works. The *sinopie* of Masolino's Empoli frescoes of 1424 are simple compositional outlines (15), but in S. Clemente, Rome, in 1428 Masolino studied the problem of showing the dramatic movement of St. Catherine's executioner in some detail in the *sinopia* (16). Perhaps in proof of the experimental function of this well-modelled, vigorous drawing, the final painting of the same figure is weak and conventional in type.

The contrast between these two *sinopie* may, on the other hand, have less to do with Masaccio's influence than with the possibilities offered by the locations of the frescoes. In churches or chapels the scope for making detailed studies of form on the large scale was often severely limited by inadequate light. Cennino appears to have recognised this problem when he wrote of 'drawing or copying in chapels, or painting in other adverse situations'.[11] The artist's difficulties in seeing what he was drawing may explain why *sinopie* were surprisingly seldom exploited for artistic study. Simone Martini worked in full daylight on the Avignon portal, but his *sinopia* for *St. Martin sharing his Cloak with a Beggar* made in the relatively dimly lit Montefiore Chapel in the Lower Church of S. Francesco at Assisi is an outline drawing with scarcely any modelling added within the contours of the forms. Working in the reasonably good light of the Camposanto at Pisa, Francesco Traini and Benozzo Gozzoli modelled their figures more than did contemporaries working in less favourable conditions; and the wall surface there was occasionally used for brief experimental sketches which bear no relation to the fresco finally painted.

An increasing desire to exploit *sinopia* drawing for making detailed, large-scale studies of form may have been an important stimulus to the development of the use of cartoons in fresco painting. But it was essentially the growing need for stronger individualisation of forms, faces and expressions that led to the wider use of cartoons. A cartoon is a full-scale drawing on thick paper, which in the fifteenth century was normally transferred by pricking holes along the major outlines through which charcoal dust was 'pounced' onto the wall. The technical advantage of the cartoon over the *sinopia* is that the design is reproduced directly on the *intonaco*, the layer of wet plaster which was to be painted, to act as a detailed guide to the painter. Cartoons or stencils had been used at least since the mid-fourteenth century for duplicating decorative details, so the principle and the technique were well established. Cennino describes how to use a parchment stencil for reproducing brocade patterns,[12] but he writes of full-scale drawings on paper only in connection with stained-glass design. The great stained-glass commissions for the Florentine Duomo in the 1430s and 1440s may have been a further stimulus to the

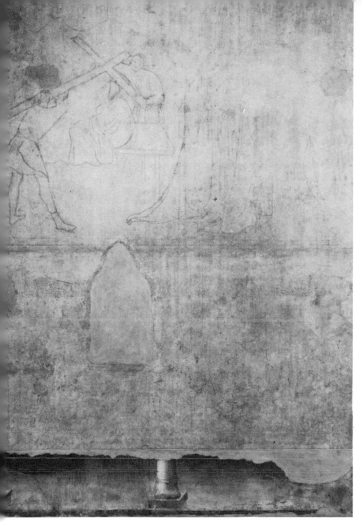

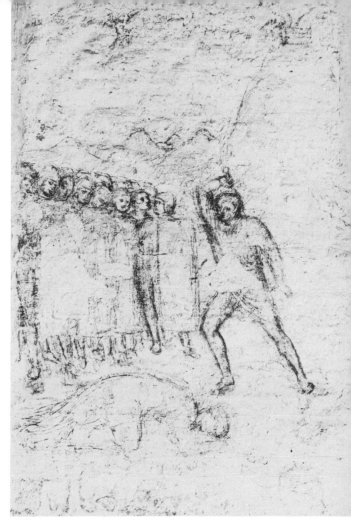

15. Masolino, *The Proof of the True Cross*. Empoli, S. Agostino. Sinopia on plaster.

16. Masolino, *Execution of St. Catherine*. Rome, S. Clemente, Castiglione Chapel. Sinopia on plaster.

adoption of cartoons for fresco painting, for evidence of the use of cartoons in fresco painting first appears at about the middle of the century. The realisation of the artistic benefits of full-scale drawings necessary in stained-glass work could lead easily to the introduction of cartoons into fresco technique. By the late quattrocento it had become standard practice to use cartoons in panel painting also, as can be seen from cartoon fragments from Verrocchio's workshop (colour plate VI) for example.

By the early sixteenth century, cartoons made of numerous sheets of paper stuck together were used for large areas of a fresco composition. Because they were cut into sections corresponding with each day's fresco work, these cartoons seldom survive. Heavily used in the course of transfer, cartoon fragments were normally discarded, probably to be returned to the paper-mills for re-pulping. It is thus the more surprising that the cartoon for the figure group of Raphael's *School of Athens* should have been reassembled and preserved: like the comparatively small cartoon for his *St. Catherine of Alexandria* (182) it was evidently recognised early on as a drawing of high value in its own right.

At first, perhaps because of the cost of paper and the unfamiliarity of the practice,

29

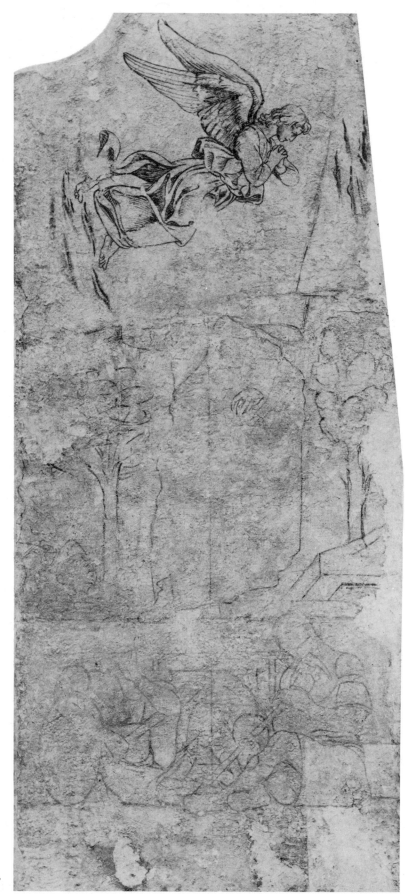

17. Andrea del Castagno,
Resurrection. Florence,
S. Apollonia. Sinopia on
plaster.

18. (facing page) Andrea del
Castagno, *Resurrection*,
detail: head of Christ. Florence,
S. Apollonia.

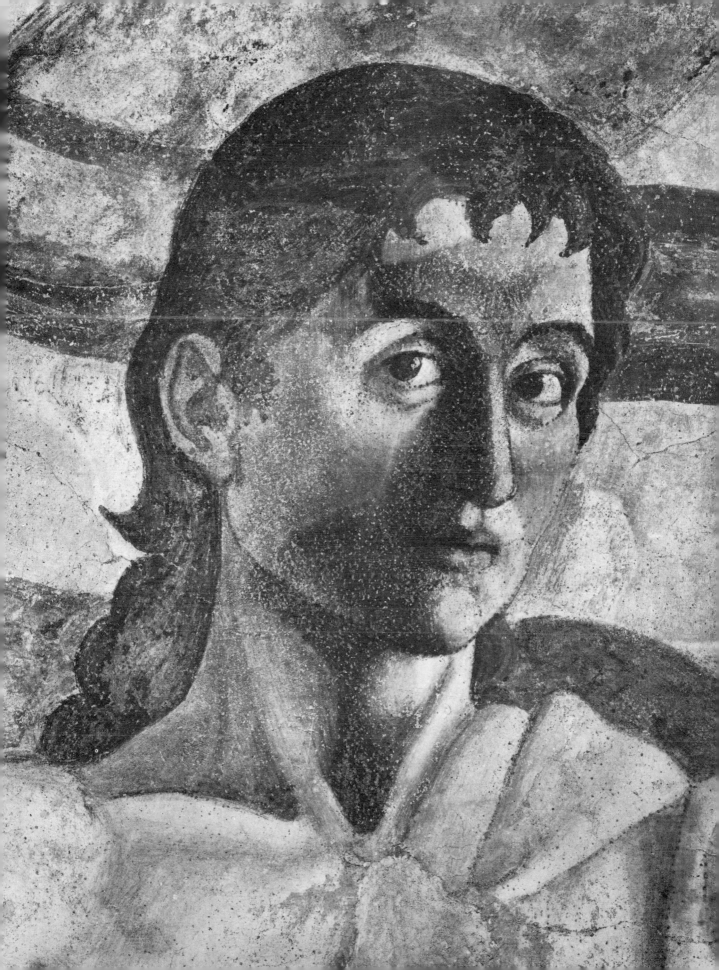

cartoons were used in conjunction with *sinopie*. In his fresco of the *Resurrection* in S. Apollonia, Florence, Andrea del Castagno combined *sinopia* with a cartoon for the main figure (17). The *sinopia* is worked up in considerable detail in areas such as the flying angel, but it is almost completely blank for the figure of Christ. The complicated fold patterns of Christ's drapery in the finished painting, the carefully rendered musculature and the keenly observed, expressive face derive from a cartoon. The series of black dots left by the charcoal dust pounced through the pricked holes can still be seen lining the wiry contours of Christ's face (18). The same evidence of the use of a cartoon is to be found round the head of St. Jerome in Castagno's small fresco of the *Trinity with St. Jerome* in SS. Annunziata, Florence. The *sinopia* for this fresco (19), drawn over a preliminary charcoal sketch which is still plainly to be seen, was worked up by apprentices in Castagno's workshop who were allowed to experiment directly on the wall surface. The contrast in the drapery styles of the two female saints shows that more than one draughtsman was at work. None of the figures in the *sinopia* has the sense of form and energetic vigour of those ultimately transferred by cartoon and painted by Castagno himself.

The gradual introduction of cartoons into the working practice of the mid-quattrocento Tuscan fresco painter indicates the painter's growing dissatisfaction with the *sinopia* alone as the working design for a fresco. This was probably due to the dual disadvantages of working directly on the wall, and covering the drawing as painting proceeded. The use of cartoons was required by several factors: the painter's increasing desire to study forms carefully and to transfer them accurately to the surface to be painted (especially import-ant in fresco, where painting had to be rapid and could not be held up for pondered reconsideration); the need to develop individualised, expressively differentiated types rather than to follow traditional formulae; and the need for detailed exemplars of complex foreshortenings, movements or expressions as auxiliary guides to painting. These new artistic demands in turn required that painters should afford the cost of paper for cartoons, and this requirement coincided with the gradual increase in the availability of paper. The growing use of cartoons may itself have acted as a stimulus to the increasing readiness of draughtsmen to invest in significantly larger quantities of paper than before, and to make greater numbers of preliminary studies which could be assembled together towards the production of full-scale cartoons for the final painting. By the end of the fifteenth century paper had largely supplanted the wall as the surface for full-scale preparatory drawings: the practical advantages of paper more than out-weighed the costs involved.

The growth of the production of cartoons is a particularly clear example of the benefit to artists of the expansion of the paper industry during the second half of the fifteenth century. The greater availability of paper was, however, exploited in numerous other ways. It almost entirely replaced parchment for formal drawings intended for preser-vation, and it rapidly superseded the prepared wooden tablet for experimental sketching from the model or for drawing in the preparation of a compositional design. This is perhaps the single most significant development in early Renaissance drawing practice, if only because it has resulted in the survival of larger numbers of drawings, from which we can more confidently judge the role played by drawing in Renaissance artistic practice.

19. Andrea del Castagno, *Trinity with St. Jerome*. Florence, SS. Annunziata. Sinopia on plaster.

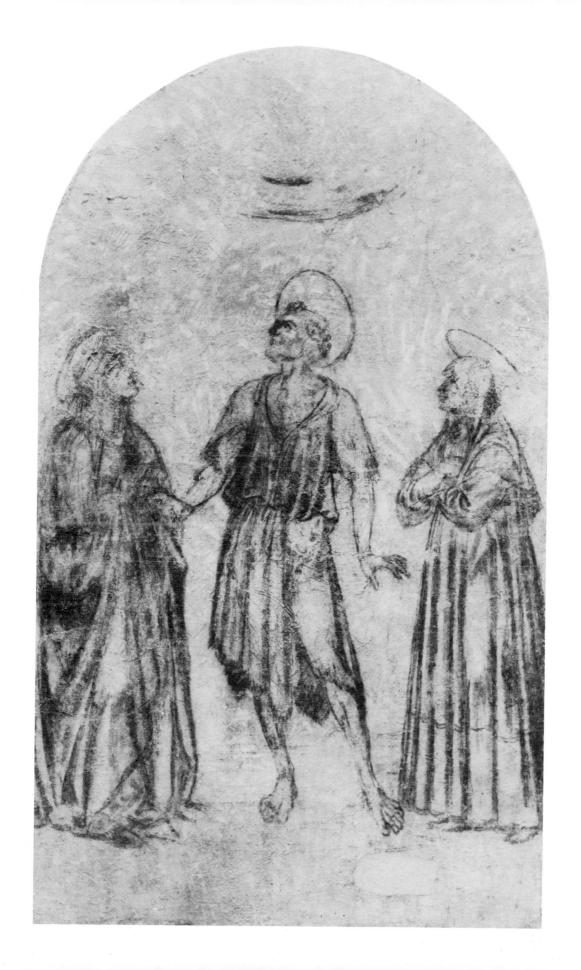

CHAPTER III

Techniques

SILVERPOINT DRAWING

AT THE beginning of his *Libro dell' Arte*, Cennino Cennini discusses the drawing mediums traditionally used in painters' workshops early in the fifteenth century. The apprentice, he writes, should start his training by learning the craft of drawing, and only when this is mastered is he ready to go on to painting on panel or on the wall.[1] Cennino recommends silverpoint as the first technique to be mastered. Silverpoint is more valuable as an initial training for the new apprentice than is any other drawing technique because of the control and discipline that it demands of the draughtsman. Cennino goes on to consider at some length the technical procedures involved in making a stylus and in preparing the surface to be drawn on. The best metal for stylus drawing is undoubtedly silver, which is recommended in preference to other metals by all early manuals.[2] A leadpoint, made of two parts lead to one of tin, will mark an unprepared paper, but the alloy lacks the resilience of silver: it does not keep a fine point for long and is too malleable, too easily distorted or flattened by pressure. Leadpoint was sometimes used instead of charcoal to make a swift outline drawing which was then worked up in another medium; but for careful, detailed studies silver was always the preferred metal. Unfortunately, silver does not make a mark on unprepared paper or parchment, so for all silverpoint drawings the surface had to be specially coated to make it receptive to the silverpoint line.

The preparation of the surface for silverpoint drawing is a laborious process. once prepared, the paper or parchment is likely to be treated with respect and not used carelessly. Preparing the paper helps to preserve it from deterioration, and makes it less liable to tear or crumple. The draughtsman will therefore normally only use prepared paper for a careful drawing which he intends to keep as a workshop model, rather than one in which a transitory idea is briefly noted. Any drawing made on prepared paper is thus likely to be thorough and highly detailed, whether it is an apprentice's exercise or the master's study. The value inherent in the prepared surface, reflecting the time and labour spent on it, imposes a discipline on the draughtsman which is complemented by the controlled precision of handling required by the silverpoint stylus.

A rudimentary preparation of ground bone in spittle can be rapidly brushed onto the drawing surface, and Cennino recommends this method for the preparation of boxwood tablets used by apprentices. For the application of the widely used tinted grounds on paper the process is, however, more complicated.[3] Four or five layers of coating (a

20. Rogier van der Weyden, *St. Luke drawing a Portrait of the Virgin*, detail: hands of St. Luke. Boston, Museum of Fine Arts, 93.153. Oil on panel; 138 × 111 cm.

mixture of ground bone, white lead and normally an earth pigment) tempered with glue-size are laid onto the paper with a wide brush. Great care must be taken, if necessary with the help of burnishing (although this may make the surface too hard to draw on), to ensure that the coating is absolutely smooth and even. The general unevenness of quattrocento paper was another good reason for applying a preparation, for finer and more accurate lines can be produced on a completely even surface. The process of preparation of the drawing surface is superficially similar to the more complex preparation of a panel for tempera painting; and other parallels can be drawn between silverpoint drawing and tempera painting.

The silverpoint line is thin and delicate. When the sharp point passes across the prepared paper, a thin deposit of silver is scraped off by the texture of the preparation. This rapidly tarnishes in the air to leave a pale grey line. Strengthening of pressure on the stylus will not increase the width or tone-value of the line, but will merely score the preparation and disrupt the smoothness of the surface. Ideally, therefore, a light, controlled touch is needed. Thicker lines can only be produced by a blunter stylus, and most Renaissance styluses had points at both ends, one finer than the other. St. Luke uses such an instrument in Rogier van der Weyden's *St. Luke drawing a Portrait of the Virgin* (20). The delicate linearism of silverpoint is very suitable for small-scale, finely detailed drawings, which were also particularly appropriate when draughtsmen felt themselves limited by the scarcity and cost of paper to small surface areas which needed to be guarded jealously and used with the utmost efficiency. The control required in making a silverpoint line, which cannot be erased without resurfacing the paper, and the discipline of building up the shadows by close hatching, mean that the technique demands unparalleled care and precision of handling. For all these reasons it served perfectly as the preliminary training-ground of the workshop apprentice. Silverpoint is best exploited for drawings of restful, delicate subjects. It is inherently less appropriate for the study of dynamic subjects which demand rapid, free-flowing strokes to invigorate the forms, or for figure drawings in which strong modelling is needed to generate anatomical structures.

Leonardo da Vinci's silverpoint *Bust of a warrior* (colour plate I), made on a cream-coloured prepared surface, shows the extremes of subtle delicacy which can be achieved with the technique. The purity of the silverpoint line is marvellously demonstrated in the crisp detailing of the armour and helmet, and the modelling of the face is so finely rendered that the slight, pale lines blend together to describe the elderly skin. Almost unbelievable patience must have been needed to achieve the smoothly changing tone-values in these passages: Leonardo triumphs over the limitations inherent in a rigorously linear technique. This drawing, almost certainly made early in Leonardo's career when he was an assistant in Verrocchio's workshop, is the ultimate in the apprentice exercise, raising the technique to heights of subtlety far beyond Cennino's expectations.

Despite the immaculate precision of his technique, not even Leonardo could induce the silverpoint to suggest any extensive differentiation of texture. The absolute constancy of the stylus line, the invariability of width or tonal strength, prevent the silverpoint from being able to render illusionistic textural effects. The limited tonal range of silverpoint was, however, frequently broadened in the quattrocento in two ways, by

I. Leonardo da Vinci, *Bust of a warrior*. London, British Museum, 1895–9–15–474. Silverpoint on cream-coloured prepared paper; 28.5 × 20.8 cm.

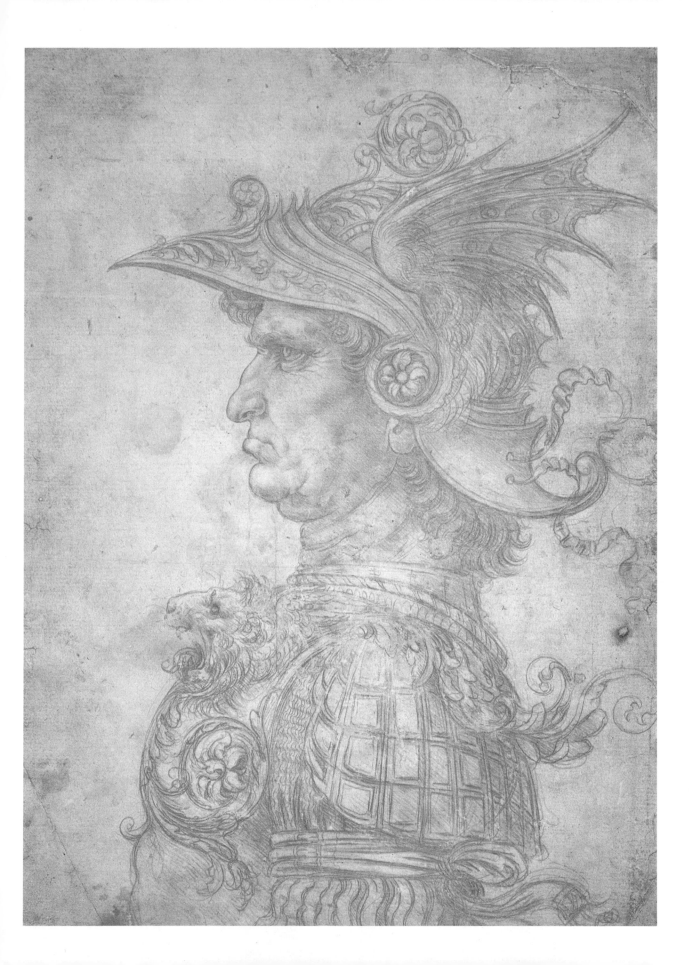

adding white heightening to bring up the highlights and by colouring the surface preparation to provide a tone-value in between the silverpoint mark and the highlights. White heightening was laid on with the brush, normally after the silverpoint lines had been drawn, adding yet another stage to an already complex, time-consuming drawing technique. White lead was generally used for heightening, and this has often blackened over the centuries, disfiguring the drawing as a result. It was certainly known when this pigment was used that it was likely eventually to deteriorate, but the highlights would remain white as long as the drawing served its purpose in the workshop, after which it had no further value to the artist. White lead was used in preference to any other white pigment because of its greatly superior covering power and textural fineness. In a thin suspension in water it produces an even, strong white which can be applied easily and fluently to bring up the highlights into relief. The use of this technique, Cennino writes, is the way 'to approach the glory of the profession step by step, to start trying to discover the entrance and gateway to painting'.[4] The process of building up forms by first laying in the shadows and then working up to the highlights was indeed also traditional in tempera painting technique. The borderline between a highly finished drawing in silverpoint and white heightening on a tinted ground, and a grisaille tempera painting is a fine one: the techniques are obviously different in various respects but the results are similar.

When a middle tone-value is used in fourteenth-century silverpoint drawings, it is usually produced by tinting the preparation a dull green, probably because the earth pigment *terra verde* was freely available and was normally used in underpainting panels. Cennino seemed to take for granted that *terra verde* would be the obvious first choice for pigmenting a preparation (although he does discuss the use of various other colours),[5] and though sometimes tonally rather dark the cool green complements well the delicate grey of the silverpoint line. Green, or equally cool greys or grey-blues, continued to be popular throughout the fifteenth century wherever the tradition of silverpoint drawing remained strong, but gradually a wider variety of pigmented grounds was introduced to increase the colour range of silverpoint drawings. Prepared surfaces were pigmented essentially so that the highlights would stand out in greater relief. The resulting increase in the tonal range of the drawing, from variations in the density of hatched stylus lines through the middle tone of the ground-pigment up to the white highlights, increases the possibilities of suggesting the three-dimensionality of forms. Sometimes, as in Taddeo Gaddi's *Presentation of the Virgin* (21), white heightening is so extensive and the ground is tonally so dark that the effect approaches that of a chiaroscuro drawing, in which forms are deliberately constructed in light tones against a very dark ground. This sort of reversal of tone-values is seldom found in the quattrocento: unlike later draughtsmen, Gaddi took little advantage of the slightly darker tones of the silverpoint lines and areas of hatching.

A characteristic 'three-tone' silverpoint drawing of the mid-fifteenth century is Fra Filippo Lippi's study for a *Standing female Saint* (colour plate II). Over a rough sketch (probably in black chalk) on the salmon-pink preparation, the forms are fluently defined by silverpoint lines. Alterations to the position of the Saint's fingers indicate a growing confidence and freedom in handling the technique. A few dabs of wash strengthen some of the deeper shadows, and white heightening is added in moderation to bring up

21. Taddeo Gaddi, *Presentation of the Virgin*. Paris, Louvre, 1222. Silverpoint, with white heightening, dark green and blue pigments, on green prepared paper; 36.4 × 28.3 cm.

III. Filippino Lippi, *Litter-bearer*. Oxford, Christ Church, JBS 35. Silverpoint with white heightening on pink prepared paper; 17.5 × 12.2 cm.

II. Fra Filippo Lippi, *Standing female Saint*. London, British Museum, 1895–9–15–442. Silverpoint over rapid black chalk sketch, with white heightening and touches of wash, on salmon-pink prepared paper; 30.8 × 16.6 cm.

the highlighted edges of drapery on the Saint's right side. This carefully finished drapery study could be used by the workshop with only slight adaptation in various different contexts. The gently graded tonal range constructs clearly both the anatomical forms and the voluminous folds of the drapery without recourse to the starker contrasts of tone which dominate in Gaddi's *Presentation of the Virgin* (21).

A growing confidence in the handling of the silverpoint technique and gradually fuller exploitation of its tonal range resulted from the continuing strength of the stylus drawing tradition in Tuscany throughout the fifteenth century. At the very end of the century, draughtsmen like Filippino Lippi still used silverpoint even for rapid figure sketches, tracing the contours of forms with a confident vitality and rapidity which is the antithesis of the controlled exactness of earlier silverpoint drawings. Traditional techniques died

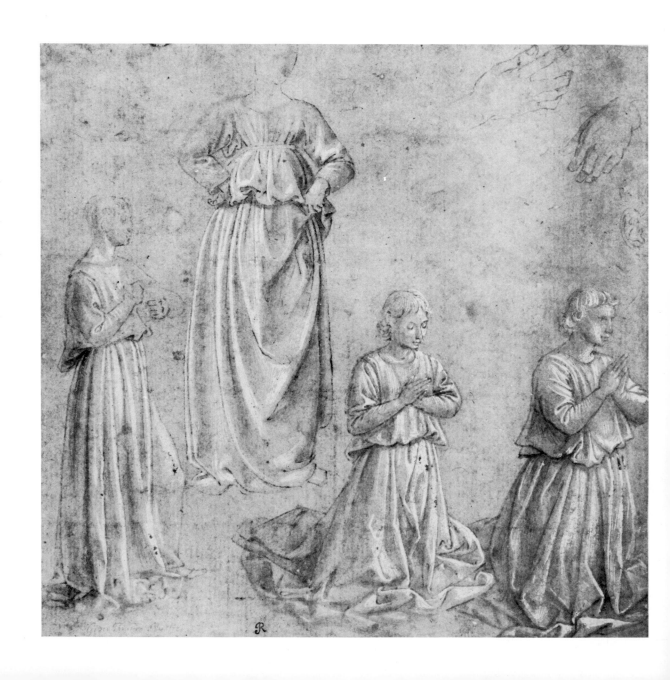

slowly: although silverpoint was inherently not ideally suited to the investigation of the major preoccupations of late quattrocento draughtsmen, many still attempted to exploit it beyond the natural limits of its usefulness. Filippino's energetic drawings, such as the study for a *Litter-bearer* (colour plate III), no longer respect the value and durability of the prepared paper, for there is a clear paradox in using a laboriously prepared surface for a vigorous, spontaneous sketch of only short-term value, however brilliant it may be. Though decorative, the silverpoint line lacks the flexibility and strength of tone needed for successful, free line drawings, for which pen and ink is ideal. Nor was the three-tone technique subtle enough to cater for the increasing concern with the precise description of three-dimensional form, for which natural chalks came to be exploited at the end of the quattrocento.

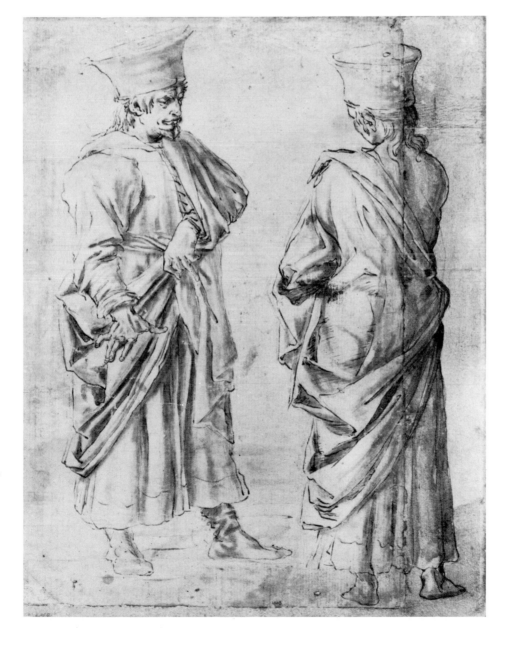

22. (facing page) Benozzo Gozzoli, *Sheet of figure studies*. Harewood Hall, Earl of Harewood Collection. Pen and ink, with wash and white heightening, on pink-tinted paper; 16.9 × 17.9 cm.

23. Florentine draughts-man, close to Pollaiuolo, *Two men conversing*. Vienna, Albertina, inv. 33. Pen and wash on paper; 27.6 × 21.4 cm.

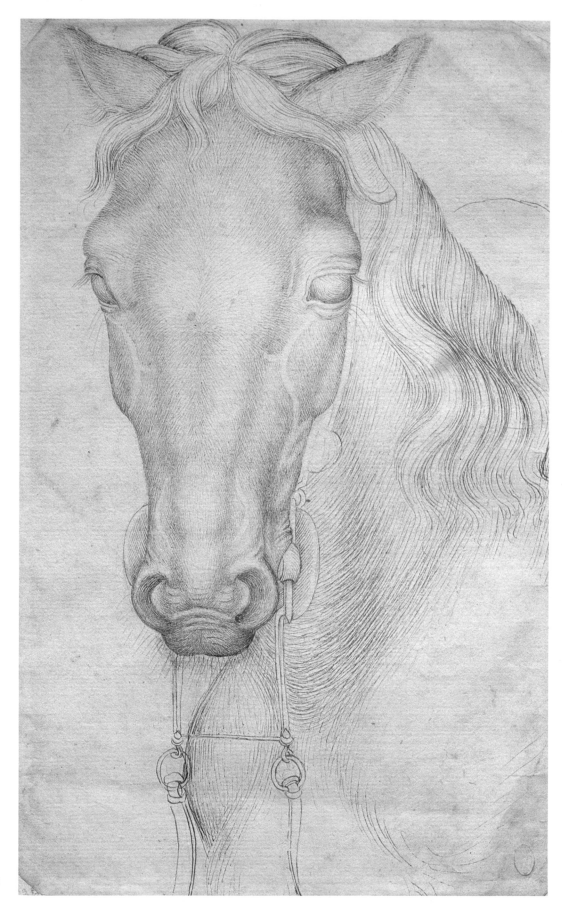

IV. Pisanello, *Head of a horse*. Paris, Louvre, Vallardi 2630. Pen and ink on paper; 26.9 × 16.8 cm.

V. (facing page) Antonio Pollaiuolo, *Hercules and the Hydra*. London, British Museum, 5210–8. Pen and ink on paper; 23.5 × 16.5 cm.

DRAWING WITH PEN AND INK

Once the discipline of silverpoint drawing had been fully learned – according to Cennino 'when you have put in a year, more or less, at this exercise'[6] – the apprentice was sufficiently skilled to try his hand at pen drawing. The goose-quill pen, the type generally recommended by the early craft manuals, is far more versatile than the stylus, and is therefore in many ways more difficult to use, needing greater skill and experience. The quill can be cut in many different ways to produce different shapes, and varying degrees of fineness, of the nib. Because it is an organic material, the quill is flexible and malleable where the stylus is unwaveringly firm. If finely cut, the quill responds to slight changes of pressure or of speed of movement to leave thickened or tonally strengthened lines, whereas the silverpoint line is uniform in width and tonal strength. This flexibility and variation in the drawn line mean that the quill-pen has far greater expressive and calligraphic possibilities than the stylus, responding to individual handling and encouraging personal graphic styles. For these reasons, and because of the smooth fluency with which it glides over the paper surface, the pen requires the controlling touch of an experienced hand.

The versatility of the pen in the formation of widely varying types of line also increases the possibility of defining textures in pen drawing. This is superbly demonstrated in the controlled and minutely detailed drawings of horses by Pisanello, such as his study of the *Head of a horse* (colour plate IV). By varying the pressure on the quill, the length and direction of the lines, and the density of the hatching, Pisanello distinguished with great subtlety between the textures of the hair of the horse's mane, neck and nose, and showed the contrast between the fine, soft down inside the ear and the bristly whiskers around the mouth. This quality made the quill-pen an invaluable tool for the draughtsman who wished to render meticulously the exact superficial appearance of a natural form. But it is difficult at first glance to believe that Pisanello's impeccably perceived study of textural contrasts was drawn in the same technique that Pollaiuolo exploited so differently in his magnificently vital drawing of *Hercules and the Hydra* (colour plate V). Pollaiuolo took full advantage of the dynamic spontaneity of the pen in tracing an expressive contour. He created the energetic form of Hercules with a calligraphic flourish which in its apparent swift ease conceals the control with which the outline was drawn. Judging by the immediacy of the effect, Pollaiuolo must indeed have moved his pen fluently and rapidly round the forms. His disciplined skill is shown, however, in his ability to indicate muscular structure and tension by slight strengthening of the line at the points where Hercules, in his forceful, bellicose movement, is under greatest physical strain. The momentary increase of pressure on the pen which reinforced the line around the left shoulder, for example, or thickened the line along the upper side of the right leg and foot, expresses the vigorous power of Hercules' movements, and illusionistically generates his wiry anatomy perhaps more effectively (and certainly more spontaneously) than could any amount of careful shading or wash modelling. The energetic contour of Hercules is played off against the gracefully flowing, calligraphic curves of his lion-skin and of the threatened Hydra to create a composition unrivalled in the fifteenth century for powerful, dynamic vitality.

These two drawings illustrate the opposite poles of the quill-pen's versatility, and its immense superiority over the stylus in textural definition and in vigorous flexibility of line. The pen, though, inevitably shares with the silverpoint the limitations of an inherent linearism, however versatile the line can be made. To render variations in tone-values in pen drawings, methods not unlike those used in silverpoint drawing had to be contrived. A coloured wash was sometimes applied to the paper to provide a middle tone. In Benozzo Gozzoli's exquisite sheet of workshop figure studies (22), usually associated with the kneeling angels in the frescoes for the Chapel in the Palazzo Medici in Florence, white heightening brings the figures into relief against a pink-washed ground. Delicate though the result undoubtedly is here, this process fails to take advantage of the pen's immediacy of touch, and requires as much time and labour as silverpoint drawing. Surprisingly, coloured papers which would save the draughtsman the labour of applying a pigmented wash were only occasionally used, principally for brush drawing.

The usual way of providing tonal values between the white of the paper and the black or brown pen lines was by applying a wash of diluted ink with the brush. Drawing inks of two main types were used in the fifteenth century:[7] iron-gall inks, which with the passage of time turn the deep brown colour characteristic of many Renaissance pen drawings, and black carbon inks. Iron-gall inks were prepared from the reaction between ferrous sulphate (widely available in the form of the mineral copperas) and the gallic and tannic acids found in high concentrations in oak-apples and other natural galls. Since they were in common use for writing, iron-gall inks were easily obtained ready prepared from a *cartolaio*. They were therefore more often used by draughtsmen than were carbon inks, which were prepared in the artist's workshop by suspending carbon particles, such as lamp-black, in a fluid binding medium of diluted gum arabic. Carbon inks have greater tonal strength and permanence than iron-gall inks, but the differences between them were not so great that either was clearly preferred for technical reasons.

Either of these inks at different dilutions will give a range of washes of varying tonal strengths, but it is unusual to find wide variations in the tones of wash used in a quattrocento drawing. The value of wash lay in its ability to indicate rapidly the direction and strength of light falling on the subject of the drawing. It could thus be used as a short-hand for parallel hatching in the shadows, with the advantage that the spontaneity of application with the brush could match the dynamic movement of the pen line. This was realised by a Florentine draughtsman close to Pollaiuolo in a drawing of *Two men conversing* (23), where the volumetric shapes of the drapery folds are indicated by a light wash fluently applied within the pen contours of the folds, with some repeated strengthening in the deep shadows. The technique is simple and quick, effective in demonstrating the three-dimensional bulk of the forms beneath the drapery. A similar use of wash to indicate the structure of a space and the positions of forms within it was developed at much the same time for compositional drawings. In special cases like contract drawings the extra labour of several repeated applications of wash, or the use of washes of different tonal strengths, was contemplated to provide a wider tonal range. A good example is Filippino Lippi's contract drawing for the *Triumph of St. Thomas Aquinas* (24). In such a complex architectural interior as this, the draughtsman needed to differentiate in some way between forms and areas lit by the strong light entering from

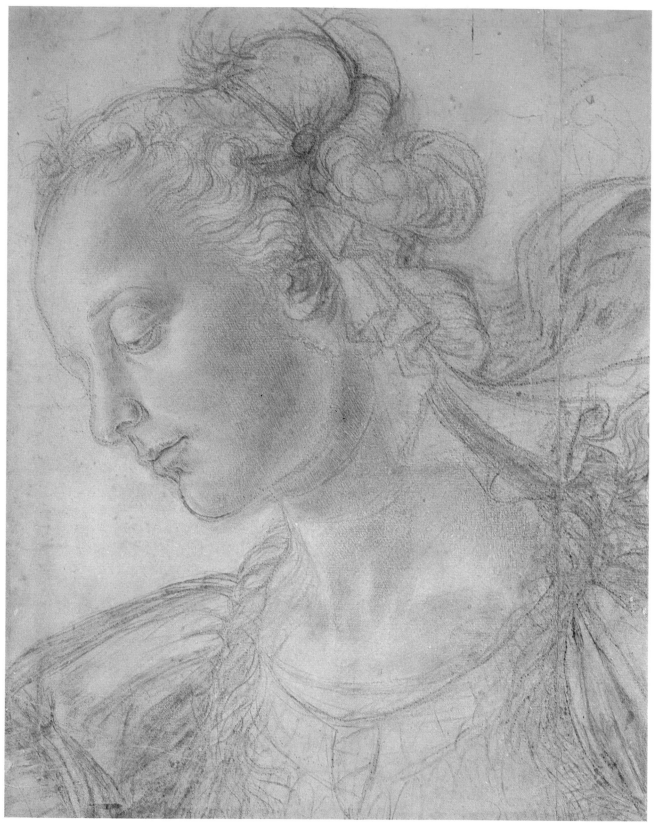

VI. Andrea del Verrocchio, *Head of a woman*. Oxford, Christ Church, JBS 15. Black chalk, with touches of wash and white heightening, on paper, pricked for transfer; 40.8 × 32.7 cm.

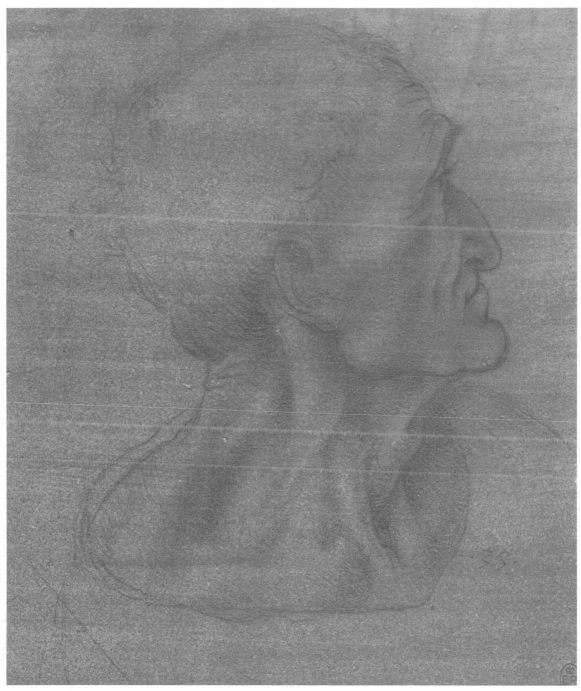

VII. Leonardo da Vinci, *Study for the head of Judas.* Windsor, Royal Library, 12547. Red chalk on reddened paper; 18.0 × 15.0 cm.

the right, and those cast into varying degrees of shadow. To match the simple, almost brusquely angular graphic handling, Filippino chose to apply washes rather than to use the more laborious process of hatching with the pen.

Wash has a swift fluency of application but can only with much effort rival the tonal flexibility of carefully varied hatching. Quattrocento draughtsmen experimented with numerous types of hatching, but to complement the immediacy of the pen in drawing the contours of forms, hatching in rapid parallel lines of varying length and spacing was generally favoured. Greater tonal range could be introduced, at the expense of some spontaneity, by the use of cross-hatching, often found in conjunction with grades of parallel-hatched areas. This method of modelling form reached its most sophisticated in the careful, almost pedantic technique developed in Ghirlandaio's workshop (49, 64). Although unusual in the fifteenth century, elaborate cross-hatching was by no means unique to Ghirlandaio and his workshop, for interesting experiments with this means of expanding the tonal modulation of shadows had been made by Parri Spinelli (57–9) among others in the early decades of the century.

Hatching in silverpoint drawings was generally of parallel strokes of limited length, perhaps a feature of the control required by the technique. Similar demands for disciplined and rather invariable handling were imposed on the copper engraver by his

24. Filippino Lippi, *Triumph of St. Thomas Aquinas*. London, British Museum, 1860–6–16–75. Pen and ink with wash on paper; 29.1 × 23.9 cm.

25. (facing page) Andrea Mantegna, *Battle of the Sea-Gods*. Chatsworth, Devonshire Collection, 897. Pen and ink on paper; 24.5 × 35.3 cm.

burin. The shading in fifteenth-century Italian engravings is almost always applied with parallel diagonal strokes of the burin, with occasional but infrequent areas of parallel cross-hatching. Mantegna's pen drawing of the *Battle of the Sea-Gods* (25), which is closely related to an engraving of the same subject, shows the same rather restricting technique of parallel-hatched modelling, clearly used here as a guide to the engraver. It is a good example of how shadows can be tonally deepened by denser or thicker hatching lines, but Mantegna deliberately did not allow the lines to cross each other. This inevitably limited the tonal range, and produced some graphic awkwardness, because to produce absolutely straight lines is an unnatural movement with the pen. Another consequence is that the forms, for example of the horses' necks, have a faceted quality, since the scope for grading tones round forms is severely limited. It is a nice irony that it should have been the master engraver Dürer who, in his pen copy of Mantegna's *Battle of the Sea-Gods* engraving, exploited the graphically more appropriate system of drawing the hatching lines to follow the curvilinear shapes of the forms, thus producing a stronger impression of the anatomical structure of the forms. Leonardo da Vinci was the first Italian draughtsman to adopt this system of curvilinear hatching, in drawings for the *Battle of Anghiari* in 1503, although it had been clear to him for a decade or so that natural chalks did not share the limitations of the pen or the stylus for the modelling of form.

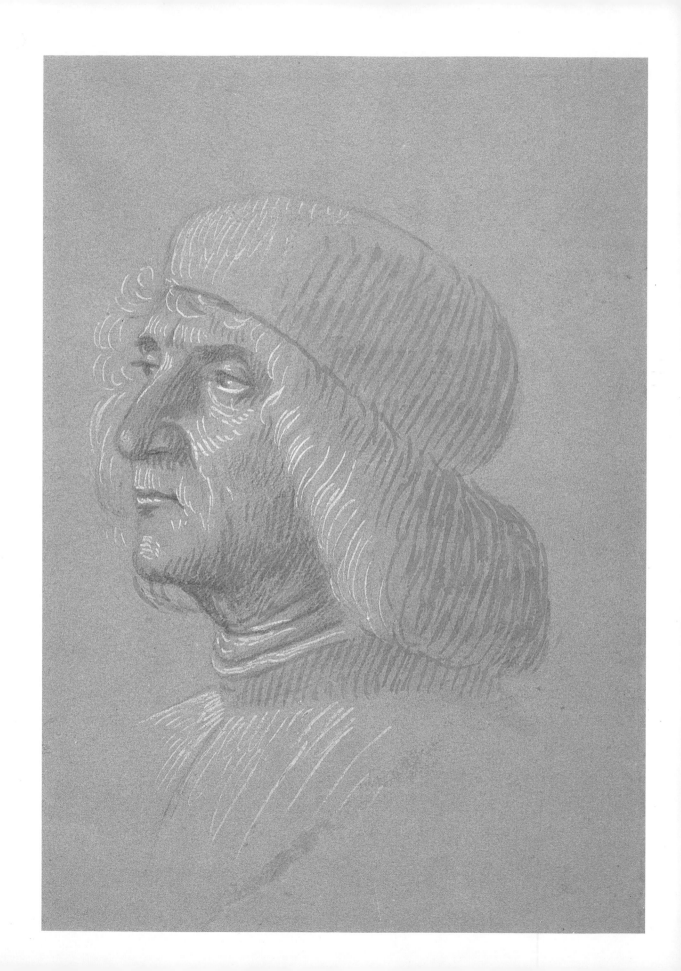

CHALK DRAWING

No graphic technique relying exclusively on line, however subtly used, can produce completely smooth transitions between tone-values. This became a more and more important objective for the quattrocento draughtsman concerned with the representation of fully modelled anatomical forms in movement. In pursuing this objective, a technique was needed which could produce lines which were both variable in thickness and chromatic strength, and capable of being merged together into a smoothly changing sequence of tone-values. Early in the fifteenth century this was not regarded as a major problem, although Simone Martini's underdrawings (12–14) suggest that charcoal and sinoper were sometimes used to investigate the modelling of form. Charcoal is recommended by Cennino as the suitable material for preliminary compositional sketching, whether on paper, plastered wall or panel.[8] Once this sketch had been made and the main lines were clear, the draughtsman was advised to fill out the details of the drawing with pen or brush. Cennino does not suggest that he had even considered whether charcoal might have inherent advantages over the stylus or the pen when it came to modelling form: the principal advantage he found in it was the ease with which the preliminary charcoal sketch could be rubbed out with a feather once the drawing was complete. It may be that for Cennino the friability of charcoal and its tendency to smudge easily outweighed its possible advantages. Furthermore, it is too broad a medium to be useful for small-scale, detailed studies, a disadvantage very noticeable early in the century when paper was a precious commodity.

Cennino also refers to black chalk, but very much as an afterthought to his detailed discussion of other drawing techniques. He comments briefly that he has 'come across a certain black stone, which comes from Piedmont', which 'can be sharpened with a penknife, for it is soft . . . you can bring it to the same perfection as charcoal. And draw as you want to'.[9] This is not so much a dismissal of black chalk as an admission of complete ignorance of its possibilities as a drawing material. Cennino wrote his treatise almost as a manifesto of the fourteenth-century tradition of Giotto, to which he was committed. Before the mid-fifteenth century the qualities and graphic advantages of natural chalks were not only not realised but also not required by the traditional draughtsman. It was not until artists began to search for new methods of rendering smooth tonal modulations that the superiority of chalk began to be understood and exploited. Natural chalks did not begin to take on an important position in the technical range of the Italian draughtsman before the last third of the century. The dearth of chalk drawing early in the century may also be due to the restricted availability of paper; like charcoal, chalk is a broad medium which shows at its best on a relatively large scale.

It may well have been in connection with the introduction of cartoons in place of *sinopie* for the full-scale preparation of a design, or a part of a design, for wall painting that chalk became more widely used and more freely available. Certainly, some of the finest quattrocento chalk drawings are pricked for transfer to wall or panel. Charcoal might also have been used for large-scale cartoons of comparatively simple designs. While excellent for broad, striking effects or sweeping lines, however, charcoal lacks the fine consistency that chalk gains from its constituent clay. It is therefore unsatisfactory for

VIII. Vittore Carpaccio, *Portrait of a middle-aged man*. London, British Museum, 1892–4–11–1. Brush and brown pigment over slight black chalk sketch, with white heightening, on blue paper; 26.7 × 18.7 cm.

the precise study of anatomical structure, pursued in the highly wrought finish of cartoons like Verrocchio's *Head of a woman* (colour plate VI). This beautiful drawing shows the versatility of black chalk in the contrast between on the one hand the fluent, broad but light strokes which indicate the contours of forms and the free flow of the drapery, hair and elaborate veil, and on the other the subtle transitions between tones which delicately build up the structure of the head, jaw and throat. The more rapid strokes were made with firmer hand pressure so that a thicker and sometimes darker line results, but the speed of movement of the chalk ensured that the lines are not dominatingly heavy, and the grain of the paper still shows through. The areas of modulated tone were built up in short parallel strokes which merge, and in places were deliberately merged by soft rubbing, to produce a convincing impression of the texture of the skin surface and a credible volumetric form gently lit from the left. The infinite care which went into the modelling of the forms implies that this sheet was not merely the means of transferring the design to the panel, but served also as an 'auxiliary cartoon' to guide the painter when he came to lay in the underpaint on the panel surface. This may also explain the delicacy with which the shadows were hatched in, for Verrocchio may still have been thinking in terms of the brush handling of the *terra verde* tempera underpainting for which the drawing was the exemplar. As egg-tempera was gradually superseded at the end of the fifteenth century by the more general use of oil as a painting medium, so chalk drawing became broader, freer and less constrained by the conventions of controlled handling demanded by stylus technique and its analogue in tempera painting.

In Venice, where traditional attachments to earlier techniques were probably less strong, painters realised sooner the value of the oil medium for the solution of some of their artistic problems. They also found that because of the loose, thickened line, the subtle tonal range and the freedom of handling, black chalk had a generally more painterly quality than any other drawing medium. Just as silverpoint drawing is analogous to tempera painting, so also natural chalks may be seen as the equivalent in drawing to oil in painting. And just as Giovanni Bellini and his contemporaries were the first in Italy to exploit the tonal possibilities of the oil medium, so also late quattrocento Venetian draughtsmen realised and exploited the potential of chalk as a drawing medium more forcefully than almost any of their Central Italian contemporaries, especially in rendering subtle tonal gradations in portrait drawings (4) and studies of heads. Close analogies can be drawn between Montagna's black chalk study of the *Head of the Virgin* (26) and the modelling of form in oil paintings from Bellini's workshop. The new medium is here exploited to create delicate transitions of tone across the rounded shapes of cheek and jaw. Montagna's handling of the chalk to produce long, loose, flowing strokes round the forms contrasts with Verrocchio's tighter, more controlled hatching (colour plate VI), but is strongly reminiscent of the softened contour and almost blurred modelling of Giovanni Bellini's later Madonnas.

In offering the draughtsman unlimited opportunities for representing the lights and shadows on an object, chalk had advantages unmatched in other drawing mediums. By slight alterations in pressure, the strength of tone of the line deposited by the chalk on the paper could be varied, and hence very gradual transitions could be built up by parallel strokes progressively lightening in strength and blending in one with the next. When used in this way, each stroke of the chalk becomes indistinguishable from the last, and an

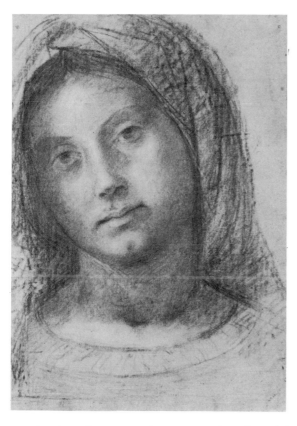

26. Bartolommeo Montagna, *Head of the Virgin*. Oxford, Christ Church, JBS 709. Black chalk, with slight white heightening, on paper; 29.0 × 20.8 cm.

evenly changing area of tone is produced; and this can be emphasised by gentle rubbing over the area to assist in the merging together of the strokes. Subtly varied in value, this area of tone can imitate precisely the fall of light on the relief surface of the model, and ultimately a convincing three-dimensional image can be projected onto the flat surface.

Many natural chalks can be used to make marks on paper, but those practical for drawing purposes need to have a combination of properties.[10] A clay base is essential both to give the chalk the necessary cohesive quality and to produce an adequately soft and fine texture. If, however, there is too high a proportion of clay to earth pigment, the chalk will not be friable enough to rub off on the paper when used with the freedom of handling for which it is especially valuable, and will produce sticky smears rather than finely graded planes of colour. The earth pigment itself needs to be dense enough to produce a consistent line and a strong colour. Finally, the qualities of both clay and earth need to be such that the stick of chalk will not break too easily and will not rub away too quickly. When artists' needs for such materials became evident, natural sources were discovered in various part of Europe, and the chalk was extracted in such large quantities that by the eighteenth century very little high-quality drawing chalk was still available, and synthetic chalks or pastels were developed as substitutes. Since demand was not noticeable at Cennino's time, few sources of natural chalk of satisfactory quality had been exploited, and the graphic possibilities of the medium went uninvestigated.

Although white chalk was occasionally used for heightening, red and black were the principal natural chalks which came into favour in the late quattrocento. Red chalk, haematite diffused in clay, has great strength and warmth of colour, and was often used for the study of forms of a delicate or lively character. It is tonally less strong at its darkest than is black chalk, and hence lacks the breadth of tonal range, valuable for the modelling

of form, offered by black chalk. Red chalk tends, however, to be less friable than black, and can be used to advantage on a smaller scale, for more detailed and finely worked studies. It did not, however, come into prominence before the sixteenth century: red chalk drawing was still rare in the fifteenth century, perhaps because in the experimental beginnings of chalk drawing the fuller tonal range was required.

Early investigations into the possibilities of red chalk for rendering volumetric form were by Leonardo da Vinci, in studies for heads of Apostles in the *Last Supper*. In the study for *Judas* (colour plate VII) the warm colour of the chalk increases the textural richness of the wrinkled, plastic surface of the skin. The smoothly modulated structure of the forms is subtly shown by soft, fluent gradations of tone within energetic contours. The expressive vigour of Judas's response to Christ's words, emphasised by the strong, sharp lines on the forehead and around the features, is generated by the convincing thrust and tension of the fully modelled muscles as the head takes up a nervous contrapposto. Leonardo was the first to realise the value of red chalk to examine in detail the underlying disposition and movement of forms under stress and strain, and his pioneer studies signposted the way for the masters of High Renaissance draughtsmanship.

Natural black chalk, a carboniferous shale, generally covers more broadly than red chalk, and was soon found to be valuable for creating large-scale tonal and atmospheric effects. Just before the turn of the century Fra Bartolommeo began to investigate how chalk, freely and spontaneously used, could suggest in an impressionistic manner the unified form of a figure enveloped by and displacing space (27). Moving the chalk in rapid, thick, full-length sweeps, Fra Bartolommeo constructed the figure with the fluency of a pen-draughtsman, while at the same time filling out the shadows and adding bravura dashes of white chalk heightening to set the implied solid within an atmospheric space. Chalk evidently has some of the immediacy of pen and ink, allowing similar freedom of graphic movement over the paper, and hence similar directness in recording an idea. But despite the convenience of the stick of chalk, which is much easier to carry about and to have always to hand than is the quill-pen and ink-pot, it seldom replaced the pen in the late fifteenth century for making rapid sketches from the model, or for experimenting with compositional ideas in a spontaneously creative manner. This may once more be due to strength of tradition, for soon after the beginning of the sixteenth century the use of chalk developed rapidly, and in the hands of High Renaissance draughtsmen it sometimes took on a sketch-like brevity of handling.

The freedom and vitality of the black chalk line can be seen to complement a full tonal range in nude studies by Signorelli, one of the masters of late quattrocento chalk drawing. In his *Hercules and Antaeus* (28) all these qualities of the technique are exploited in a drawing of immense vigour and energy. Brisk hatching is used in places, such as on the legs of the two figures where little emphasis is required, to indicate rapidly the almost geometric shapes of the forms within the vibrant contours. Signorelli concentrated on the torsos of the struggling men, where he took advantage of the dark colour and the dramatic spontaneity of handling of the chalk. The rippling musculature is indicated by sweeping, repeated curvilinear contours and a free use of hatching and cross-hatching with thick lines, using the full tonal range of black chalk. The drama of the conflict is intensified by the powerful expressiveness of the heads, especially that of Antaeus,

56

27. Fra Bartolommeo, *Study for standing male figure*. Lille, Musée des Beaux-Arts, 34. Black chalk, heightened with white chalk, on paper; 28.2 × 15.0 cm.

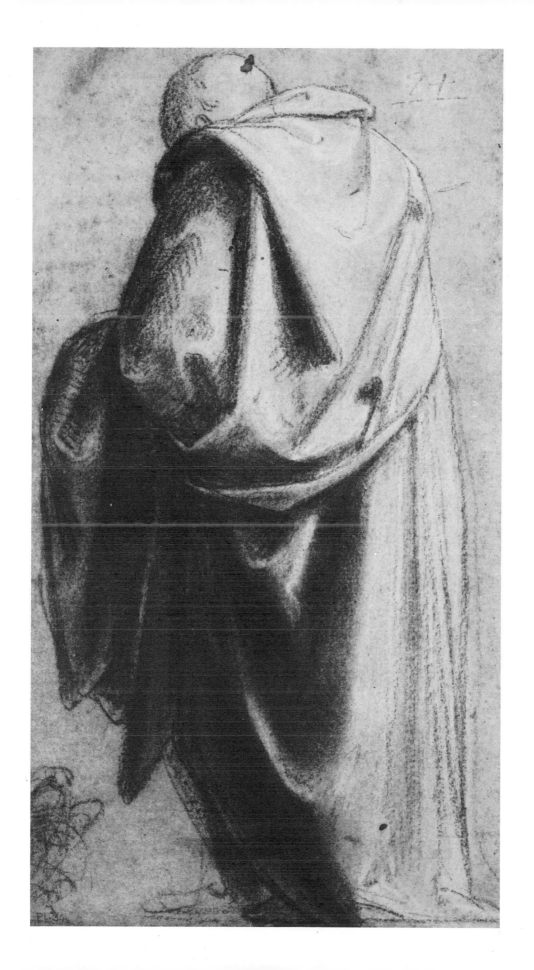

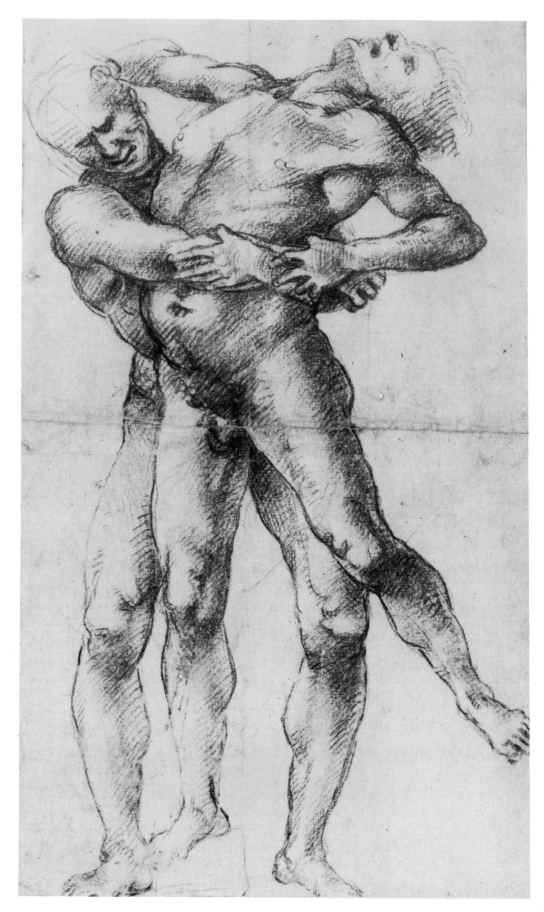

28. Luca Signorelli,
Hercules and Antaeus.
Windsor, Royal Library,
12805. Black chalk on
paper; 28.3 × 16.3 cm.

tipped back in agony and characterised by the swift profile outline, the hatched shadow, a few wiry hairs, and small patches of deep black for the open mouth and nostrils. In these three vivid demonstrations at the turn of the century of the versatility of chalk (colour plate VII, 27–8), new vistas can be seen opening up for later exploitation by Michelangelo, Raphael and their contemporaries.

BRUSH DRAWING

The use of the brush in drawing was of course a standard part of mixed techniques like silverpoint and white heightening, or pen and wash. In these techniques, however, pigment applied with the brush is a subsidiary part of the drawing process, generally following the delineation of forms with a drawing instrument. Similarly, the addition of colour to model-book drawings is subsidiary to the outlining of the forms with the pen. Towards the end of the fifteenth century, the practice of making drawings exclusively with the brush became more common, especially in North Italy. There are isolated examples of drawings made principally with the brush earlier in the century, such as Filippo Lippi's study for the Prato Duomo fresco of *St. Stephen exorcising a Demon* (29), in

29. Fra Filippo Lippi, *St. Stephen exorcising a Demon*. Hamburg, Kunsthalle, 21239. Pen and ink, with wash and white heightening, on purple-tinted paper; 32.5 × 22.3 cm.

30. Vittore Carpaccio, *Two youths*. London, British Museum, 1892–4–11–1 verso. Brush and brown pigment, with white heightening, on blue paper; 26.7 × 18.7 cm.

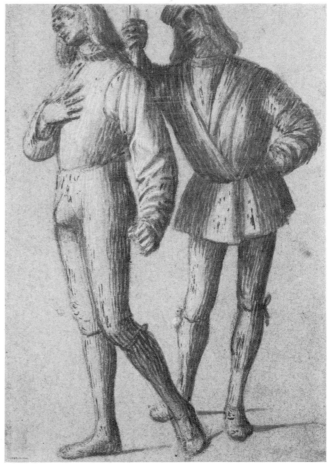

which most of the detail was freely brought up with pigment applied with a brush after a few sketchy pen lines had provided the essential compositional design. Although similar in technique to Lorenzo Monaco's *Visitation* picture on parchment (3), this procedure is unique for a light, apparently experimental compositional sketch. A group of drawings probably made in Florence by the Venetian-born painter Domenico Veneziano show the novel technique of diluted ink and white heightening applied with a brush onto blue paper (60–1). Blue paper, otherwise very rare, is also used in late quattrocento Venice: Domenico Veneziano's technique is the same as that often used by Carpaccio, which suggests that it may have been standard in Venice throughout the century. A specialised technique was developed later in the quattrocento in Verrocchio's workshop of making very careful drapery studies with the brush on prepared linen. An example by Leonardo da Vinci (31) shows a characteristically sprightly sketch with the brush and brown pigment which briefly indicates the forms of the kneeling woman's head and right side, and in contrast an immaculately studied cascade of drapery folds rendered in brown and white pigments with the brush in precisely the technique that he might use for laying in the underpaint on a panel.

A fine minever brush sensitively used can produce a line as fine, controlled and versatile as the pen line, or alternatively can be used like chalk to develop areas of tone, varied in value by changes in speed or pressure. In practice, however, just as wash added to pen drawings tends to be uniform in tonal strength, so also quattrocento brush drawings seldom go far in exploiting the potential of the technique. Carpaccio, who was it seems the major exponent of brush drawing, used the brush as though it was a fine-pointed instrument like a stylus. He failed to work in terms of tonal gradation when he modelled a head like the *Portrait of a middle-aged man* (colour plate VIII) with long strokes of pigment to produce parallel hatching of both lights and shades on the blue paper. In the study of *Two youths* on the verso of this sheet (30) the prominent brush strokes which follow the forms in near-vertical, short parallel strokes do not blend to form areas of varying tone, but rather produce a soft but artificial tonal gradation. The fluent but coarse application of pigment produces a delicate, feathery texture but fails to give a convincing impression of form.

Although evidently an important technique, brush drawing did not take on as significant a role as others used in quattrocento drawing, either as a conventional workshop practice or as one which could lead painters towards new solutions to their problems. The importance of the brush lay essentially in its use as an adjunct to other techniques, for heightening, washing or colouring a drawing. Metalpoint, pen and ink, and chalk (red and black), with or without refinements added with the brush, are the three major techniques current in the fifteenth century. The use of these techniques waxed and waned with changes in artistic concerns, varied according to local interests and regional traditions, and finally was progressively more and more closely conditioned by the purpose of each drawing and its place within the practice of the draughtsman. It is these variations and developments which provide the material for much of the discussion in this book: the following chapters trace the almost incredibly rapid changes during the fifteenth century in artists' use of drawings against the background of the variety of potential of the available techniques.

31. Leonardo da Vinci, *Drapery study*. London, British Museum, 1895-9-15-489. Brush and brown and white pigments on brown linen; 28.3 × 19.3 cm.

levn pards

CHAPTER IV

Model-Books and Sketch-Books

The Model-Book and its Functions

Most medieval working drawings were probably made on prepared wooden or wax tablets. Very few drawings made on loose sheets of paper or parchment before the fifteenth century survive. Medieval drawings on permanent surfaces were generally bound into book form: some are finished drawings in manuscript books ready for illumination, but others were made neither for a specific work to be produced in another medium nor as autonomous sketches in pursuit of artistic concerns. They were copies: the medieval artist tended to study from other works of art rather than directly from Nature or from the imagination, and his stock of copies was an essential part of his workshop equipment.[1] Medieval artists needed to travel to make copy drawings of works in fixed locations, records on which they could draw after returning home through the intermediary of the pattern-book.

The best surviving example of the itinerant artist's pattern-book is that of Villard de Honnecourt, made apparently during a journey through France in the 1230s.[2] It is a record of motifs seen during the architect's travels (7), augmented by theoretical and practical studies made later in the workshop – a cumulative record of artistic experience to be consulted for ideas when new projects were being planned or executed. From the survival of Villard's pattern-book it may be assumed that it was a common working tool in the medieval craftsman's workshop, and that pattern-books played a significant role in the communication of artistic ideas between places and generations.

The late Gothic model-book stemmed from the tradition of the medieval pattern-book, and had similar functions; but in execution and format it usually shows significant differences. It is typically a collection of studies of individual forms or motifs which were evidently intended as a stock of exemplars to be faithfully reproduced in finished works. By the early quattrocento, perhaps in response both to patrons' demands and to more orderly organisation of workshop materials, model-books show more limited fields of artistic activity than does Villard de Honnecourt's book. Like medieval pattern-books, however, they contributed to the spread of forms and motifs by the process of copying, which was a regular part of the activities not only of the apprentice but also of the artist who wished to increase the range of exemplars for transfer to finished works. Few of the studies found in model-books were done from life: most are copies of other drawings which themselves may have been at several removes from the original model.

That a surprisingly large number of model-books and model-book pages survive

63

from around 1400 indicates both that they were a particularly popular working tool at that time, and that they were made to be preserved. They were intended to contain definitive studies which would still be useful to the later generations who inherited the artist's workshop, and were venerated not only as reservoirs of motifs but also as yardsticks of the workshop's tradition. These aspects of the use of model-books suggest that they held a fundamentally important and prestigious place in the workshops of the early quattrocento.

Almost without exception, model-books are made of fine or carefully prepared materials, again a clear indication that they were intended to be long lasting. Some, like the one attributed to Jacquemart de Hesdin (now in the Pierpont Morgan Library), were made of thin wooden panels prepared for silverpoint drawing and bound together with strips of parchment. On each maplewood face of the so-called 'Vienna *vademecum*' four square pieces of prepared paper were pasted; each has a single head delicately drawn in silverpoint. A range of standard types and expressions which could be transferred by copying into narrative painting or illumination is thus preserved in durable form. Most surviving model-books have good-quality parchment pages which were bound together before the drawings were made, showing that from the start they were intended as books of drawings: seldom were they random collections of loose sheets subsequently bound up together. The technique and finesse of execution of model-book drawings also indicate that the books were made to last, for clearly such time and expense would not be devoted to a book of drawings which was not expected to have long-term value to the workshop.

Model-books often reveal their workshop function by signs of extensive use. Pages may be missing, or damaged and worn; drawings were often reinforced at a later date to make the outlines clear once more, with consequent distortion to the character (and sometimes to the quality) of the original. Cennino wrote of 'fixing' a charcoal drawing by overdrawing with the pen in terms which might reflect this workshop method of ensuring the continuing practical value of the model-book.[3] Overdrawing sometimes involved up-dating the drawing, for example in the alteration of details of costume in the Bohemian model-book now in Brunswick, to take account of changes in fashion. Reinforcement of a drawing may also sometimes have been associated with its function as an exemplar for trainee-apprentices to copy.

In North Italy, and especially in Lombardy, model-books principally contain studies of birds and animals. That their ability in nature study was the mainspring of the Lombard artists' tradition is indicated by Umberto Decembrio's comments on the great early quattrocento Lombard painter Michelino da Besozzo, which particularly emphasises his powers in this field: 'I knew Michele da Pavia, notable painter of our time, when he was a boy, whom nature had so formed to that art that before he could talk he was drawing birds and very small animal designs, so subtly and accurately that the experts in this art were amazed.'[4] Nothing survives for certain of these drawings, although a model-book of 'animali coloriti' by Michelino belonged early in the sixteenth century to Gabriele Vendramin.[5]

Cennino Cennini advises the painter to 'copy [animals] and draw as much as you can from nature, and you will achieve a good style in this respect',[6] and at about the time that Cennino was writing his *Libro dell'Arte* in Padua the prime example in form and character

64

33. Workshop of Giovannino de' Grassi, *Seated greyhound and other animals*. Bergamo, Biblioteca Civica, cod. ΔVII.14, f.15 recto. Pen and ink, with wash and watercolours, on parchment; 26.0 × 17.5 cm.

cane corse

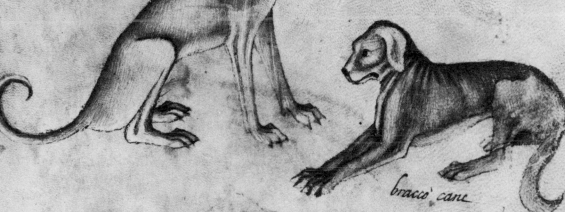

alma

bracco cane

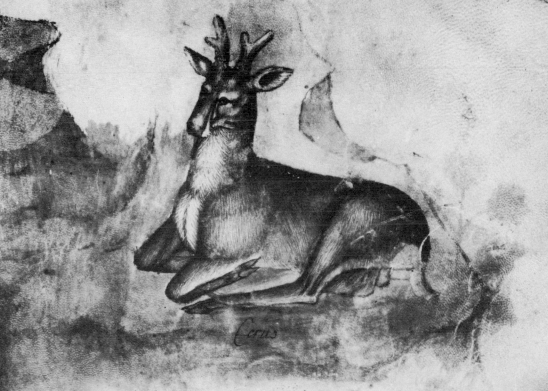

Cervo

of the late Gothic model-book was inscribed with the name of the Lombard Giovannino de' Grassi. Variations in the styles and quality of the drawings in the Bergamo model-book show that several hands were active in making the studies, perhaps at different times. Giovannino's 'signature' may therefore have been a workshop authentication and ex-libris, like Giotto's on panel paintings issued from his Florentine studio. The Bergamo book has three main groups of drawings, most of which are carefully finished, naturalistic studies of animals. The accuracy and sense of character of some of these studies, such as that of a *Leopard* (32), suggest that the best of them might have been made directly from nature. Clearly though, no live leopard could remain posed for such an intricate drawing: although perhaps drawn from a carcass, an element of imagination seems to have been combined with sensitive observation. On the other hand, they may be unusually good copies of earlier studies from the life, in which the draughtsman was particularly sensitive to qualities of surface texture. In comparison with drawings by other hands in the Bergamo model-book, such as the *Seated greyhound* (33), however, the precision of detail and the understanding of the animal's anatomy and movements are evident.

Comparisons between the Bergamo drawings and other surviving books or pages show the interdependence of model-book drawings and hence indicate their role in the transmission of motifs between workshops. Giovannino de' Grassi's *Seated greyhound* (33)

34. Lombard workshop, ca. 1400. *Two greyhounds.* Haarlem, Teylers Museum, K.IX.25 and 22. Brush and wash, with white heightening, on parchment; 7.0 × 8.8 and 7.3 × 8.6 cm. respectively.

35. Lombard workshop, ca. 1400. *Two dogs.* London, British Museum, 1895–12–14–95 recto. Brush and wash, with bodycolour, on parchment; 15.4 × 11.5 cm.

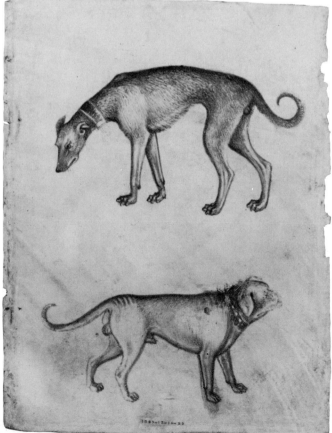

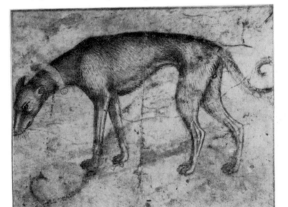

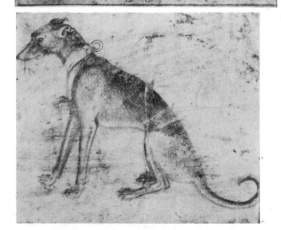

is related to other drawings which were originally pages of model-books. A sheet now divided into two fragments (34) has two drawings in silverpoint, wash and white heightening. One of these is a very high-quality version of Giovannino's seated greyhound, and is often considered to be the prototype, drawn directly from nature, for that copy and perhaps for a whole family of descendants. On another sheet (35) is a less good version, with bodycolour added as in the Bergamo drawings, of the standing greyhound on the Haarlem sheet (34), and was again probably derived ultimately from that model. Drawings of *Two leopards* (36–7) are related to Giovannino's *Leopard* (32) but at several removes from the original: they seem to be weaker attempts to represent the external appearance of the animal by merely repeating without comprehension superficial information supplied by an earlier drawing. It may generally be that the further the draughtsman is from the original the more mediocre is his copy. On the other hand, improvements in lifelikeness and vitality may result from increasing technical proficiency; thus the Haarlem sheet (34), although higher in quality of perception and textural rendering, may none the less be a later reinterpretation of some such prototype as the drawings in the Bergamo model-book. It is impossible to assess whether this is more likely to be the case, or alternatively that the draughtsman studied the greyhound afresh while remaining bound by model-book conventions of pose and treatment. A later parallel is Pisanello's *Cheetah* (50), in placement and pose very close to Giovannino's

36. Lombard workshop, ca. 1400. *Two leopards*. Oxford, Christ Church, JBS 1059–1058. Pen and ink on paper; 5.3 × 7.7 and 7.3 × 11.5 cm. respectively.

37. Lombard workshop, ca. 1400. *Two leopards*. London, British Museum, 1895–12–14–94 recto. Brush and wash, with bodycolour, on parchment. 15.6 × 11.5 cm.

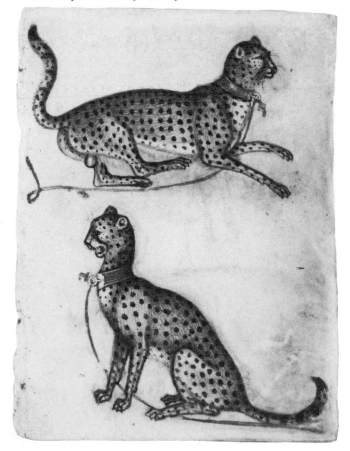

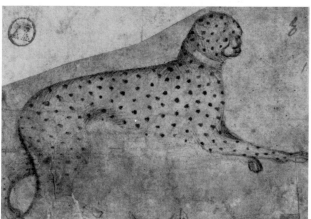

Leopard (32) but strikingly more sophisticated in the observation of anatomical proportions and articulation, and of the varying textures of the natural surface.

The appearance of a motif in widely separated centres at much the same time, which contributes to the apparent 'international' nature of late Gothic art, indicates strong, widespread interest at the end of the fourteenth century in the type of nature study usual in model-book drawings. Because of the care put into the copying, and the premium placed on accuracy, many model-book drawings (especially the mediocre ones) have an anonymity which makes them very hard to date or place. The uniformity of these drawings matches the universality of artistic production in Europe around 1400. Even books of drawings which have a more sketchy quality than the Lombard model-books, such as the so-called 'Uffizi sketch-book', are difficult to place since they are products of a phase in which individual characteristics of graphic style were suppressed in favour of a general preoccupation with naturalistic enrichment. The primary role of the model-book was to supply the workshop with a stock of natural motifs which could easily and rapidly be incorporated into finished works, without recourse to the original models, so that those works would meet up to the current taste for decorative naturalism.

The outcome of this function can be traced in paintings and manuscript illuminations of the period. A *Bear* in the Bergamo model-book, for example, reappears almost line for line in Giovannino de' Grassi's *Book of Hours* for Giangaleazzo Visconti.[7] Because they were intended primarily as models for paintings, model-book drawings were frequently coloured, sometimes rather simply in a small range of watercolours, sometimes more elaborately in gouache. Colour clarifies for the copyist important qualities of the surface and texture of an animal's form, and supplies necessary authenticity of detail. The application of colour to model-book drawings is a yet further extension of the labour that went into their production and, consequently, of the value attached to them as workshop tools.

The format of the model-book page was fairly regular. Animal studies were generally drawn two to the page (35–7) in strict profile, with stress on the contours of the forms. Because of the need to transmit a motif to artists who may have had no knowledge of the original, drawings were placed with great care on the page, with conscientious avoidance of overlap so that no detail should be obscured. Almost all model-book drawings show the smallest possible unit of form, ready for interpolation into, and recombination within, a painting. From around the middle of the century draughtsmen gradually broke away from these rigid formulae, to use the page with greater flexibility; but often even in the late fifteenth century the layout of a series of studies seems to reflect, if only subconsciously, the format of the model-book page. This formal tradition evidently exerted a strong influence over the quattrocento draughtsman's approach to the blank sheet when he began to formulate ideas in free response to his artistic preoccupations.

A few pages of the two books of drawings by Jacopo Bellini are close in type to the conventional model-book sheet, showing a series of precise drawings of natural motifs (38). A page of copies of antique monuments and inscriptions (39) shows the same layout used for the same reason in response to the different intellectual interests of the circle in which Bellini moved and worked. These pages emphasise the extent to which Bellini's books derive from the North Italian model-book tradition, with which they

39. Jacopo Bellini, *Antique monuments and inscriptions*. Paris, Louvre, 1512 recto. Pen and ink on parchment; 29.0 × 42.7 cm.

38. (left) Jacopo Bellini, *Studies of leopards and other animals*. London, British Museum, 1855–8–11–91 verso. Leadpoint on (prepared?) paper; 41.5 × 33.6 cm.

share meticulous draughtsmanship on parchment and the firm intention of preservation within the workshop. However, the concerns shown by most of Bellini's drawings lack, in both subject matter and graphic emphasis, the universality of application which is a hallmark of the model-book motif. Most of them are compositional drawings, stretching from the verso of one page to the recto of the next (112–13), and these can in no sense be associated with the purposes of a model-book, since they were probably not intended as designs for paintings, let alone to be indefinitely repeated. They are completed grisaille pictures drawn with the pen or stylus on the bound pages of a book, showing Jacopo's concern with artistic problems such as perspective and landscape representation. The high respect given to drawing, due to the strength of the model-book tradition in North Italy, encouraged the continuing use of preservable books for the practice of drawing, although the model-book form itself gradually gave way to less formal types of 'pattern' drawings later in the fifteenth century.

PISANELLO: THE TRANSITION FROM MODEL-BOOK TO SKETCH-BOOK

Lombard model-books were important sources of naturalistic motifs for artists of the succeeding decades, and set a regularly followed standard for the character of model-books elsewhere in Italy. The subject matter of model-books changed of course with developments in artistic and patronal taste in different centres. Furthermore, new artistic traditions and methods of study evolved, requiring different approaches to the use of models or exemplars recorded in drawing-books. Another type of book gradually developed, best given the wide-ranging term 'sketch-book'. This is distinguished from

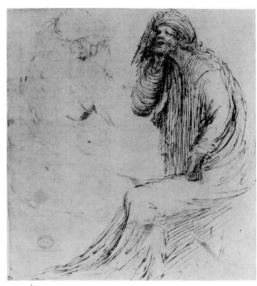

40. Jacopo Bellini, *Study after an antique nude figure*. Paris, Louvre, 1544 recto. Silverpoint on prepared parchment; 29.0 × 42.7 cm.

41. Stefano da Verona, *A Prophet*. London, British Museum, 1895–9–15–788. Pen and ink, over black chalk sketch, on paper; 23.2 × 21.0 cm.

the Lombard model-book in the range of subject matter covered, and in the much greater freedom of treatment which means that its workshop function is far less clear.

Some pages of Jacopo Bellini's books of drawings contain random studies that have the lack of finish and apparent purpose characteristic of the sketch-book (40), which suggests that although the concept of experimental drawing may have developed more strongly in Central Italy towards the middle of the fifteenth century, it was by no means exclusive to that region. Stefano da Verona's drawings, of perhaps the 1420s and 1430s, are in complete contrast to the Lombard tradition: Stefano used a free, rapidly flowing stroke of the pen to create figures of superb, excited vitality (41). His spontaneity may have been the catalyst for Pisanello, the most imaginative and versatile of all early quattrocento draughtsmen, whose drawings show an unparalleled range of both subject matter and treatment. Pisanello explored and extended the possibilities of drawing more than any other artist before Leonardo da Vinci. In his work, model-book drawings rub shoulders with pages of arbitrarily placed sketches which set new patterns for the use of the sheet, with compositional studies, with landscape studies, and with drawings in preparation for specific paintings and medals.

Several drawing-books from Pisanello's workshop can be reconstructed on the basis of the type of paper used, watermarks, page sizes and preparations: and from these it can be deduced that different books had different purposes.[8] Sixteen sheets with drawings mostly of birds and horses (colour plate IV, 42) have a watermark of a moor's head with a diadem, and are all about the same size (allowing for trimming over the years). All these drawings, and others which can be directly associated with them, are careful studies of animal forms. They are mostly very finely worked and detailed, and several have colour added. In general, they show the characteristics of a model-book, but none the less they can also probably be related specifically to the preparatory work for the *St. George and the Princess* fresco in S. Anastasia, Verona, painted probably in the late 1430s. Another group of sheets, most of which have a watermark of a pig and all of which are on greyish paper

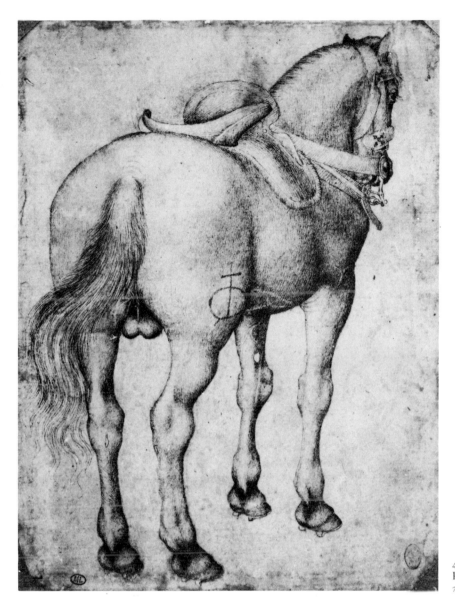

42. Pisanello, *Study of a horse*. Paris, Louvre, Vallardi 2378. Pen and ink on paper; 22.3 × 16.6 cm.

reddened before use, seem to be from a sketch-book used by Pisanello's workshop possibly when he was in Mantua in the 1440s. All of these drawings are rapid sketches arbitrarily placed on the page: many are of poor quality which lends the book the appearance of a workshop jotting-pad, in which assistants could note down and briefly explore an idea. Only a few show the touch of Pisanello himself, and these are experimental sketches scattered at random over the sheet and often overlapping one another (43). On the versos of the sheets, and on many other pages of the same paper, workshop apprentices have laboriously made ill-conceived studies or copies of figures or heads.

Another fascinating example of the shared sketch-book is a *taccuino di viaggi* originating in Gentile da Fabriano's Rome workshop, probably inherited by Pisanello when he took over Gentile's work in S. Giovanni in Laterano late in the 1420s, and used

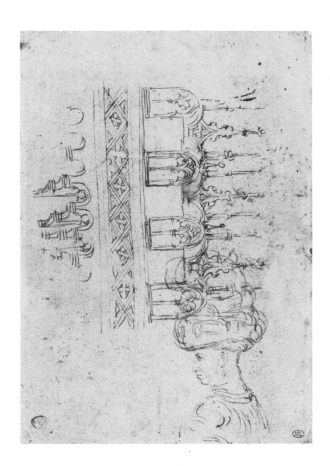

43. Pisanello, *Sheet of sketches*. Paris, Louvre, Vallardi 2278. Pen and ink on greyish paper; 20.8 × 14.8 cm.

continuously in his workshop during the 1430s.[9] This was a working book which combined the functions of model-book and sketch-book, although at first it was probably closer to the former. The pages are of parchment, and the drawings are mostly in pen and ink, some with watercolour added. One double page shows the range and variety of the drawings made in this extraordinary book. On one side (44) are two copies after celebrated fourteenth-century works of art, on the left one of the frescoes by Altichiero in the Oratorio di S. Giorgio in Padua and on the right Giotto's *Navicella* mosaic: the first overlaps onto the right-hand side of the sheet which implies that this was the centre-spread of one gathering of the book. On the other (45) is a precise rendering of one of the *Dioscuri*, and a series of studies of peacocks and other birds. The antique copy has the exactness of handling of a model-book drawing, the copies after Giotto and Altichiero are slighter, and the studies of birds have the freedom in the use of the page and in graphic style of Pisanello's studies of the 1440s. Other sheets from the book also have drawings of apparently widely varying date: one has early studies after the antique on one side (46) and costume studies which probably date from the late 1430s on the other (47). This *taccuino di viaggi* seems to have been a continuously used drawing-book in which especially striking motifs, and aspects of the experimental study of forms in movement, were recorded for workshop preservation.

The earliest drawings in the sketch-book, made in Gentile da Fabriano's workshop, are careful studies after antique sarcophagi and figure sculpture in and around Rome (45–6, 48). This group is a notable precursor of the Ghirlandaio workshop Codex Escurialensis,

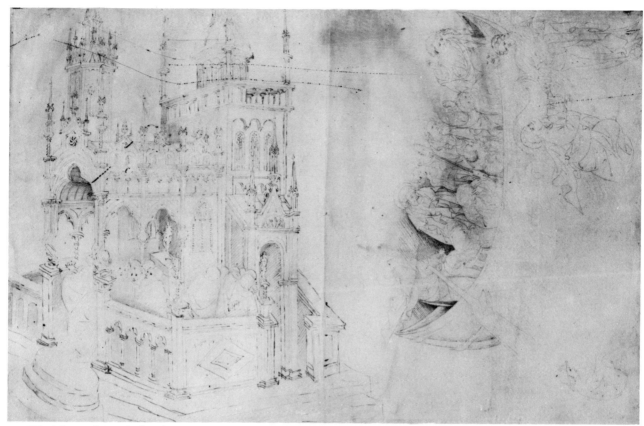

44. Workshops of Gentile da Fabriano and Pisanello, *Sheet of sketches, including a copy of Giotto's Navicella*. Milan, Ambrosiana, 214 inf. f 10 recto. Pen and ink with wash on parchment; 23.0 × 36.0 cm.

45. Workshops of Gentile da Fabriano and Pisanello, *Sheet of sketches, including a copy of one of the Dioscuri*. Milan, Ambrosiana, 214 inf. f.10 verso. Pen and ink on parchment; 23.0 × 36.0 cm.

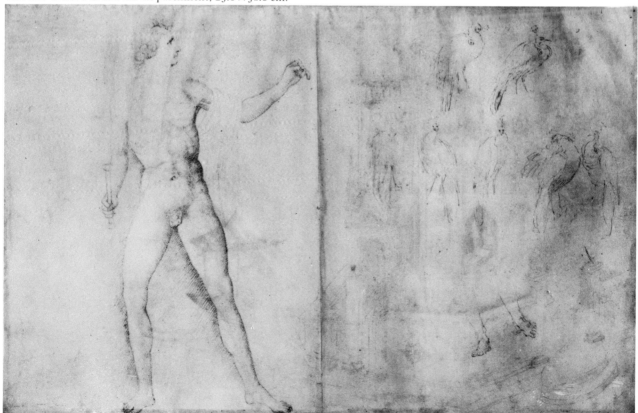

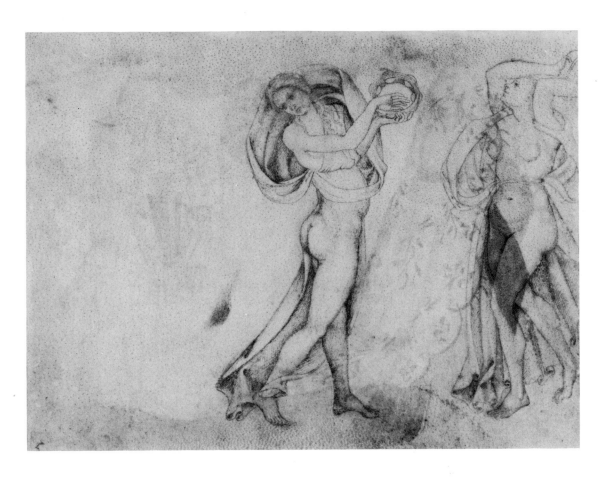

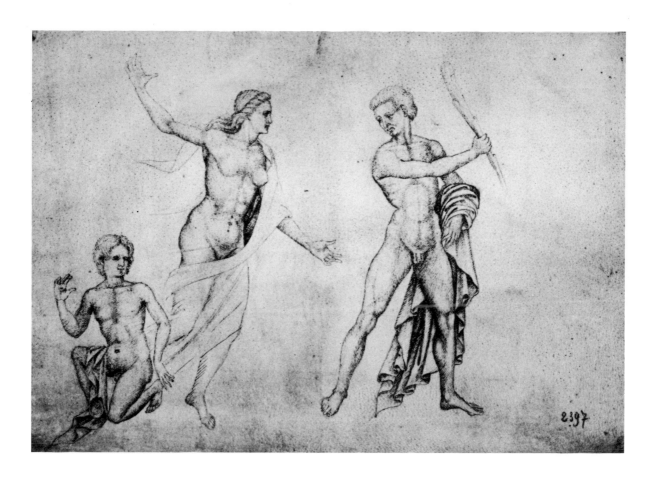

46. (facing page top) Workshop of Gentile da Fabriano, *Studies after the antique*. Oxford, Ashmolean Museum, KP 41 verso. Pen and ink on parchment; 18.3 × 24.0 cm.

47. (facing page bottom) Workshop of Pisanello, *Studies of costumes*. Oxford, Ashmolean Museum, KP 41 recto. Pen and ink, with watercolour washes, on parchment; 18.3 × 24.0 cm.

48. (above) Workshop of Gentile da Fabriano, *Studies after the antique*. Paris, Louvre, Vallardi 2397 verso. Pen and ink on parchment; 19.5 × 27.2 cm.

49. (left) Workshop of Ghirlandaio, *Study after antique female figure*. Madrid, Escorial, Codex Escurialensis f.46 verso. Pen and ink on paper; 33.0 × 23.0 cm.

which is essentially a model-book of antique motifs although assembled as late as around 1500 (49). The antique copies in Gentile's workshop *taccuino* also have the character of model-book drawings: they are careful records of poses, forms and movements for reuse in later work, which explains the use of parchment and the extreme delicacy of the graphic handling. The figures are immaculately drawn: the contours are laboriously set down but the modelling, although fine, shows little feeling for the anatomical structure inherent in the marble carvings studied. Concern was with figure-types and poses, but the figures lack the fluent rhythms of their prototypes. Much attention was devoted to drapery: classical folds were converted to late Gothic twists and arabesques which enliven the draperies but contrast with the classical high-relief of the originals. The exquisite finish of these drawings is characteristic of Gentile da Fabriano's workshop and of the young Pisanello: the concern to define and to distinguish qualities of surface displaces any interest in the rendering of structure. This inevitable result of the model-book draughtsman's attitude to form is more clearly a limitation in the para-doxical results produced in these studies after the antique than in the animal studies which are the principal subject for the model-book draughtsman.

As in the antique copies in the Gentile da Fabriano workshop *taccuino*, so also in Pisanello's 'Verona model-book' (colour plate IV, 42) the draughtsman's main concern is the precise definition of surface textures. The resulting microcosmic approach lends the

Head of a horse a wooden appearance: lifelike, because the technique is almost incredibly proficient, yet lacking any sign of the small natural movements which persuade us that an animal is alive. By definition, the model-book drawing cannot have the spontaneity and liveliness of a rapid sketch from nature. This is an inherent limitation, from Giovannino de' Grassi's drawings to Dürer's *Hare* a century later, and beyond. The appearance of a form is crystallised: set in aspic, as it were, it can be studied exhaustively. The very conscientiousness of the transcription of surface appearance means that the artist inevitably loses sight of the form's inner structure and rhythms. The two perceptions are irreconcilable; and it is noteworthy that it was concern with the second which came to dominate the quattrocento draughtsman's attitude towards nature.

Not least Pisanello's. Another group of his drawings are free, spontaneous sketches from nature itself in which his 'model-book' concern with surface texture is replaced by a deep interest in the dynamic life of the whole animal. A drawing such as the *Cheetah* (50) – already briefly compared with Giovannino's *Leopard* (32) – bears all the characteristics of the model-book. Textures are exquisitely rendered: the contrast between soft fur and the stiff leather of the collar is superbly clear. The proportions are so correctly perceived that the animal's species is not in doubt, and dabs of watercolour assure us again that it is indeed a cheetah. It was surely drawn from nature, so convincingly are the surface qualities shown, yet it has a frozen quality, hovering timelessly in pure profile against the

50. (facing page) Pisanello, *Cheetah*. Paris, Louvre, Vallardi 2426. Pen and ink with watercolours on parchment; 16.0 × 23.1 cm.

51. Pisanello, *Studies of a peacock and a monkey*. Paris, Louvre, Vallardi 2389 verso. Pen and ink on paper; 25.9 × 18.0 cm.

52. Pisanello, *Studies of the Emperor John VIII Palaeologus*. Paris, Louvre, M.I.1062. Pen and ink on paper; 19.9 × 29.0 cm.

53. (right) Pisanello, *Studies for a Crucifixion*. Paris, Louvre, Vallardi 2368 verso. Pen and ink on paper; 26.0 × 19.5 cm.

inert whiteness of the page. No greater contrast could be found between the *Cheetah* and the studies of a *Peacock and a monkey* (51). In the brilliant sketches of the monkey, Pisanello explored the shapes and movements of the animal in rapid notations of momentarily perceived poses. He followed the changes of pose in seven brief sketches on one sheet, using the paper randomly in his effort to understand the dynamic rhythms of the animal. The surface textures clearly do not matter here: Pisanello was sketching from life, starting again as often as the animal moved in order to study it from various angles.

Other drawings made by Pisanello at about this time confirm his growing practice of sketching directly from life. On the sheets connected with the medal of Emperor John VIII Palaeologus cast in 1438–9 he made a number of studies of the Emperor and his retinue (52) which contribute to the evolution of the composition on the reverse of the medal.[10] The pen moved rapidly over the paper, recording details of costume, pose and figure-type. As in the sketches of the monkey, Pisanello's pen-technique is similar to the broad fluency of Stefano da Verona's drawings (41, 100), whereas in the *Cheetah* it reflects Giovannino de' Grassi's delicate model-book handling. Time did not allow the addition of colour to the Palaeologus sketches: colour-notes are quickly added as an *aide-memoire* and as a guide to further thought. This is the earliest group of drawings which can securely be associated with a surviving, datable finished work. While suggesting that Pisanello approached this particular project, fulfilled in a technique as yet unfamiliar to him, with exceptional seriousness, it may also indicate that preparatory drawing of this type was already a feature of artistic practice that Pisanello here amplified.

This possibility is supported by another example of Pisanello using drawing in working out the details of a composition, the sheet of studies for a *Crucifixion* (53), usually regarded as studies for the crucifix borne by the stag in the London *Vision of St. Eustace*. Judging by the layout of these sketches on the page, the two finely detailed

studies for the hands of Christ were probably made first (or at least early on), before the looser sketches in which Pisanello considered the angle of the head and its relation to Christ's shoulders. Whatever the order of the drawings, this is evidently an exploratory sheet in which Pisanello tried out a number of alternatives in his search for the answer to the problem of Christ's pose, refining his ideas through studies from life. Given that Pisanello used this method of experimental study as early as the 1430s, it seems surprising that it should not have gained currency more rapidly in Florentine workshops. This is perhaps both a tribute to Pisanello's extraordinary, anticipatory versatility, and a sign of the relative traditionalism of Florentine artistic practice.

Unfortunately it is not clear whether experimental drawings like these by Pisanello formed in any sense a 'sketch-book', or were made merely on loose sheets of paper. The range of Pisanello's drawings indicates, however, that he formed a crucial bridge between the late Gothic model-book tradition and the new, more versatile and inventive uses of drawing of the mid-fifteenth century. Pisanello's model-book drawings are generally similar in graphic style to prototypes of the 1420s or before, whereas the more spontaneous preparatory sketches tend to relate to the medals and other works of the 1440s. It is impossible, however, to place his different types of drawings in crude chronological order: indeed, it is far preferable to see them as concurrent, the handling of each being appropriate to its purpose. Pisanello still needed model-book drawings for the transcription of motifs into paintings of his later career, and he could not necessarily rely entirely on his inherited stock. Conversely, freely executed sketches were probably made in preparation for early projects just as they were for those produced later in his life.

DRAWING-BOOKS IN EARLY QUATTROCENTO TUSCANY

The situation in Tuscany early in the fifteenth century differed from that in Lombardy, probably due to the lack of a strong Court whose tastes and patronage encouraged the formation and use of model-books of natural forms. Such studies were not, however, neglected in Central Italy. According to Vasari, Uccello 'loved painting animals, and in order to do them well he studied them very carefully, even keeping his house full of pictures of birds, cats, dogs, and every kind of strange beast whose likeness he could obtain';[11] and 'in our book there are many drawings by Uccello of figures, perspectives, birds and wonderfully fine animals'.[12] Ghiberti is documented as having owned 'charte delli ucelli', perhaps loose sheets of bird studies acquired in connection with the natural details in the frames of the Florentine Baptistery doors, and Jacopo della Quercia possessed 'una charta di animagli da disegno'.[13] None the less, only one surviving model-book of animal studies is certainly Tuscan, probably made in Florence around 1450 (54): before this, Tuscans may have used model-books by North Italian draughtsmen, well known for their ability in drawing from nature. This or a very similar model-book was apparently available to Benozzo Gozzoli's workshop at Pisa, for many of the motifs were used in his Camposanto frescoes, and it was also probably used in the early engraving studios of Florence, for some forms reappear in reverse in the so-called 'Otto prints'. Indeed, the book may have originated in a goldsmith's workshop for just this purpose:

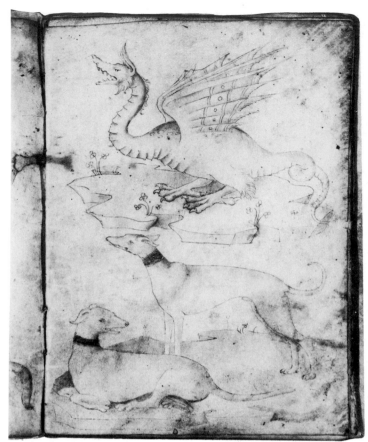

54. Florentine draughtsman, ca. 1450 (?), *Studies of animals*. Paris, Roths-child Collection sketchbook, f.2 recto. Pen and ink with wash on parchment. 19.5 × 14.0 cm.

55. Workshop of Benozzo Gozzoli, *Studies of animals*. Rotterdam, Museum Boymans-van Beuningen, inv. I, 562, f.14 verso. Pen and ink on paper; 22.5 × 15.5 cm.

the drawings seem to be Florentine copies of a typical North Italian model-book prototype. The layout compares directly with earlier examples: the animals, almost all in pure profile, are set two to the page, each isolated on a rocky stage against the blank white of the paper.

In format and purpose, this book evidently qualifies as a model-book. Another book of drawings apparently made in Benozzo Gozzoli's workshop in about 1460 is, however, rather different in character (55–6). The contents of this book are so varied as to suggest that, like Pisanello's sketch-book on reddened paper, it was a workshop sketch-book used by various Gozzoli assistants for noting down ideas for future reference. There are exploratory studies of figures and groups, and copies after other works, several of which may have been copied from drawings by Gozzoli himself, suggesting that pages of the sketch-book were used by apprentices in training. The way that this book is made up suggests that in Tuscany the sketch-book was used very informally, and looks forward to the replacement of the form later in the century by the workshop portfolio stock of loose sheets of sketches.

Another representative of the type in early quattrocento Tuscany is a sketch-book by Parri Spinelli, from which a number of sheets survive. In this book, Parri made a wide range of experimental studies of figures, of compositional schemes and especially of

56. Workshop of Benozzo Gozzoli, *Studies of nudes*. Rotterdam, Museum Boymans-van Beuningen, inv. I, 562, f.51
Silverpoint, with white heightening, on violet prepared paper; 22.5 × 15.5 cm.

57. Parri Spinelli, *Christ and the
Adulteress*, left side. Florence, Uffizi,
23E. Pen and ink on paper;
27.4 × 19.6 cm.

drapery patterns. A compositional drawing of *Christ and the Adulteress* (57–8) was
probably the initial exploration of an unusual subject, a type of drawing which has no
place in the conventional model-book. Drawings of the *Madonna and Child* (101–2) offer
alternative solutions for the pose of the group; Parri Spinelli can here be seen using pages
in his book to study a compositional problem in detail. Other studies are of individual
figures (59), in which Parri concentrated on his investigation of exaggeratedly fluid,
looping drapery which cascades fantastically over and across an attenuated form. All
these drawings were loosely executed in pen and ink, with a fair degree of hatching and
cross-hatching but certainly lacking a model-book drawing's delicate precision of
textural rendering. A sense of the sketch-book as a cumulative record of artistic activity
can here be discerned: drawing was used for exploratory rather than for recording
purposes. One fascinating drawing studies the male nude in a peculiarly contorted pose

82

58. Parri Spinelli, *Christ and the Adulteress*, right side. Chatsworth, Devonshire Collection, 703. Pen and ink on paper; 27.4 × 19.6 cm.

59. Parri Spinelli, *St. Paul and an Evangelist*. Florence, Uffizi, 8E verso. Pen and ink on paper; 29.1 × 40.8 cm.

(73), an investigation of a difficult problem of foreshortening which anticipates the experimental study of the nude later in the century.

This study seems to be exceptional in Parri Spinelli's work, but another interesting sketch-book which was apparently being used around 1440 indicates a growing concern with the study of the nude model. Sixteen fragments of sheets of pigmented blue paper, on which brush drawings in bistre and white were made, survive from this book.[14] The technique of brush drawing on blue paper was especially common in Venice, and on stylistic grounds too these drawings can be associated with Domenico Veneziano's Florentine career. One sheet (60) shows two studies from the nude model which can probably be linked with Domenico's lost *Marriage of the Virgin* painted in S. Egidio, Florence, in 1439–41. In other studies too (61), Domenico continued his enquiries into the representation of figures in movement, both in preparation for particular projects, and in general response to the activities of Florentine artists and theorists of the previous two decades. In this sketch-book, Domenico Veneziano anticipated the fervent interest devoted to problems of form later in the century, when study from the nude or draped workshop model dominated the output of Florentine draughtsmen.

FROM SKETCH-BOOK TO PORTFOLIO 'PATTERN' DRAWING

The inventory of studio property left at the death of Fra Bartolommeo in 1517 lists twelve sketch-books;[15] but it is seldom possible to reconstruct convincingly the sketch-books of late quattrocento draughtsmen. One important example, however, is the book

60. Domenico Veneziano, *Studies of nude figures*. Stockholm, National-museum, inv. 48. Brush and brown pigment, with white heightening, on blue paper (faded); 19.2 × 20.8 cm.

61. (facing page) Domenico Veneziano, *Studies of three figures*. Paris, Louvre, 2688. Brush and brown pigment, with white heightening, on blue paper (faded); 18.3 × 32.4 cm.

usually attributed to the Verrocchio workshop assistant Francesco di Simone Ferrucci, from which a number of sheets survive.[16] These pages show an increase in the informality of usage already noticed in Pisanello workshop sketch-books. Some sheets are scarcely used while others are crammed with small, slight experimental sketches of figures and other motifs. The sheets were used haphazardly: there is no sense of order in the sketches, which often range widely in subject, scale and handling on a single page. On one sheet Francesco di Simone repetitively explored the form of the blessing Christ-Child (62); related sketches are juxtaposed on another page with a drawing after Pollaiuolo's *Hercules and the Hydra* and one or two other jotted motifs (63). The sketch-book here becomes a memo-pad, arbitrarily used and entirely lacking the discipline and relative formality even of Pisanello's or Gozzoli's books, let alone of the model-book.

The unrestrained indiscipline of Francesco di Simone's book and the fleeting character of some of his brief figure sketches reflect Leonardo da Vinci's advice in the section of his treatise entitled 'How to learn the movements of man':

> be sure to take with you a little book with pages prepared with bone meal, and with a silverpoint briefly note the movements and actions of the bystanders and their grouping. This will teach you how to compose narrative paintings. When your book is full, put it aside and keep it for your later use, then take another book and continue as before.[17]

Francesco di Simone's drawings are in pen and ink, but Raphael used prepared paper sketch-books for silverpoint sketching, which has clear advantages over the pen for immediate operation when a suitable subject suddenly appears. 'Observe and sketch

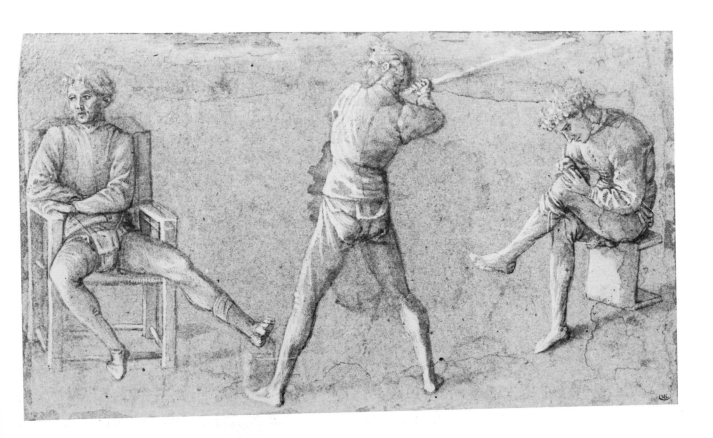

62. Francesco di Simone, *Sheet of sketches, mostly of the standing, blessing Christ–Child*. London, British Museum, 1875–6–12–15 recto. Pen and ink on paper; 25.5 × 18.5 cm.

63. Francesco di Simone, *Sheet of sketches, including a copy of Pollaiuolo's Hercules and the Hydra*. Paris, Louvre, RF 446 verso. Pen and ink on paper; 25.1 × 17.1 cm.

briefly, with few lines, the actions of men as they occur accidentally, without their being aware of it',[18] Leonardo advised.

Although free drawings in silverpoint, usually with white heightening (which could not be added under the conditions that Leonardo envisaged), survive in large numbers from the late fifteenth century, few seem ever to have been made in the bound sketchbook that Leonardo discussed. It may be that new attitudes to the use and disposal of paper resulted in less concern to collect and preserve drawings as re-usable models, so that the formal 'drawing-book' lost popularity in certain workshops. A painter may well, however, have had a less constraining portfolio of drawings in his possession: Cennino Cennini advised the painter to 'have a sort of pouch made of pasteboard, or just thin wood, made large enough in every dimension for you to put in a royal folio, that is, a half; and this is good for you to keep your drawings in, and likewise to hold the paper on for drawing'.[19] Although informal in structure, and often in the character of each drawing, such portfolios could none the less play a role similar to the early quattrocento model-book as workshop tools.

That Antonio Pollaiuolo's *Nude man seen from front, side and back* (81) was evidently a 'pattern' of nude form suggests that his workshop property included a stock of informal

nude model studies which could serve as stimuli for work on specific projects or for the development of apprentices' drawing skills. Indeed, Pollaiuolo's drawings served as models beyond the confines of his own workshop. As we saw earlier, Benvenuto Cellini wrote that 'many sculptors and painters, and I speak of the most accomplished in these arts, also used his designs, and through them achieved the greatest honour': Francesco di Simone copied his *Hercules and the Hydra*, Squarcione owned at Pollaiuolo *cartone*, and the draughtsmen of the so-called 'Venice sketch-book' frequently availed themselves of Pollaiuolo exemplars.[20] This role of drawings, to disseminate far and wide the artistic skills of the workshop, could not have been achieved had such drawings been made in studio sketch-books.

Increasing individuality in drawings towards the end of the fifteenth century did not, however, lead to the disappearance of the model-book type of drawing. Its form changed with changes in artistic interests, to be sure; and with the increasing use of paper rather than parchment the book gave way to a less formal stock of studies. Bound books of models like the Ghirlandaio workshop Codex Escurialensis were, however, still made, and several sheets of drapery studies also made in Ghirlandaio's workshop indicate that he had a portfolio of 'pattern' drawings.[21] These drawings are in the pen-and-ink cross-hatching technique characteristic of Ghirlandaio's workshop, and were used as proto-types for apprentice copying and as 'patterns' for the transfer of drapery formulae into paintings. A typical example (64) is a mediocre workshop copy of a Ghirlandaio prototype which was used as the pattern for the drapery of the Emperor Augustus in a fresco in Sta. Trinita, Florence.

There is also good evidence of the use of patterns by late quattrocento Venetian artists, again both for teaching purposes and for the transfer of forms to finished paintings. 'Pattern' drawings were frequently used at a formative stage in the preparation of a finished work, and they also served to disseminate particular motifs not only within the workshop but also further afield. Gentile Bellini's visit to Constantinople from 1479 to 1481 as a Venetian painter–diplomat gave him the opportunity to make many drawings of Oriental types which provided in turn a vocabulary of such types which, it seems, other artists were able to draw on. Gentile Bellini's *Turkish woman* (135) was made with the impeccable refinement of a model-book drawing, and as in Pisanello's Palaeologus drawing (52) colour-notes were added for later guidance whenever the type should be used in a painting. Pinturicchio had access to a group of 'pattern' or *simile* drawings of Orientals made in Gentile Bellini's workshop (65) which are included in his frescoes of the 1490s in the Borgia Apartments in the Vatican, and slightly later in those for the Piccolomini Library in Siena Cathedral.[22] Copy drawings of Orientals were also used by Carpaccio for the staffage of his St. George cycle, and many sheets of figure studies from Carpaccio's workshop (66) are apprentice copies of portfolio *simile* drawings also used for figures in his paintings. Late quattrocento decorative painters may also have referred back to late Gothic model-books or more recent copies of them. Just as Benozzo Gozzoli drew on a mid-fifteenth century Florentine model-book (54) which in turn probably copied an earlier North Italian exemplar, so also the frigid, lifeless precision of the animal and bird studies in the backgrounds of Carpaccio's paintings strongly suggests that he too had access to a similar model-book.

Carpaccio's and Ghirlandaio's workshops were, however, relatively traditional in working method, and especially in the use of 'pattern' or *simile* drawings for the transcription of motifs into finished paintings. Early in the century, when model-books supplied individual motifs for inclusion in decorative manuscript borders, the advantages of that type of microscopic study made independently of a context were evident. When, however, such motifs were gratuitously and heterogeneously interpolated into a painting like Pisanello's London *Vision of St. Eustace*, delightful and perceptive though each study may be, the failure of the painter to bring them together within a unified composition is equally clear. It would indeed have been painfully clear to the late

64. Workshop of Ghirlandaio, *Study of drapery*. Lille, Musée des Beaux-Arts, 231. Pen and ink, with white heightening, on reddened paper; 25.0 × 12.4 cm

65. Workshop of Gentile Bellini, *Standing Oriental*. Paris, Louvre, 4653. Pen and ink, with light wash, on paper; 20.7 × 11.4 cm.

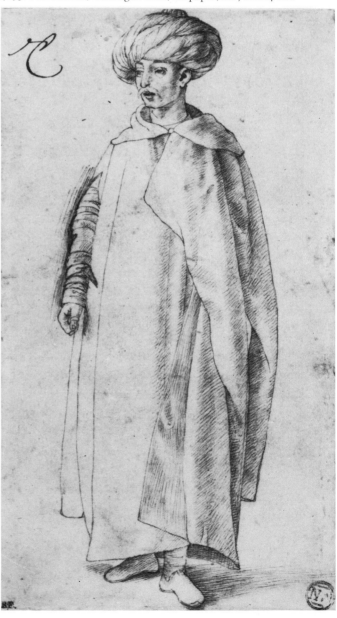

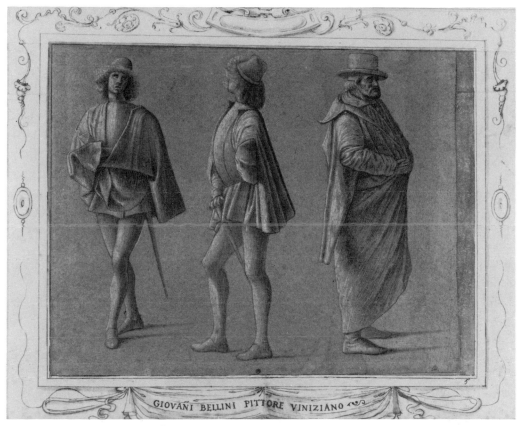

GIOVĀNI BELLINI PITTORE VINIZIANO

66. Workshop of Carpaccio, *Studies of three figures*. Oxford, Ashmolean Museum, KP' 8 recto. Brush and grey wash, with white heightening, on blue paper (discoloured); 21.8 × 26.8 cm. In the mount drawn by Vasari in his Libro de' Disegni, and with his attribution to Giovanni Bellini.

quattrocento Florentine artist whose primary aim was to evolve a convincing, realistic pictorial structure appropriate to the needs of each individual project. Natural details needed to be studied afresh and included in the painting only under the control of a unified pictorial composition. Equally, drapery formulae transcribed into Ghirlandaio's paintings from 'pattern' drawings may have appeared disjointed in comparison with the general consistency of the work of his Florentine contemporaries. 'Patterns' or models have no place in the working practice of the artist who plans each detail from the start as a unit within the whole composition.

During the transition to this approach to pictorial composition, the model-book drawing and its later equivalents inevitably lost their importance in artistic practice. The changes away from the traditional uses of model-books and sketch-books were fundamentally due to the development by which drawing came more and more to be an experimental process. With the growing freedom with which the later quattrocento draughtsman made studies on paper, the relatively restrictive form of the bound book gave place to the loose working sheets on which the draughtsman increasingly pursued his growing preoccupations with anatomical form and compositional design.

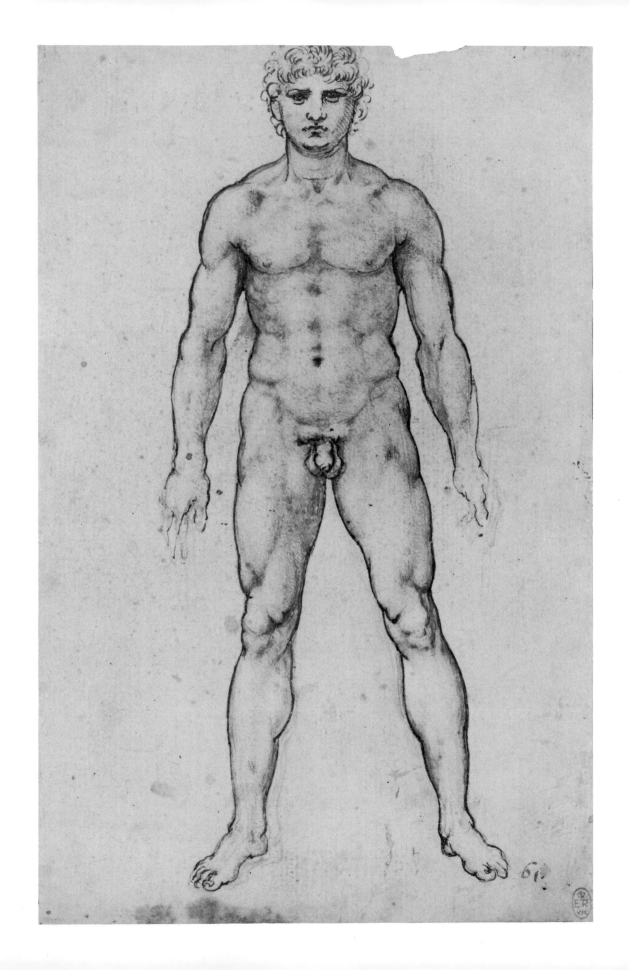

61.

CHAPTER V

Figure Drawing

STUDY OF THE NUDE IN FLORENCE

ONE OF the major preoccupations of the Renaissance artist was with the representation of the human form. Only by the inclusion in his narrative paintings of anatomically convincing figures which moved and gestured easily and persuasively could the artist match up to Renaissance ideals of narrative communication. The development of this concern with realistic narrative was stimulated by the intellectual ideas codified by Alberti in *de Pictura*. Alberti attached much importance to the representation of the 'movements of the mind' through the study of the movement, gesture and expression of the human figure. His desire that artists should pursue this study is shown by the detailed discussion in his treatise of the methods that painters should adopt in their exploration of how to represent the figure, its parts and movements. The parallels between his advice and the methods and techniques used in their studies by Tuscan draughtsmen from around the mid-fifteenth century indicate both the influence of early Renaissance intellectual ideas and the rapidly growing value given to drawing as a medium for investigating the rhythms and dynamics of human anatomy.

The impact of Albertian ideas is further suggested by the fact that no Florentine nude studies survive from before about 1440, although to judge from surviving drawings and other works later in the century the greatest interest in these problems was aroused there. Some of the most important passages in *de Pictura* deal with the analysis of human form,[1] and the concern of Florentine artists and theorists in the mid-fifteenth century with such investigations was primarily responsible for a fundamental change in attitudes towards nude study. This change may initially be illustrated by comparing a nude drawing which was probably made by a Veronese draughtsman at the beginning of the quattrocento (68) with a nude study by Leonardo da Vinci (67) made shortly after the beginning of the cinquecento. The Veronese draughtsman was not concerned, as Leonardo was, with the muscular structure of the body. Leonardo's red chalk feels its way over the forms and solidly builds the powerful frame of the nude, who takes up a classic pose for anatomical study. The earlier draughtsman, on the other hand, tentatively stroked the surface of the skin with his pen, without defining the underlying anatomical structure: his figure is posed as weakly as Leonardo's is confidently firm. Leonardo's prime objectives were the study of the body's structure and the clarification of the proportions and muscular rhythms of the limbs. So ineffectual is the earlier drawing as a study of nude form, however, that one is left wondering why the model should have been asked to pose

67. Leonardo da Vinci, *Standing male nude*. Windsor, Royal Library, 12594. Red chalk on reddened paper, the outlines later reinforced in ink; 23.6 × 14.6 cm.

naked (if indeed there was a model at all) unless simply for obscure iconographical reasons. Leonardo's study, on the other hand, is assertively of a nude model for its own sake.

The Veronese drawing is relatively low in quality, but it is none the less indicative of the competence of early quattrocento draughtsmen in representing the nude and in even grasping the problem of how to demonstrate the movements of the human figure. A drawing from Stefano da Verona's circle (69) attempts to show a nude man in dramatic action, but fails through the draughtsman's lack of understanding of relationships between parts of the body. Individual limbs are well drawn: the structure of the upper leg, defined by hatched gradations of tone across the skin surface, is for example effectively indicated. But the outline is laborious and restricts the freedom of movement implied by the pose, and passages such as the chest and throat are so stylised that overall the anatomy fails to be credible. In contrast with the hard, parallel lines of the hatching, the hair is characterised with swirling pen strokes to create a sense of fluent movement: if the draughtsman was not concerned with anatomical accuracy he could certainly describe vigorously its superficial appearance. The type of nude study made in Benozzo Gozzoli's Florentine workshop in about 1450 is similar to these Veronese drawings in the approach to anatomical form (70). Again in comparison with Leonardo's masterly study (68) of half a century later, the model is insecurely posed and the musculature is

68. Veronese draughtsman, ca. 1400, *Nude man holding a ball.* Oxford, Christ Church, JBS 685. Pen and ink on paper; 21.5 × 17.5 cm.

69. Circle of Stefano da Verona, *Male nude.* Florence, Uffizi, 59E. Pen and ink on paper; 18.7 × 12.9 cm.

schematically indicated in white highlights. The effect is delicately charming but the proportions are awkward and the figure completely lacks a sense of sculptural solidity.

A concern with surface description which characterised late Gothic model-book drawings still predominated in the earliest surviving drawings after the antique. To copy sculptural forms onto a flat surface was a standard way of studying the fall of light over a three-dimensional surface: it was recommended by Alberti and had been exploited by numerous painters during the preceding centuries. As in the Veronese draughtsmen's attitudes to the nude model, however, it was the surface detail of classical sculpture rather than the structure of the carved forms, as we have already seen, which preoccupied the draughtsmen of the Gentile da Fabriano workshop *taccuino di viaggi* (48). Much more attention was paid here to the delicate pen-hatching, used to define the texture of skin and the decorative drapery of the man with a club, than to anatomical structure. In the accompanying copy of a Venus from an Adonis sarcophagus the draughtsman has been more selective: the drapery is only briefly indicated and the torso and head of the figure are more fully worked up. The approach to structure is, however, still tentative, and the emphasis is on the observation of surface texture. In these drawings the antique supplied motifs of pose, gesture and superficial detail, but the draughtsmen were not concerned with what might be learned through copying about sculptural form. This is stressed by the pen handling and the carefully drawn, uninformative 'closed' contour. No nude

70. Workshop of Benozzo Gozzoli, *Standing male nude.* Vienna, Albertina, inv. 12. Pen and wash on mauve-tinted paper; 19.5 × 12.3 cm.

71. Workshop of Filippo Lippi, *Study of one of the Dioscuri.* London, British Museum, Pp.1–18. Silverpoint, with white heightening, on blue prepared paper; 36.0 × 24.7 cm.

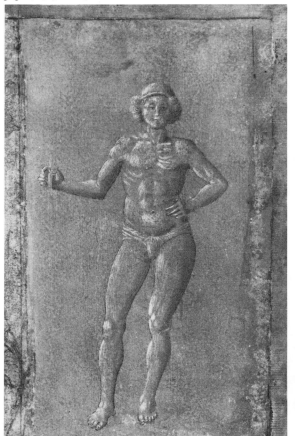
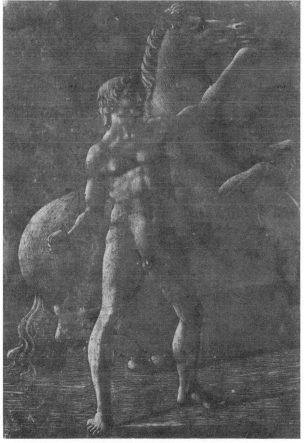

studies were made in this sketch-book, and the detailed records of antique sculpture suggest that the interest was more antiquarian than artistic.

At about the middle of the fifteenth century, Florentine copies of classical sculpture show new interests. In a comparison between two drawings after one of the *Dioscuri*, one in the Gentile da Fabriano workshop *taccuino di viaggi* (45) and the other perhaps made in Filippo Lippi's workshop (71), the more energetic approach of the Florentine draughts-man indicates a desire to represent the volumetric shape of the statue rather than merely its surface detail. The Florentine characteristically worked in silverpoint on green prepared paper, adding white highlights fluently and broadly to construct the forms. He aimed to show the muscular tension of the whole form rather than to break it down into numerous small, individually observed areas. Another example of the study of classical sculpture at the time is the careful drawing of a female torso in one of Benozzo Gozzoli's workshop sketch-books (72). The three-dimensional structure of the marble figure is shown by the subtle intermeshing of lights and shadows: the draughtsman again evidently wished to convey the solid, volumetric forms of his model rather than to record merely its surface patina. This is no antiquarian record, but the positive pursuit of sculptural form, following Alberti's dictum, that 'if it is a help to imitate the work of others . . . I prefer you to take as your model a mediocre sculpture rather than an excellent painting, for from painted objects we train our hand only to make a likeness, whereas from sculptures we learn to represent both likeness and correct incidence of light.'[2] The Florentine draughtsman here strove to understand the 'correct incidence of light', just as other mid-quattrocento Florentines indicate in their drawings their acceptance of Alberti's advice on the investigation of anatomy and movement.

It is no surprise that the earliest drawings made from the posed, nude studio model date from the same time as these studies of the structure of classical sculpture. Compared with the care with which the model was considered at this time, the early quattrocento Veronese nude studies appear arbitrary and accidental. Innumerable studies were made from the nude model in Florence from the 1460s onwards. Earlier still, though, draughtsmen directly affected by the new attitudes recorded by Alberti were prepared to use paper to make figure studies which could be preserved, either in sketch-books or in workshop portfolios, for further consideration or future adaptation. An early example is the extraordinary drawing in Parri Spinelli's sketch-book showing a male nude in an exaggeratedly contorted pose (73). It is difficult to decide whether this is a study of foreshortening with some particular narrative composition in mind, or an experimental drawing of the human form for study's sake. Either way the figure has a sense of coherent and dynamic three-dimensionality notably lacking in earlier studies (69), generated by the detailed cross-hatching which constructs form and by the almost aggressive vigour of the pose.

The drawings from the blue-paper sketch-book from Domenico Veneziano's Floren-tine workshop are among the earliest to suggest that the exploration of form in movement had become an important artistic activity. Although some of these drawings may have been for specific projects, most appear to be random observations of posed workshop models (60, 74). The impetus behind Domenico's study of the nude may have been the theoretical ideas current in the 1430s and put into words by Alberti:

94

72. Workshop of Benozzo Gozzoli, *Study of a classical female torso*. New York, Cooper–Hewitt Museum, 1901.39.2971. Silverpoint, with white heightening, on grey prepared paper; 17.2 × 9.2 cm.

73. Parri Spinelli, *Foreshortened male nude*. Florence, Uffizi, 32E. Pen and ink on paper; 18.6 × 10.3 cm.

one must observe a certain conformity in regard to the size of members, and in this it will help, when painting living creatures, first to sketch in the bones, for, as they bend very little indeed, they always occupy a certain determined position. Then add the sinews and muscles, and finally clothe the bones and muscles with flesh and skin. But at this point, I see, there will perhaps be some who will raise as an objection something I said above, namely, that the painter is not concerned with things that are not visible. They would be right to do so, except that, just as for a clothed figure we first have to draw the naked body beneath and then cover it with clothes, so in painting a nude the

bones and muscles must be arranged first, and then covered with appropriate flesh and skin in such a way that it is not difficult to perceive the positions of the muscles. As Nature clearly and openly reveals all these proportions, so the zealous painter will find great profit from investigating them in Nature for himself.[3]

If the painter is to observe these human proportions from Nature for himself, clearly he will do so by drawing from the nude model, paying particular attention to the relative positions of bones, muscles and sinews beneath the surface of the skin. Only if the under-lying structure of the anatomical form is understood, can that form be convincingly represented on a flat surface and enlivened with a sense of coherent, rhythmic movement. The representation of expressive movements and gestures is fundamental to an effective narrative painting, the Albertian *istoria*. 'The painter', wrote Alberti, 'must know all about the movements of the body, which I believe he must take from Nature with great skill',[4] and he then discussed at length the variety of human movements which the painter must observe and comprehend instinctively if he was to convey successfully and with decorum the expressive and emotional states of his figures.

Later on Leonardo da Vinci re-emphasised the importance of detailed knowledge of musculature and movement, to be gained through life-drawing: 'The painter who knows the sinews, muscles, and tendons, will know very well, when a limb moves, how many and which sinews are the reason for it, and which muscle, by swelling, is the reason for the contraction of the sinew, and which sinews, changed into very thin cartilage, surround and contain the muscle.'[5] By implication, this knowledge can only be gained by diligent study of nude form, both at rest and under tension. Leonardo's demands are much more stringent than Alberti's: whereas Alberti's painter needs zealously to study Nature alone, Leonardo's needs a detailed knowledge of anatomy. The development of nude drawing between the times of Alberti and of Leonardo shows an analogous change in attitudes towards the study of anatomical structure. A growing freedom in the representation of the human figure in motion indicates that an instinctive awareness of anatomical structure was bred into the late quattrocento Florentine draughtsman as part of his apprenticeship.

Despite its limitations, silverpoint was the most frequently used technique for drawing from the model during the rapid increase in nude study in Florence from around 1460. This reflects Alberti's suggestions about working in black and white:

> I would prefer learned painters to believe that the greatest art and industry are concerned with the disposition of white and black, and that all skill and care should be used in correctly placing these two. Just as the incidence of light and shade makes it apparent where surfaces become convex or concave . . . so the combination of white and black achieves what the Athenian painter Nicias was praised for, and what the artist must above all desire: that the things he paints should appear in maximum relief . . . as regards the representation of light with white and of shadow with black, I advise you to devote particular study to those surfaces that are clothed in light or shade. You can very well learn from Nature and from objects themselves.[6]

And in what sounds like a positive recommendation of a 'three-tone' technique like the traditional Florentine use of silverpoint and white heightening, Alberti continues:

you may change the colour with a little white applied as sparingly as possible in the appropriate place within the outlines of the surface, and likewise add some black in the place opposite to it. With such balancing, as one might say, of black and white a surface rising in relief becomes still more evident.[7]

Throughout *de Pictura* Alberti summed up, and probably extrapolated from, his experience of artistic activity in early Renaissance Florence. It was these new activities (as much as Alberti's treatise itself), combined with traditional practices, which stimulated later generations of Florentine painters to expand the range of drawing, and to exploit available techniques in new ways, in studying the human figure.

An important characteristic of nude study in mid-quattrocento Florence was a new

74. Domenico Veneziano, *Studies of two male nudes*. Florence, Uffizi, 1107E. Brush and brown pigment, with white heightening, on blue paper (faded); 22.0 × 26.0 cm.

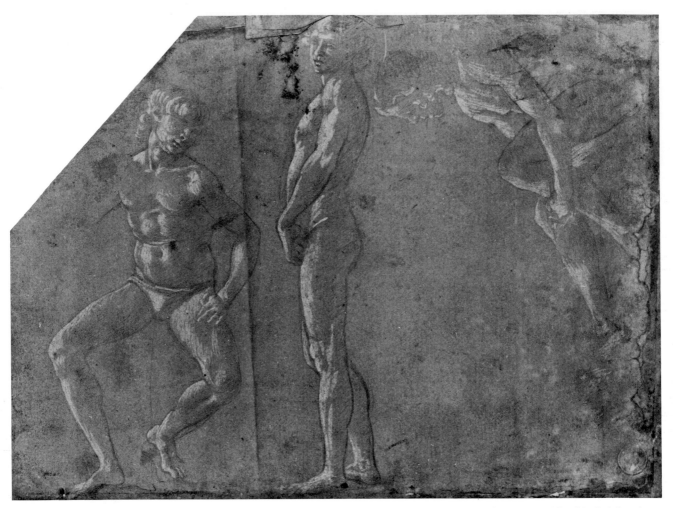

75. Workshop of Botticelli (?), *Studies of a male nude* (verso of 76). Lille, Musée des Beaux-Arts, 82. Silverpoint, with white heightening, on pink prepared paper; 19.0 × 27.7 cm.

recognition of its value in broadening artistic awareness. Domenico Veneziano's studies were probably made in a sketch-book, but draughtsmen of the next generation made their experimental drawings on loose sheets of paper without considering preservation for later reuse as part of their purpose. Domenico strove towards a clearer understanding of the figure and its rhythmic movements with a consciousness that his drawings might come in useful later. Experimental though they are, they have a polish seldom found in the freer nude sketches of his successors. In a sheet of studies of a *Male nude* at Lille (75–6) the draughtsman was liberated from Domenico's self-imposed constraints. He made rapid sketches from the workshop model, turning the paper round and over as the nude changed his pose. The prepared paper is well used, but there is no sense that the draughtsman was working on a particular problem. He was simply training his eye and exercising his hand, developing his intuitive awareness of proportion and anatomy so that later he would be better equipped to tackle problems of pose and movement in figures for painted compositions.

Other drawings of about the same date bear this out. A study of *Arms* in a variety of

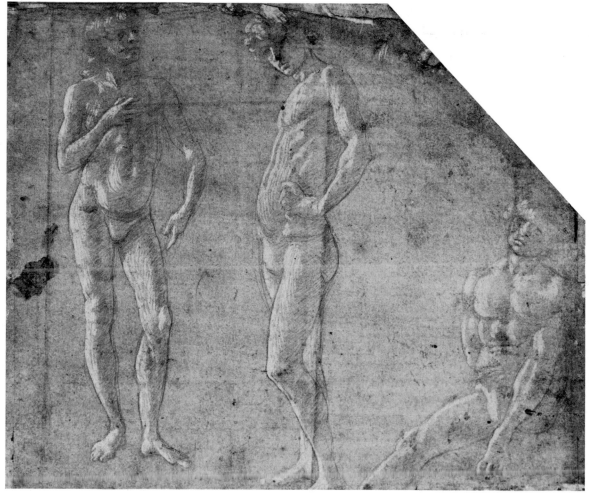

76. Workshop of Botticelli (?), *Studies of a male nude*, detail. Lille, Musée des Beaux-Arts, 81. Silverpoint, with white heightening, on pink prepared paper; 19.0 × 27.7 cm.

positions (77) was made by a draughtsman, probably in Filippino Lippi's workshop, who sought to understand how the relationships between sinews and muscles change with movements of the arm. A finely worked study of the male torso (78), with only brief indications of the limbs, shows the artist's deep preoccupation with the plastic flow of skin over the underlying muscular structure. With unusual sensitivity for this date, he observed precisely the anatomical relationships between shoulder, neck and chest, and delicately built up the shadows at the left side and hip of the model to indicate the fullness of the forms. Fine drawings such as these show clearly the strength of the new concern with the human figure, and the search for a fuller understanding of the appearance of anatomy under muscular stress.

This torso study shows the possibilities of delicate silverpoint drawing in the hands of a draughtsman (perhaps Lorenzo di Credi in this case) highly accomplished in the technique. Another marvellous nude study from Filippino Lippi's workshop (79) shows a freer use of silverpoint in a more rapid drawing, so that gradations of tone are less precisely rendered. The silverpoint hatching lines down the left leg, for instance, are

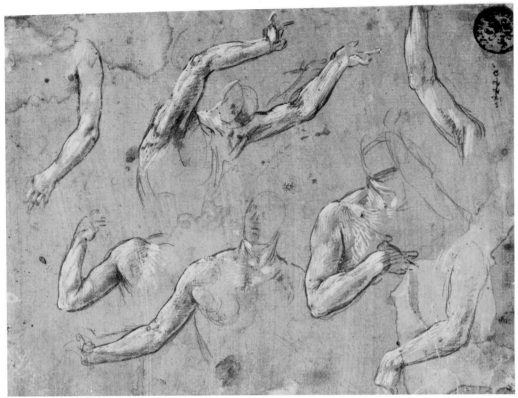

77. Workshop of Filippino Lippi (?), *Studies of arms*. Düsseldorf, Kunstmuseum, F.P.10. Silverpoint, with white heightening, on greyish-lilac prepared paper; 18.8 × 24.6 cm.

thick and somewhat uncontrolled; the white heightening is applied in undifferentiated dabs, or in coarse hatching which produces a faceted appearance lacking the gentle plasticity of the torso study (78). The draughtsman was striving towards an understanding of the rhythms of the whole form and needed to capture the dynamics of the figure rapidly, while the model held the pose. It is a virtuoso performance in the spontaneous handling of silverpoint, not as dramatically in motion as Filippino's *Litter-bearer* (colour plate III) but just as vibrantly life-like. None the less, the silverpoint technique and handling are made to look somewhat laboured when compared with the fluid vitality of Pollaiuolo's drawing of a *Nude youth* (80) which, like all surviving figure studies from his workshop, is in pen and ink. The pen line constructs the figure with an organic, intuitive sense of sculptural form, and the underlying musculature is implied by the brisk, light wash. The easy fluency of line effortlessly captures the sense of contained energy of the model. The wiry vigour and direct gaze of Pollaiuolo's youth, alert and ready to leap into action instantly, makes Filippino Lippi's nude study look stolidly earthbound. Pollaiuolo's swift, exploratory pen line, feeling its way around the muscular forms with dynamic urgency, has no parallel in the quattrocento. It is the prime example of a new way of defining sculptural form which replaced the 'three-tone' silverpoint technique with a more immediate means of recording anatomy and movement with the pen.

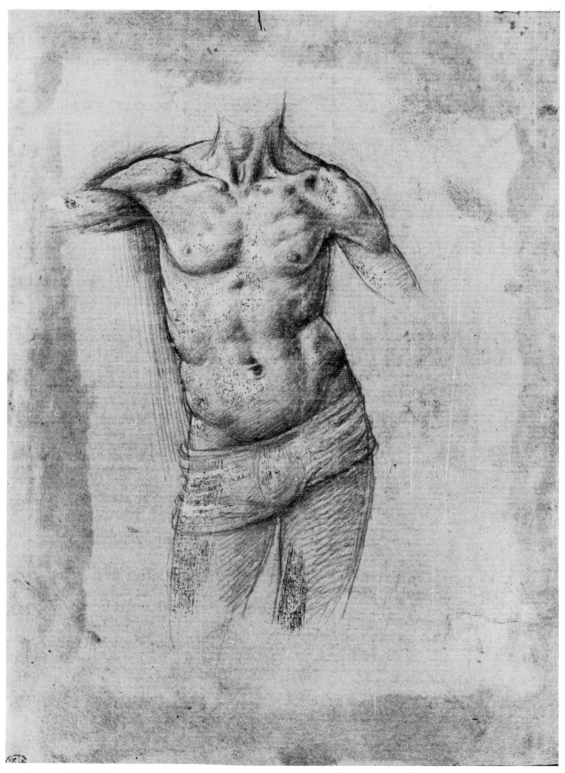

78. Lorenzo di Credi (?), *Nude male torso*. Paris, Louvre, 2677. Silverpoint, with white heightening, on rose-red prepared paper; 20.0 × 14.5 cm.

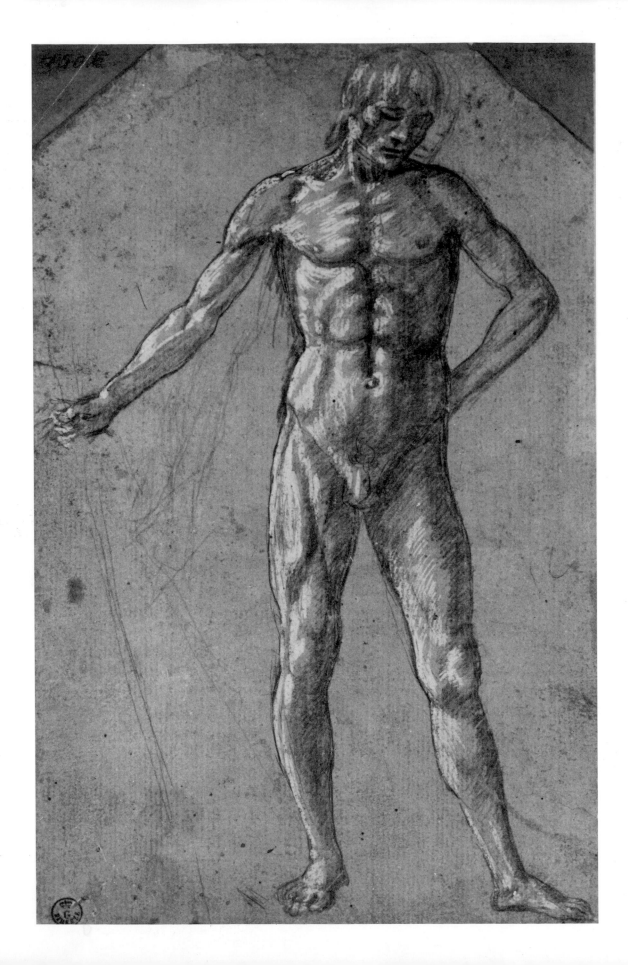

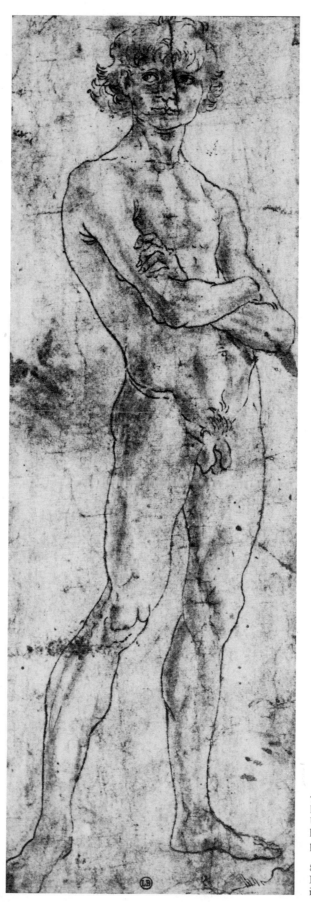

79. (facing page) Workshop of Filippino Lippi (?), *Male nude*. Florence, Uffizi, 150E. Silverpoint, with white heightening, on silver-grey prepared paper; 25.2 × 15.7 cm.

80. Antonio Pollaiuolo, *Nude youth*. Bayonne, Musée Bonnat, 1269. Pen and ink on paper; 26.8 × 8.8 cm.

SCULPTURAL DRAWING

As observed in Chapter I, the inscription on the sheet showing a *Nude man seen from the front, side and back* (81) is an early tribute to Pollaiuolo's accomplishment in rendering anatomical structure by means of the pen line. Indeed, his skill in suggesting volume by linear means is emphasised when this drawing is compared with a workshop copy (82) which shows the inferiority of Pollaiuolo's apprentice in his grasp of how line can be used to generate form. The assistant's lines lack the incisive energy and range of thickness of Pollaiuolo's masterly exemplar, by which anatomical structure is powerfully and convincingly implied.

Perhaps more important, however, is the artistic principle here explored by Pollaiuolo. He viewed his model three-dimensionally, drawing from three angles as though sketching the form on three faces of a block of marble before carving. Or rather, since Pollaiuolo was essentially a bronze sculptor, he moved round the figure as though modelling in wax, building up the volumes to produce a form credible from any point of view. From the mid-fifteenth century onwards, bronze sculpture was more and more frequently intended to be seen not frontally, imprisoned in a niche, but freely from all sides. This set new compositional problems for the figure sculptor, nowhere better

81. Antonio Pollaiuolo, *Nude man seen from front, side and back*. Paris, Louvre, 1486. Pen and ink on paper; 26.4 × 35.1 cm.

solved than in Pollaiuolo's small bronzes. Pollaiuolo used his drawings to explore the same problems: he observed the nude figure from three angles to examine its muscular structure, rounding out his transcription of the form as though in preparation for modelling. The three studies on this sheet can loosely be compared with three views of a small bronze. An interesting contrast is provided by an early quattrocento North Italian drawing (83) which shows three views of a draped figure sculpture. The emphasis here is on superficial textures: the rhythms of the drapery folds are carefully imitated but the draughtsman lacked the concern with anatomy which Pollaiuolo showed in his deep, sculptural sensitivity for three-dimensional form. A remarkable parallel to Pollaiuolo's triple-view is a sheet of studies by Mantegna, in which he observed a recumbent figure from three foreshortened angles when formulating an Entombment composition (84).

Pollaiuolo's study may be termed a 'sculptural' drawing, based as it is on a sculptor's observation of the nude figure. His handling of the pen and his way of using the model show a preoccupation with capturing the inherent energy and rhythms of human form which runs throughout his work, from drawings (80, colour plate V) through engravings to small bronzes. The earliest drawings which show this approach to the perception of dynamic form are Pisanello's rapid sketches of a monkey (51). These sketches are free and vibrant with life: Pisanello followed the animal's movements as in a series of

82. Workshop of Pollaiuolo, *Nude man seen from front, side and back*. London, British Museum, 1885–5–9–1614. Pen and ink on yellow parchment; 25.5 × 28.1 cm

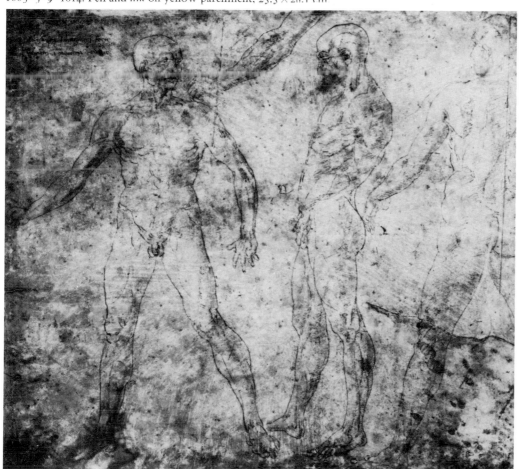

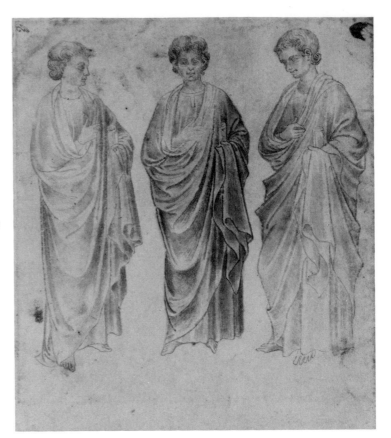

83. Veronese draughtsman, ca. 1400 (?), *Three studies of a male figure*. Oxford, Christ Church, JBS 686. Pen and ink, with wash, on paper; 20.0 × 17.4 cm.

84. (centre) Andrea Mantegna, *Three studies for an Entombment*. London, British Museum, 1909–4–6–3. Pen and ink on paper; 12.2 × 8.9 cm.

85. (far right) Lorenzo Ghiberti, *Studies for a Flagellation*. Vienna, Albertina, inv. 24.409. Pen and ink on paper; 21.6 × 16.6 cm.

cinematographic frames, seeking to encapsulate its innate energy on paper. In relief rather than in the round, these sketches are relatively unsophisticated, since Pisanello worked from one side only rather than right round his model, noting different movements and poses, as Florentine draughtsmen did later. None the less, Pisanello's tracking of the movements of the monkey, that most fluently mobile of beasts, contrasts keenly with the regal poise of the peacock. Many of Pisanello's later drawings show this new, free use of the pen in sketching directly from the live model in motion. It may be no coincidence that at just the same time he re-introduced the craft of the cast medal into Italy. It is as though working in wax stimulated his artistic thoughts towards new ways of investigating three-dimensional form through drawing.

Drawings such as these by Pollaiuolo and Pisanello may be called 'sculptural', but they were not of course necessarily made for sculpture. Indeed, very few drawings can be attributed to early quattrocento sculptors, and very few at any time during the century can be associated directly with sculptural works. Contract drawings like the two sheets by Jacopo della Quercia for the Fonte Gaia in Siena (116–17) show merely that sculptors, like painters, were sometimes required to submit fully detailed drawings for contractual purposes. Many drawings by relatively minor painters like Parri Spinelli survive, but only one working drawing generally accepted as by Ghiberti survives, and by Donatello only a handful of uncertain attribution. Ghiberti's series of vibrating, lively sketches (85) may rightly be associated with the *Flagellation* on his first set of bronze doors for the Florentine Baptistery: the repeated and rapid observation of the powerful swinging

movements of his model suggests the same interests as Pisanello as he in turn sketched the twists and turns of his monkey (51). And, if the sources can be believed, Donatello's drawings were equally rapid, spontaneous and bold.[8]

More drawings can probably be linked directly with later quattrocento sculptural projects, but there are still very few in comparison with the quantity made in preparation for painting by Filippino Lippi or Ghirlandaio, for example. Outside Florence, drawings which can be connected specifically with the work of sculptors are very rare indeed. Preparatory work for sculpture, at least from the middle of the century, normally took the form of *bozzetti*, sketches in wax or clay. *Bozzetti* from Verrocchio's workshop are plentiful. That for the Forteguerri Monument in Pistoia (now in the Victoria and Albert Museum, London) shows that they were sometimes used for contractual purposes, perhaps in preference to a drawing on paper: the documents for Luca della Robbia's reliefs for the 1439 Altar of St. Paul for the Duomo in Florence required him to work from a wax model by Donatello.[9] Studies in three dimensions were also essential, however, for compositional preparatory work in relief carving, and in studying figure poses for transfer to a block of marble. Furthermore, there is a directness of transfer from wax to cast bronze which made the *bozzetto* the obvious form for the bronze sculptor's preparatory work.

Conversely, experimental drawing has only limited value for the artist working in three dimensions. Many quattrocento drawings through which the artist seeks ways of representing form and movement convincingly, however, may be called 'sculptural'.

The draughtsman is not concerned with showing the relief of form by studying the flow of light across the plastic muscular surface, an effect analogous to the aims of the painter achieved by refined hatching in areas of shadow and highlight. In sculptural studies the draughtsman constructs a fully physical structure by following the three-dimensional form with a sweep of the pen which rapidly but clearly builds forms in space, and describes by implication the movements and inner rhythms of the figure.

Two sheets by Verrocchio demonstrate these different values in drawing. In the *Head of a woman* (colour plate VI) much of his effort went into building up the relief of the surface by tonal means. Delicate modelling in black chalk is the most appropriate technique for describing the gentle fall of light over the sculpturally conceived head and neck. The conscientiously rendered tone values can be directly transcribed into the underpainting on the panel. A sheet of studies of a *Child* (86–7) suggests, in contrast, Verrocchio's desire to capture a dynamic subject. The spontaneous pen line builds form by implication, perhaps following the equally spontaneous movements of a model, perhaps inventing freely and experimentally from the visual imagination. The way that Verrocchio made a series of studies of the same form in different positions, speedily turning the page to find new spaces to draw in, is a more flexible version of Pisanello's (51) or Ghiberti's (85) sketching. As informal in the use of the sheet as was the Botticelli workshop assistant (75–6), in his handling Verrocchio was much faster and more immediate. By swinging his pen as though it were carving the child's shape out of the surrounding space, Verrocchio sought to demonstrate on paper the structure and articulation of the baby's form, and the tensions and rhythms of its movements.

Tempting though it is, it would be limiting to associate the free, rapid handling of the pen by Pollaiuolo, Verrocchio and others solely with the movement of the modeller's fingers round his wax *bozzetto* as he moulds the forms. The loose, experimental sketch is a natural catalyst to the creative thought process of both painter and sculptor, and was so used by Pollaiuolo, Leonardo da Vinci and Mantegna (amongst many others) in the preparation of paintings. None the less, statistical evidence does suggest some division in the technical practice of later quattrocento Florentine draughtsmen. In the workshops of painters such as Filippino Lippi and Botticelli, figure studies from the model were generally made in silverpoint, the technique also used by the painter Lorenzo di Credi in Verrocchio's workshop. On the other hand, artists like Verrocchio and Pollaiuolo who were trained primarily as sculptors or goldsmiths used, for the most part, pen and ink.

Filippino Lippi's workshop silverpoint drawings follow Florentine technical tradition in using the more laborious technique perhaps deliberately in order to simulate the problems facing the panel painter. It is rare to find the sculptor considering these issues through drawing, since so much of the preliminary work on sculpture was normally done in the form of *bozzetti*. Leonardo da Vinci's silverpoint investigations of the horse (88), to be reproduced in the clay model for the Sforza Monument, seem therefore to be paradoxical. They can be seen, however, to represent the painter Leonardo's deep concern with the plastic surface of the horse's flesh stretched over the underlying form to reveal the tensed musculature. Leonardo was also the principal beneficiary of the type of sculptural drawing developed in Verrocchio's workshop. Whereas Francesco di Simone's sketch-book studies often have a rather wooden quality (62–3), Leonardo's

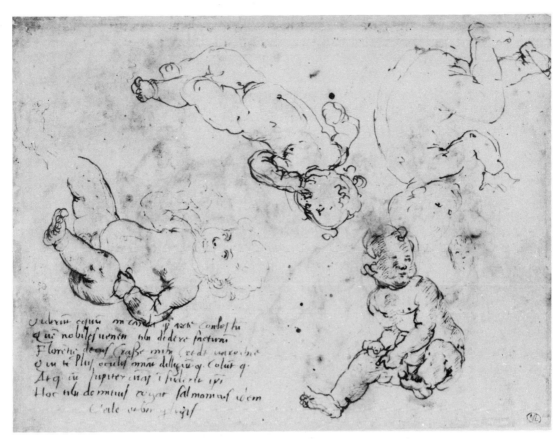

86. Andrea del Verrocchio, *Studies of a child*. Paris, Louvre, 2.R.F. recto. Pen and ink on paper; 14.5 × 20.0 cm.

87. Andrea del Verrocchio, *Studies of a child*. Paris, Louvre, 2.R.F. verso. Pen and ink on paper; 14.5 × 20.0 cm.

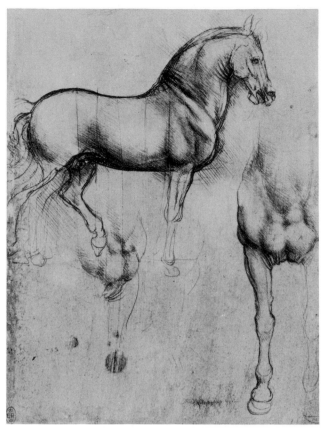

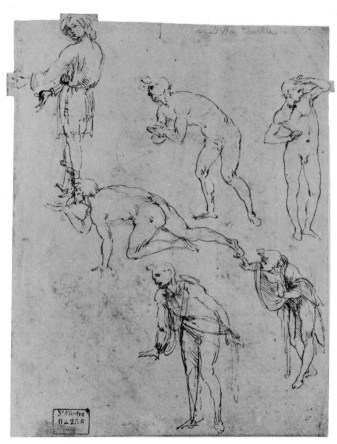

88. Leonardo da Vinci, *Studies of a horse, for the Sforza Monument.* Windsor, Royal Library, 12321. Silverpoint, with white heightening, on blue prepared paper; 21.4 × 16.0 cm.

89. Leonardo da Vinci, *Sheet of figure studies.* Paris, Louvre, 2258 verso. Pen and ink, over metalpoint outlines, on paper; 27.8 × 20.8 cm.

early pen studies are of breathtaking speed and brevity. A sheet of figure studies (89), perhaps early ideas for the 1481 *Adoration*, captures the momentary poses or fleeting gestures of the model with a miraculous, instinctive control of the pen: the handling here closely reflects Leonardo's advice, quoted in Chapter IV, about sketching briefly the movements of man. Leonardo sensed and conveyed the forms with a vivid, fluent line and a few slight touches of hatching. Through the convincingly implied three-dimensional quality of his figures he communicated their expressions and emotions with an unmatched immediacy. These sketches have a simple directness which make Pollaiuolo's drawings seem almost studied in their virtuosity (80). Leonardo's free graphic handling sets the stage for his more complex investigations of figure-grouping, which will be considered later in this chapter.

FIGURE-DRAWING OUTSIDE FLORENCE

Reflections of the new, vigorous pen drawing of mid-quattrocento Florentine draughtsmen blended in North Italy with ripples created by Stefano da Verona's dashing line (41) and by Pisanello's new perceptions and graphic handling (51). The artist most responsive to these possibilities was Andrea Mantegna, who was more concerned than any other

90. Andrea Mantegna, *Christ at the Column.* London, Trustees, Home House Society. Pen and ink on paper; 23.4 × 14.4 cm.

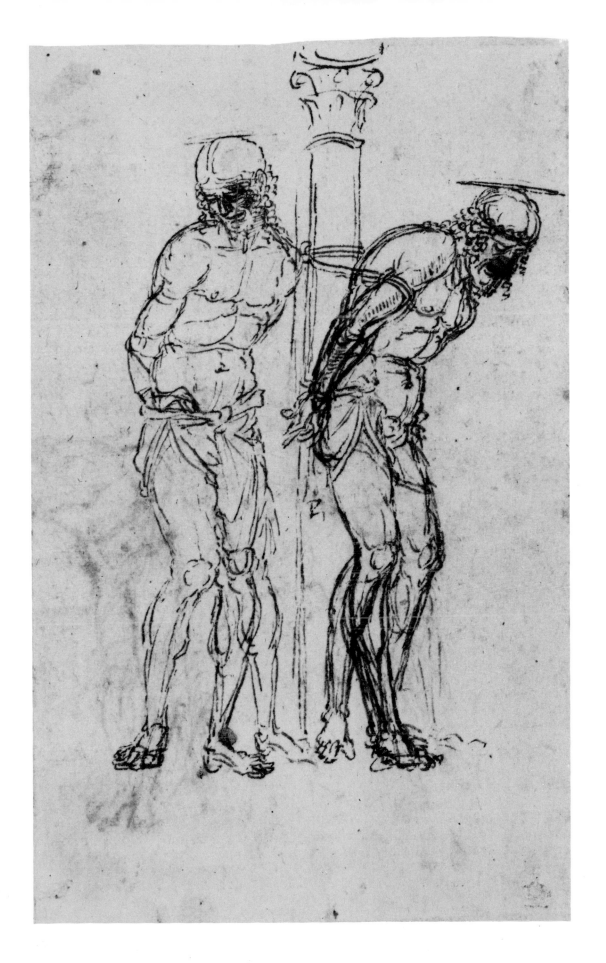

North Italian quattrocento painter with sculptural form and anatomical structure. In his sheet of sketches of *Christ at the Column* (90) Mantegna considered and reconsidered Christ's pose and form using a rapid, angular pen stroke. As in a Pollaiuolo drawing (80) the pen is used with fluent speed, reinforcing lines to increase the sense of contained muscular tension. Changes to the legs show Mantegna thinking directly on the paper, reworking the pose perhaps to reflect the movements of a model, perhaps in response to the working of his visual imagination. Mantegna's energetic but light touch gives great plasticity, showing keenly his ability to imply form through the movement of the line: similar results are produced by the same springy style in the *Entombment* studies (84). His general concern to create sculpturally three-dimensional figures is clear both from his paintings and from Vasari's criticism that his style 'is in fact quite sharp and sometimes suggests stone rather than living flesh'.[10] The development of a free graphic style, perhaps affected by Pollaiuolo's dynamic line, was a further stimulus to his experimental drawing of anatomical form. Neither here, however, nor in any other North Italian nude study can we find an equivalent to the Florentine study of the nude as a process of developing an awareness of form and structure.

The North Italian painter did not use the nude model in an experimental, self-educational way. Alvise Vivarini's studies of *Hands and arms* (91) were made to be transcribed directly into an altarpiece painted in 1480: they are therefore conscientious, highly finished 'model-book'-type drawings, very different in handling from the Florentine studies of *Arms* (77) which is comparable in technique and date. The dissemination in North Italy of Alberti's theoretical encouragement of study from the nude model was

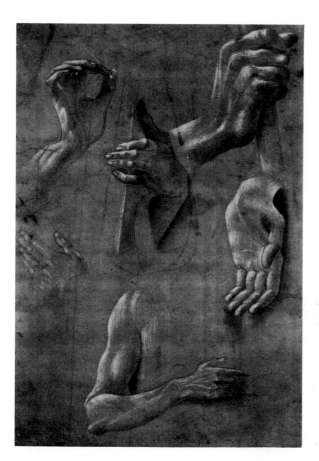

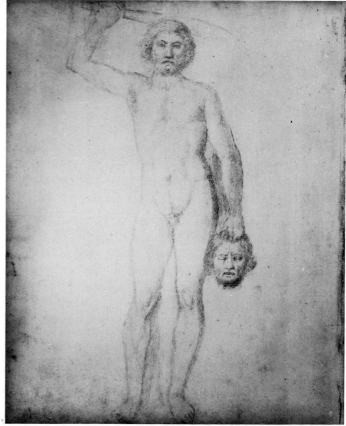

slow and was hindered by the strength of the model-book tradition and the elevated status of the art of drawing. Nude studies are therefore rare in North Italian practice, and occur only when specifically appropriate to the subject under preparation.

An elaborate metalpoint drawing of *David* in Jacopo Bellini's London drawing-book (92) may indicate that the mid-quattrocento Venetian draughtsman did not study from a model any more closely than did the Veronese draughtsman half a century earlier (67). Jacopo seems to have been concerned not with the reality of anatomical form but with an imaginative reconstruction of it, and with a sensitive but inventive response to the surface of forms. Like the nude study in the Paris drawing-book (40), Jacopo Bellini's *David* may have been derived from an antique sculptural source, but if so the source is concealed beneath a textural sensitivity which is more important to the draughtsman than is the examination of form.

Like almost all the drawings in Jacopo's books, the *David* is a finished work. The strong Venetian tradition for finished drawings restricted the draughtsman's opportunities for making free, experimental nude studies on paper. Also fundamental to the Northern tradition is the fact that drawings, if not themselves finished works, were directly related to finished paintings, as is the case with Alvise Vivarini's studies of *Hands and arms* (91). Mantegna, Giovanni Bellini and their contemporaries drew with a completed work as the goal towards which drawing was directed. When Giovanni Bellini used a nude model for a brush drawing (94) it was in preparation for a painting of St. Sebastian, and this affected the pose of the model and Bellini's approach to his drawing. He was not striving for a detached understanding of muscular tension in the

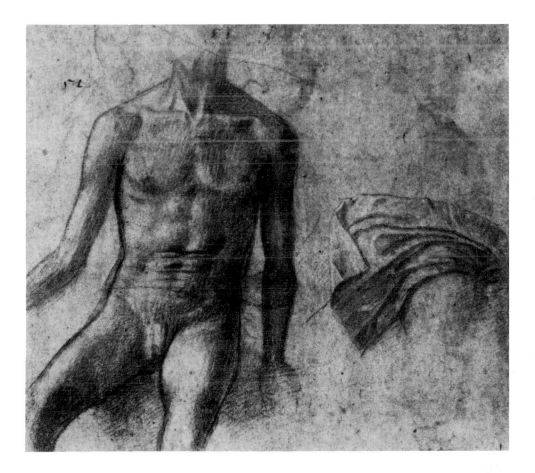

91. (far left) Alvise Vivarini, *Studies of hands and arms*, Paris, Fondation Custodia (Collection F. Lugt) 2226, Institut Néerlandais. Silverpoint, with white heightening, on pink prepared paper; 27.8 × 19.3 cm.

92. (centre) Jacopo Bellini, *David*. London, British Museum, 1855–8–11–60. Leadpoint on (prepared?) paper; 41.5 × 33.6 cm.

93. Vittore Carpaccio, *Study of a seated male nude*. London, British Museum, 1946–7–13–3 verso. Black chalk on green paper; 19.7 × 22.0 cm.

human form, but was laying the foundations for a painting, drawing with brush on paper just as later he would lay paint on the panel, carefully detailing the tone-values and describing the fold patterns of the loincloth. In a drawing which could not be experimental, Bellini inevitably showed none of his Florentine contemporaries' concern with exploring muscular energy, but rather described surfaces in order to facilitate transfer to the panel.

The Venetian tendency to concentrate on the textures of surfaces led to the exploitation of black chalk in as subtle a manner as was to be found anywhere in Italy before the early cinquecento. In Bellini's use of chalk for finished portrait drawings (4) there seems to be an almost sensuous feeling for the ripple of soft light over the plastic surface of the face, defining contrasting textures with an immaculate smoothness of handling. Carpaccio's handling of chalk in an exceptional study of a *Seated male nude* (93) reflects the technique in workshop *simile* drawings of brushing on the pigment in vertical stripes (30, 66). None the less he exploited the textural softness inherent to delicately handled black chalk to achieve a result more appropriate to the Pietà theme than a study with the brush could have been. Anatomically, however, the study is lax: an understanding of muscular structure was evidently not Carpaccio's concern. He was interested almost entirely in the characterisation of the flaccid surface of Christ's dead flesh, and he read this quality into his nude model as he drew. The limited, light tonal range and the way that the strokes of the chalk caress the surface, cutting across the rather schematic indication of underlying forms, again show that Carpaccio's interpretation of his model was directly guided by the drawing's role in preparation for a painting.

The small group of late quattrocento chalk drawings produced in Venetian workshops indicates a growing interest in tonal drawing. Probably through contact with North Italian contemporaries, Leonardo da Vinci was awakened to the possibilities of chalk: like those produced in the Bellini circle, his early chalk drawings were of heads. His handling of chalk in the drawings for the *Last Supper* (174, colour plate VII) suggests the approach of a powerfully exploratory mind to the scope of the new technique. He seems not to have realised the potential of chalk for the examination and rendering of nude form, however, until after his return to Florence from North Italy at the turn of the century. Just at that time Luca Signorelli, working in centres remote from strong, restrictive artistic traditions, began to exploit these possibilities. Most of his surviving drawings are studies in black chalk from the nude model, with red chalk added sometimes to heighten anatomical or expressive nuances. In a drawing of a *Nude man seen from behind* (95) Signorelli exploited the speed and immediacy with which black chalk could be used to generate energetic forms. The outline has almost the tension achieved by Pollaiuolo's pen, and the musculature is vigorously rendered with a full tonal range to create an anatomical structure which convincingly reinforces the dynamic movements of pose and contour. Of unprecedented confidence in the free representation of nude form in movement, Signorelli's chalk drawings bring together the various approaches to the investigation of the human form through drawing developed in Central Italian workshops in the fifteenth century. They formed the foundation for further investigation of anatomical structure for which, early in the first decade of the sixteenth century, Leonardo da Vinci and Michelangelo realised that the use of chalk was indispensable.

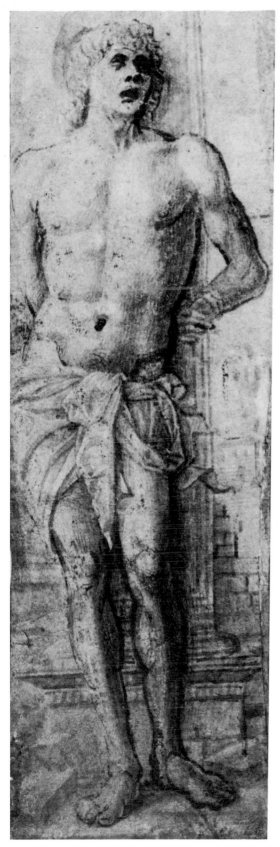

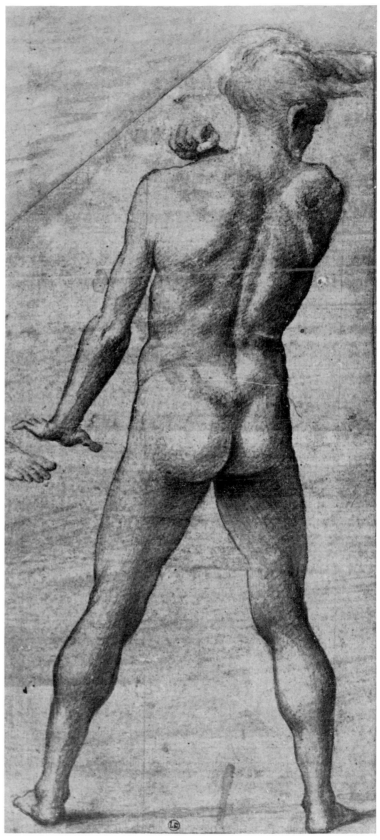

94. Giovanni Bellini, *St. Sebastian*. London, British Museum, 1895–9–15–800. Brush and wash, with white heightening, on pink-tinted paper; 18.6 × 5.8 cm.

95. Luca Signorelli, *Nude man seen from behind*. Bayonne, Musée Bonnat, 148. Black chalk and coloured wash on paper; 37.0 × 12.0 cm.

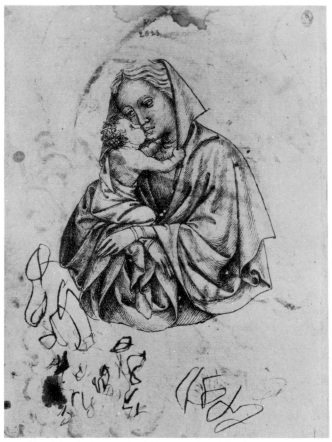

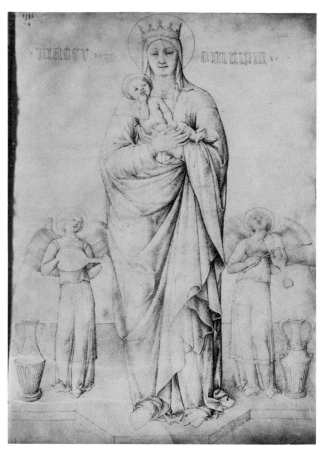

96. Pisanello, *Madonna and Child*. Paris, Louvre, Vallardi 2623 verso. Pen and ink on reddened paper; 26.4 × 19.0 cm.

97. Jacopo Bellini, *Madonna and Child*. Paris, Louvre, 1536. Silverpoint on prepared parchment, reinforced with pen and ink; 42.7 × 29.0 cm.

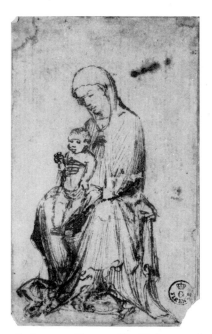

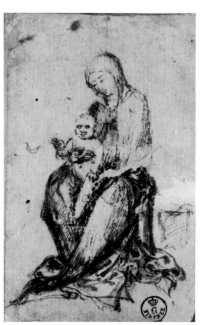

98. Lorenzo Monaco (?), *Madonna and Child*. Florence, Uffizi, 179E. Pen and ink on paper; 10.5 × 6.5 cm.

99. Lorenzo Monaco (?), *Madonna and Child*. Florence, Uffizi, 180E. Pen and ink on paper; 10.4 × 6.3 cm.

100. Stefano da Verona, *Madonna and Child (?)*. Florence, Uffizi, 1102E verso. Pen and ink on paper; 16.7 × 13.4 cm.

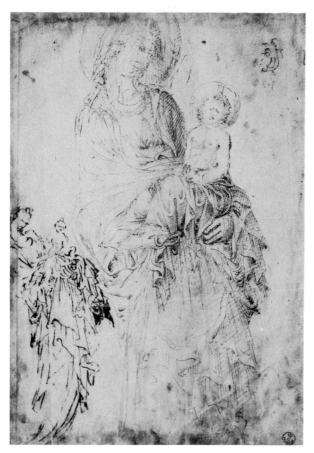

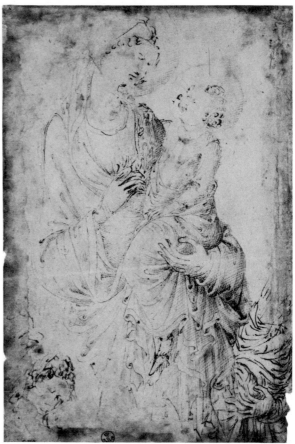

101. Parri Spinelli, *Studies of the Madonna and Child*. Florence, Uffizi, 38E recto. Pen and ink on paper; 28.9 × 19.6 cm.

102. Parri Spinelli, *Studies of the Madonna and Child*. Florence, Uffizi, 33E recto. Pen and ink on paper; 28.2 × 18.1 cm.

FIGURE GROUPS

The Renaissance draughtsman's study of volumetric form became more complicated when he had to deal with groups, and with the interrelationship between two or more figures. The challenge was how best to exploit available techniques to transpose a close yet informal physical relationship, observed from the model, onto the two-dimensional surface. The draughtsman had essentially to train his sensibilities in the perception of interrelated volumes set in space. The Madonna and Child group was represented more often in quattrocento painting and sculpture than any other, and furthermore demanded more and more from the artist in terms of conveying an emotional relationship between the figures. Artists' explorations of the problem of figure-grouping may therefore be followed by considering the ways that this subject was tackled, with occasional reference to other standard figure groups, such as the Pietà, which presented a similar challenge.

The general pattern of the preoccupation with figure-grouping is similar to that for nude study, but some other interesting considerations arise which make it worth tracing separately. Early in the century 'model-book'-type drawings of the Madonna and Child such as Pisanello's (96) present a straightforward solution: indeed, no problem yet existed for Pisanello. His figures are set onto the paper as a pattern of curving drapery folds and

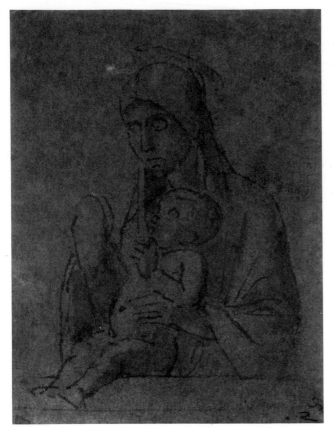

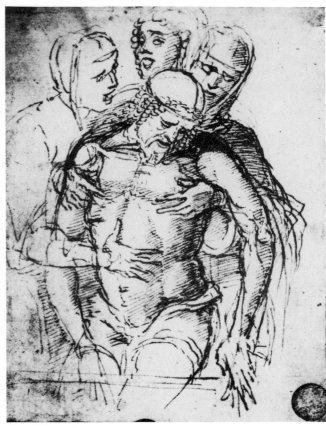

103. Giovanni Bellini, *Madonna and Child*. London, British Museum, 5227–101. Pen and ink, with wash, on blue paper; 12.8 × 9.6 cm.

104. Andrea Mantegna, *Pietà*. Venice, Accademia, 47A. Pen and ink on paper; 12.9 × 9.8 cm.

two-dimensional curvilinear forms, with some slight relief developed by the fine modelling; but there is no sense of psychological contact between the figures. Jacopo Bellini too produced a version (97) which has an icon-like frontality and fully hatched but essentially low-relief forms, perhaps demanded both by the subject and by the formal character of the drawing. Early in the century, however, a Florentine draughtsman, perhaps Lorenzo Monaco, began to consider the possibilities of drawing on paper for exploring this sort of compositional problem (98–9). On two minute sheets he experimented with the figure-grouping, slightly changing the child's position perhaps in order to compare two versions before deciding which to use. There may already have been a regional difference early in the quattrocento between finished model-book drawings and leanings towards exploratory sketching.

Further investigation of figure-grouping came from the two first draughtsmen by whom substantial numbers of experimental drawings survive. On several sheets Stefano da Verona explored the grouping of two or three figures (100), but his brusque, angular style tended to discourage close rapport, either physical or emotional, between mother and child. Parri Spinelli's variants on the Madonna and Child theme are more interesting, for he anticipates the creative handling of later Tuscan draughtsmen. Two sheets from his sketch-book show detailed drawings of the *Madonna and Child* (101–2) with subsidiary notations of other thoughts or solutions added in the lower corners, scanty reworkings of the drapery patterns which have the irrational elongation typical of Parri's style.

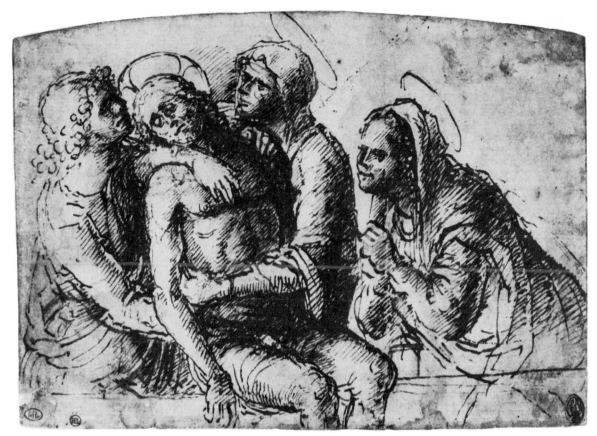

105. Giovanni Bellini, *Pietà*. Paris, Louvre, 436. Pen and ink on paper; 13.1 × 18.1 cm.

Continuously stimulated by the most recent sketch to reformulate the idea, Parri placed the sketches on the page in a manner which suggests that the image evolved spontaneously in his mind as he thought through variations directly on paper.

In drawings from the circles of Mantegna and Giovanni Bellini as well, an experimental approach to the construction of a group can be sensed in the handling of the pen.[11] In a Bellini *Madonna and Child* (103) an incisive pen line briefly builds convincing forms, rapidly sensing the volumes and the physical closeness of the child to his mother. In drawings for the *Pietà*, both Mantegna (104) and Bellini (105) felt their way round the group, correcting themselves as their perceptions focused and the idea developed. Certain parts of Mantegna's drawing were more heavily worked than others as he struggled towards the ideal solution; elsewhere alternatives were jotted down for further consideration at the next stage of work on the group.

The experimental practice of the Mantegna circle is best shown in the drawings of Marco Zoppo. Several sheets of studies of the *Madonna and Child* (106) show Zoppo's rather formal way of laying out alternative interpretations of the relationship between the figures. Hints of background architecture or accessories show that he was thinking towards finished paintings by collecting together a series of records, but the drawings are interrelated in the exploration of the physical and expressive contact of mother and child. One sketch follows from another in a carefully pondered sequence of inventions to form almost a 'model-book' of the image. In contrast, a Florentine contemporary of Zoppo's

119

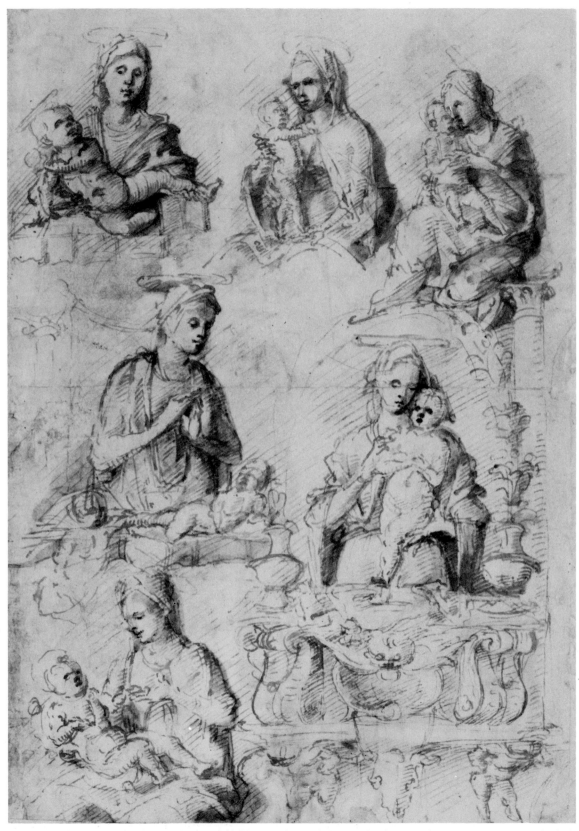

106. Marco Zoppo, *Studies of the Madonna and Child*. Munich, Staatliche Graphische Sammlung, 2802 recto. Pen and ink, with light grey wash, on paper; 28.8 × 19.6 cm.

107. (right) Raffaellino del Garbo (?), *Studies of the Madonna and Child*. London, British Museum, 1946–7–13–4 verso. Pen and ink, with light wash, on paper; 15.7 × 24.6 cm.

(perhaps Raffaellino del Garbo) drew a series of informally tender images (107), using a similar technique and handling, in an evolving exploration of the emotional scope of the group.

This kind of experimental striving towards a happy solution to the problem of capturing an expressive contact between mother and child characterises many drawings produced from about 1470 in Verrocchio's workshop. Early quattrocento experiments were probably products of the imagination, but as in nude study later draughtsmen often worked from posed models. The need for speed in following the constant changes in the child's position and in his contact with his mother gave these sketches a new liveliness and immediacy. This in turn stimulated imaginative, creative exploration, found at its highest pitch in Leonardo da Vinci's early studies. Drawings recording a momentary pose or a stage in a rapidly developing line of thought were generally in pen and ink which had the greatest flexibility and exploratory potential. Charcoal or chalk may have been used more often for this type of drawing than now appears, for few are extant. In one survivor (108), which may exemplify a whole genre, the draughtsman exploited the swift movement of black chalk to note successive poses of the figures. The overlapping images which suggest the dynamic interplay of the group are reminiscent of the repeated contour in Mantegna's pen-and-ink figure sketches (90). This repetition was perhaps the springboard for Leonardo's way of allowing each image, crystallised under the rapid movement of his pen, to stimulate the next in a constant flow of ideas recorded one on top of another.

Verrocchio's studies of a *Child* (86–7) show him seeking to understand and record the form's sculptural plasticity and rhythmic vitality on paper. This practice was developed by Leonardo in rapid sketches of the model in action: sheets like the studies for a *Madonna and Child with a Cat* (109) are covered with brief notes of pose and movement. These

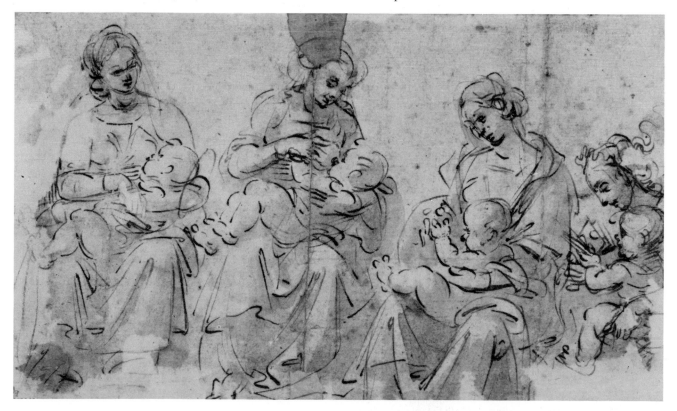

spontaneous jottings of the group's natural rhythms provided a set of dynamic images which fuelled his imagination in the next stage of creative activity. Leonardo himself gives us an insight into the purpose of this experimental method:

> Sketch subjects quickly and do not give the limbs too much finish: indicate their position, which you can then work out at your leisure . . . rough out the arrangement of the limbs of your figures and first attend to the movements appropriate to the mental state of the creatures that make up your picture rather than to the beauty and perfection of their parts.[12]

Leonardo used the drawn line as a creative continuum, to mould the figures with the pen into an emotional unit 'appropriate to [their] mental state' by blending their physical forms. This technique is the antithesis of the perfect, finished study without alterations or erasures to which the model-book draughtsman aspired at the beginning of the century. With his growing concern to convey 'mental states' (or, for Alberti, 'movements of the mind') and the responses between figures, Leonardo constantly explored how to encapsulate directly on paper his figures' mutual expressive and emotional contact.

Thus in the *Madonna and Child with a Cat* (110), Leonardo took off from the sheet of model studies (109), further evolving the figures' relationships from his creative imagination. Responding to the development of the expressive idea in his mind, Leonardo's pen turned and twisted with a dynamic dexterity unknown to his peers in Verrocchio's workshop. Each new twist stimulated the next idea to build up a bewildering complex of

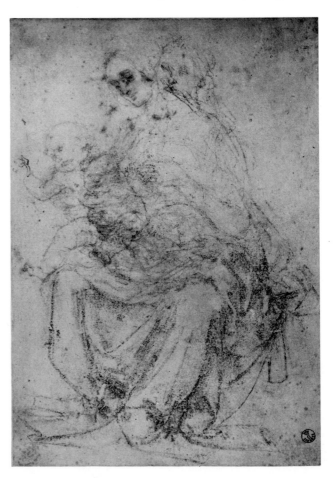

108. Workshop of Verrocchio, *Madonna and Child*. Florence, Uffizi, 444E. Black chalk on paper; 22.5 × 15.5 cm.

109. (centre) Leonardo da Vinci, *Studies for a Madonna and Child with a Cat*. London, British Museum, 1860–6–16–98 recto. Pen and ink on paper; 28.1 × 19.9 cm.

110. (far right) Leonardo da Vinci, *Madonna and Child with a Cat*. London, British Museum, 1856–6–21–1 verso. Pen and ink on paper; 13.2 × 9.6 cm.

superimposed images. But as he himself wrote, 'the mind of the painter . . . is stimulated to new inventions by obscure things';[13] and so out of this whirl of lines he could eventually reformulate those which most satisfactorily crystallised the idea towards which his vigorous imagination led him. Gombrich has written that Leonardo 'works like a sculptor modelling in clay who never accepts any form as final but goes on creating, even at the risk of obscuring his original intentions'.[14] The result is a mass of repeated lines and re-emphasised forms, intelligible to Leonardo alone. With his extraordinary ability to conceive sculpturally, and to transpose his conception onto paper with a swift, form-developing pen line, Leonardo was able to follow through his creative idea with an unprecedentedly direct contact between idea and image.

Leonardo had the creative imagination to appreciate and to exploit the possibilities of this kind of compositional experiment more fully than any of his contemporaries. His intuitive feeling for form was, however, crucially quickened by Verrocchio's development of the use of pen and chalk to define sculpturally the structures and movements of the human figure. In his rapid pen drawings, Leonardo applied his sculptural sense of the forms, volumes and voids of the Madonna and Child group to his effort to capture an ideally harmonious emotional contact between the figures. Although Leonardo used this revolutionary handling of drawing in the imaginative evolution of his late quattrocento pictorial compositions, it was not until the early cinquecento that the full significance of the technique was grasped and exploited by other draughtsmen in the pursuit of High Renaissance ideals of pictorial composition and expression.

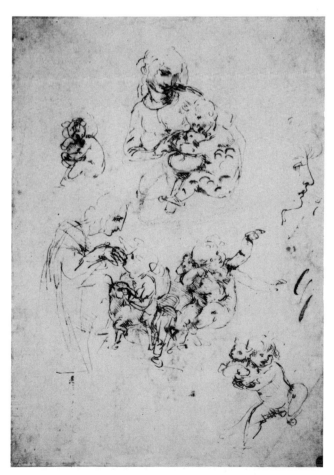
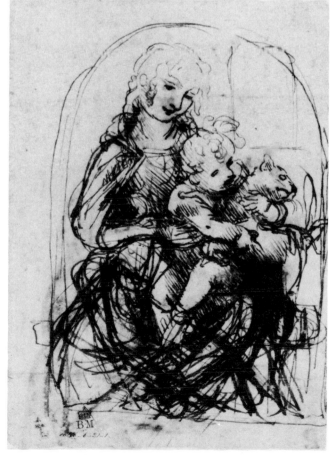

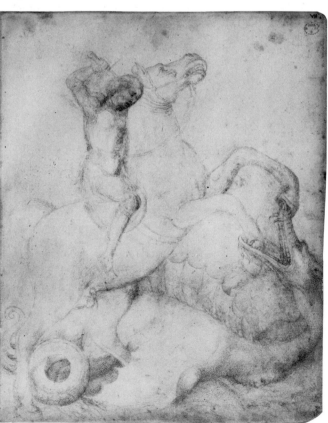

CHAPTER VI

Compositional Drawings

COMPOSITIONAL DRAWINGS IN DRAWING-BOOKS

MANY drawings were made in preparation for compositions to be executed in other mediums, normally painting. These fall into two broad categories: those made with the patron's approval specifically in mind, which are therefore clearly finished and readable 'contract' drawings, and those which map out stages in the evolution of a compositional idea. Other compositional drawings were themselves considered by the draughtsmen to be completed works of art. The strong tradition of such drawings in North Italy is shown by Mantegna's *Judith* (2), and by Jacopo Bellini's books of drawings which are the sole surviving examples of what was probably standard workshop property. As we have seen, most of the drawings in Jacopo Bellini's books are compositional drawings, produced by Jacopo for his own interest and self-conscious concern with his abilities. They form the largest group of compositional drawings by any quattrocento artist, a record to be inherited by later generations of the family workshop and to establish an artistic tradition in compositional design which might be perpetuated by inheritance. This attitude was probably especially characteristic of the Venetian workshop which was generally family-based and dependent on the inheritance of styles and techniques over generations. The Central Italian workshop relied less on the family than on the individual: apprenticeship training through copying encouraged a uniform workshop figure style but a heritage of established patterns of compositional design does not seem to have existed.

Central Italian draughtsmen were deeply preoccupied with the study of the human figure, its anatomical structure and movement. Jacopo Bellini, on the other hand, principally explored compositional design, often tackling fresh problems of perspective arrangement and landscape observation in his drawings. Often the narrative scene is worked out on the recto of a sheet, and aspects of setting are added as a lateral extension on the verso of the previous page. In a *Stigmatisation* (113) the figures occupy the right half of the composition while the looping line of a stream at the left leads the eye into a deep, rocky landscape populated with 'model-book' animals to fill the barren space. On a single page, a *Crucifixion* (111) is dominated by the swirling forms of stark rocks which dwarf the myriad of briefly sketched figures grouped around the three crosses. This drawing shows Jacopo's concern with the organisation of compositional masses in the balance of figures and landscape forms, a quality notably lacking in the double-page drawings. Another double-page spread, of *St. George and the Dragon* (112), suggests that

125

111. (top) Jacopo Bellini, *Crucifixion*. Paris, Louvre, 1525 recto. Brush and ink on parchment; 29.0 × 42.7 cm.

112. (bottom) Jacopo Bellini, *St. George and the Dragon*. London, British Museum, 1855–8–11–5 verso and 6 recto. Leadpoint on (prepared?) paper; 41.5 × 67.2 cm.

113. Jacopo Bellini, *Stigmatisation*. Paris, Louvre, 1532 verso–1533 recto. Silverpoint on prepared parchment,

reinforced in pen and ink; 42.7 × 58.0 cm.

Jacopo's preoccupation here was with the exploration of new intellectual interests in perspective in townscape representation, for which the narrative on the right seems no more than an excuse. Drawings like these could clearly not be directly transferred to painting as intelligible compositional designs: the aim was to establish a range of compositional systems from which workshop assistants could extrapolate their painted compositions.

To perpetuate workshop traditions in design and to explore new ideas for later adaptation may in general have been the main purposes of compositional drawings made in bound books. The design for a particular commissioned work did not have a natural place in a volume of sketches in which the artist and his assistants noted down motifs for future reference, or experimented with the rendering of drapery or anatomy. Two compositional drawings made by the Tuscan Parri Spinelli in his now-dismembered sketch-book may have had some purposes in common with Jacopo Bellini's drawings. A *Baptismal scene* (114) and the *Christ and the Adulteress* (57–8) appear to have been developed in the same way as Jacopo's compositions, starting on one side with the narrative and expanding onto the other side of the double page. These drawings look less like exploratory designs than like completed compositions to which no more attention need be given; yet they cannot be contract drawings, which must be on isolated sheets. Although less carefully and minutely finished than Jacopo's, they are more fully worked-up than Parri's copy drawings of Giotto's *Navicella* (115), visual tributes to that famous mosaic which are analogous to Alberti's written praise in *de Pictura*,[1] and demonstrate the same interest shown by the briefer copy in the Gentile da Fabriano workshop *taccuino di viaggi* (44). The inclusion of copies of important compositions and detailed compositional designs in Parri's sketch-book suggests that he used it for a wide range of purposes, although it is unlikely that he shared Jacopo Bellini's intention that his drawings should stand as finished works of art.

CONTRACT DRAWINGS

Compositional drawings do not appear to have been included in later quattrocento sketch-books, for their principal purposes, whether contractual or preparatory, generally required the use of single sheets and not bound pages. In the trecento and early quattrocento, most compositional drawings on paper or parchment were made for contractual purposes, or to gain the approval of the patron. The earliest surviving example of this type is Taddeo Gaddi's *Presentation of the Virgin* (21), which was so finely drawn and so closely followed in the execution of the fresco in Sta. Croce in Florence as to indicate that it was shown to, and approved by, the Baroncelli patrons. Contracts frequently record the existence of some such *disegno* or *modello* on the basis of which the artist was constrained to work. Pitifully seldom do drawings remain attached to contracts, so that general assessments of the character and quality of such drawings cannot be made. One from early in the century which can securely be associated with a contract, however, is Jacopo della Quercia's design for the Fonte Gaia in Siena (116–17). In January 1409 a contract was drawn up requiring Quercia to build the Fonte Gaia

114. Parri Spinelli, *Baptismal scene*. Florence, Uffizi, 8E recto. Pen and ink on paper; 29.1 × 40.8 cm.

115. Parri Spinelli, *Copy of Giotto's Navicella*. Chantilly, Musée Condé, 1 bis. Pen and ink on paper; 25.0 × 39.0 cm.

'according to the form drawn on parchment which is in the notary's possession'.[2] The two fragments of the original parchment contract drawing are immaculately drawn and finely detailed, reminiscent of Vasari's criticism of Jacopo's drawings in his collection 'which rather resemble the work of an illuminator than that of a sculptor'.[3] The decorative detail on the fountain is precisely noted, and the forms and extent of the sculpture are recorded in a fine pen style which intentionally leaves nothing to the imagination. The drawing which survives attached to the contract for the tomb of Cristoforo da Reccanati by the Paduan sculptor Giovanni Minelli in 1483 has exactly the same impersonal exactness and clarity as Quercia's drawing.[4] Like a model-book drawing a contract drawing typically has a highly wrought finish with as much significant detail included as possible. On this basis one may conclude that unusually

117. (above) Jacopo della Quercia, *Contract drawing for the Fonte Gaia*, right side. London, Victoria and Albert Museum, Dyce 181. Pen and ink on parchment; 15.1 × 22.8 cm.

116. (left) Jacopo della Quercia, *Contract drawing for the Fonte Gaia*, left side. New York, Metropolitan Museum, 49.141. Pen and ink on parchment; 20.2 × 21.8 cm.

highly finished drawings like Gentile Bellini's *Procession* (135) or Carpaccio's *St. Augustine in his Study* (137) belong to the contract stage of work on a commissioned painting.

The contract drawing was the approved pattern from which the artist would proceed to his finished work. The patron therefore wanted as much information included on it as possible, so that the artist's freedom to depart from the terms of the contract should be as limited as possible and so that the grounds existed on which legal redress could if necessary be obtained. Ghirlandaio was obliged by his contract to submit a drawing of each scene in the fresco cycle in Sta. Maria Novella in Florence to his patron Giovanni Tornabuoni before the painting of the scene could begin, so that changes or additions could be made.[5] As we shall see later, Tornabuoni took some advantage of this condition. Altarpiece designs often had a similar function, and were produced for the patron's approval before work got under way. This is sometimes indicated by the inclusion of alternative ideas for frame mouldings or other decorative forms, as in the drawing for a *Madonna and Child with Saints* altarpiece by the Ferrarese Boccaccio Boccaccino (118), leaving the final choice of motifs to the patron.

COMPOSITIONAL SKETCHING

There may have been little differentiation, early in the fifteenth century, between contract drawings and compositional sketches in preparation for the final stage of design. Discussing underdrawing for frescoes or for panels, Cennino makes no mention of preparatory designs on other surfaces, to be transferred to the surface to be painted. Indeed, he seems even to suggest that preparatory design work should be done on the final prepared surface: 'When you have finished drawing your figure . . . leave it alone for a few days, going back to it now and then to look it over and improve it wherever it still needs something'.[6] For this process he recommends the use of charcoal 'so that if you are not satisfied with any stroke, you may erase it with the barbs of [a] feather, and draw it over again';[7] and for fresco, 'when the plaster is dry, take the charcoal, and draw and compose according to the scene or figures which you have to do'.[8] In his discussion of drawing techniques there are hints, but no more than hints, that Cennino practised compositional sketching, but he was essentially concerned with figure drawing. Al-

118. Boccaccio Boccaccino, *Design for an altarpiece of the Madonna and Child with Saints*. London, British Museum, 1860–6–16–43. Pen and ink, with wash, on paper; 28.7 × 20.7 cm.

119. Master of the Bambino Vispo (?), *Fragment of a drawing for a Flagellation*. Berlin, Kupferstichkabinett, 5149. Pen and ink, with wash, on paper; 20.5 × 12.0 cm.

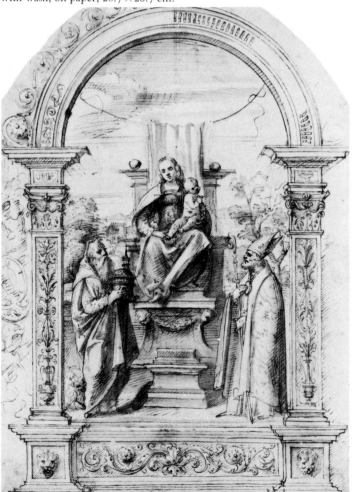

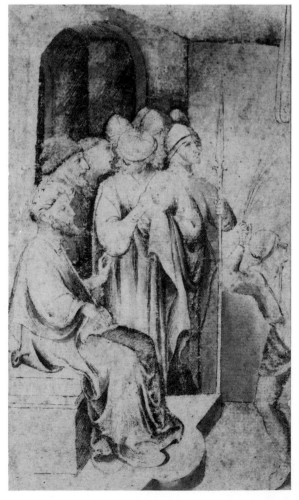

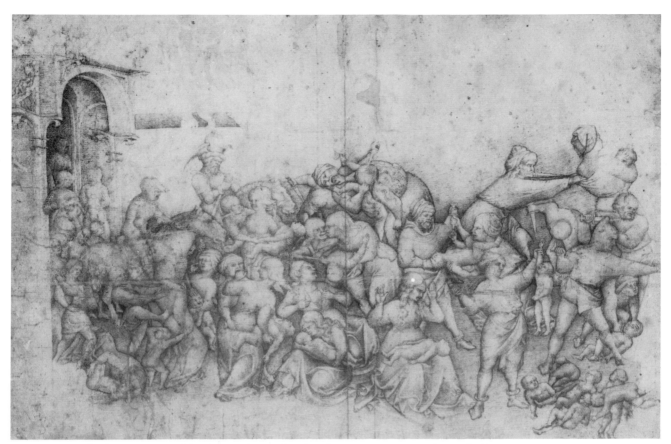

120. Lorenzo Salimbeni, *Massacre of the Innocents*. Oxford, Ashmolean Museum, KP 43. Pen and ink on paper; 28.2 × 43.4 cm.

though a contract drawing like Taddeo Gaddi's (21) must obviously have been used as the small-scale prototype for the painting, the graphic freedom of much *sinopia* drawing agrees with Cennino's outline of traditional preparatory procedure. On the other hand, reusable tablets must surely have been used for compositional sketching as well as for figure drawing, even if Cennino concentrated on the latter in his discussion. For this reason, once again, a general type of compositional sketch probably current as an experimental form early in the century is all but lost: Lorenzo Monaco's *Six Saints* (6) stands once more as an indication of this type of design sketch.

Most surviving compositional drawings of the early part of the century are more finished than Lorenzo Monaco's, because only at the later stages of design would the ideas have been committed to precious paper. Lorenzo Salimbeni's *Massacre of the Innocents* (120) was not completed in all details, which may suggest that it was a working draft for a finished drawing for patronal approval. Yet the work that was done is extremely refined and precise, comparable in handling with Quercia's Fonte Gaia drawing (116–17), as though the draughtsman worked through his composition slowly, building detail upon careful detail in an additive manner. It is perhaps equivalent to carefully finished model-book drawings which were transcribed motif by motif onto the picture surface. Likewise it is not clear whether the *Flagellation* fragment (119), perhaps by the Master of the Bambino Vispo, was the outcome of the draughtsman's early

133

121. Benozzo Gozzoli, *St. Augustine suffering from a Toothache*. Cambridge, Mass., Harvard University, Fogg Art Museum, 1932.123. Pen and ink on paper; 9.6 × 13.1 cm.

122. Benozzo Gozzoli, *St. Ambrose preaching*. Darmstadt, Hessisches Landesmuseum, A.E.1297. Pen and ink on paper; 8.0 × 9.5 cm.

consideration of the composition or was, as on balance seems more likely, submitted to the patron for approval. Hatching and wash are carefully applied within precise, wooden outlines: the drawing has none of the spontaneous freedom of some early quattrocento *sinopie* or of later compositional sketches.

As observed earlier, the need which arose in the middle of the fifteenth century to reconsider traditional formulae led to a growing use of cartoons on paper. In response to similar artistic needs, acceptance of the practice of making exploratory compositional sketches on paper evolved at much the same time. The value of this procedure, realised by early Renaissance artists and theorists, was twofold. Able now to consider and reconsider a series of earlier attempts, the draughtsman could evolve a more satisfactorily unified composition. Furthermore, he could more easily ensure that the figure scale and compositional settings of a number of scenes in a cycle were consistent. Neither of these artistic desiderata was possible for the painter who worked directly on the wall, nor were they easily realised if compositions were evolved on the prepared surfaces of panels or drawing tablets. Perhaps the earliest surviving group of small, quick compositional sketches, experimenting with interdependent designs, was made by Benozzo Gozzoli for his fresco cycle in S. Agostino at San Gimignano. Neither of the two extant sketches (121–2) was precisely used in the final fresco: both were preliminary ideas reworked later. They are light, spontaneous sketches, delightfully fresh in touch, paradigmatic reflections of Alberti's advice that the painter should 'work out the whole "historia" and each of its parts by making sketch models on paper'.[9] This recommendation may have stimulated the change from the use of prepared wooden tablets for such drawings as Benozzo's. Prepared surfaces were laborious to use and totally unsuitable for pen-and-ink drawing, which is the most usual and most appropriate technique for compositional experiment. The advantages of assembling for comparison a group of variations on a compositional theme, with a view to unifying the design or the cycle, was soon realised in full. The new willingness to use paper for this process was a very important development of the artist's awareness of the value of preparatory drawing.

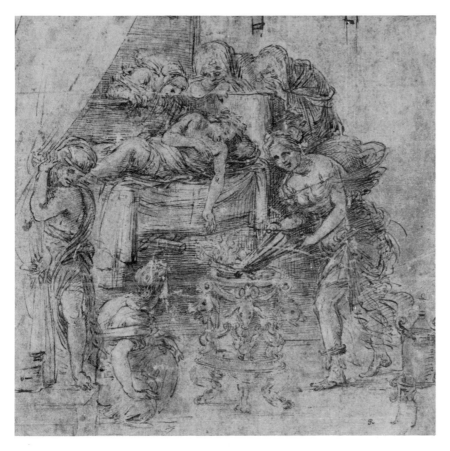

123. Filippino Lippi, *Death of Meleager*. Oxford, Ashmolean Museum, KP 21. Pen and ink, with wash, on paper; 22.6 × 23.0 cm.

124. Filippino Lippi, *Death of Meleager*. London, British Museum, 1946-7-13-6. Pen and ink, with wash and white heightening, on paper; 29.7 × 28.4 cm.

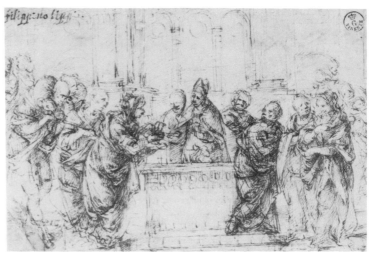

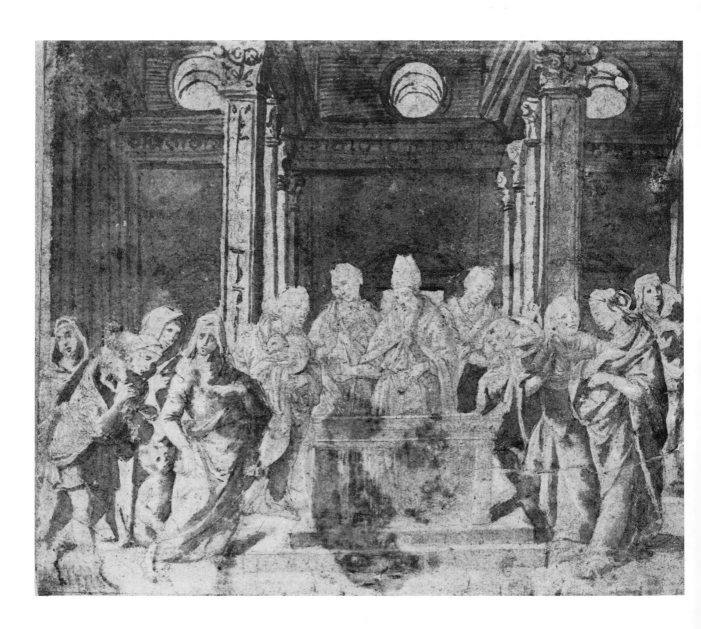

125. (top left) Piero di Cosimo, *Expulsion of Joachim*. Florence, Uffizi, 169E. Pen and ink on paper; 10.0 × 15.5 cm.

126. (top centre) Piero di Cosimo, *Expulsion of Joachim*. Florence, Uffizi, 168E. Pen and ink on paper; 17.0 × 19.0 cm.

127. (bottom) Piero di Cosimo, *Expulsion of Joachim*. Lille, Musée des Beaux-Arts, 269. Brush and ink, with white heightening, on red-tinted paper; 19.4 × 22.9 cm.

128. (left) Leonardo da Vinci, *Maiden with a Unicorn*. Oxford, Ashmolean Museum, KP 15. Pen and ink on paper; 9.5 × 7.5 cm.

These points can be illustrated with examples of Florentine practice later in the fifteenth century. Two drawings for a *Death of Meleager* (123–4) show Filippino Lippi experimentally trying out different compositional arrangements for the figure group of an unusual subject, for which no standard design could be adapted. In one (123) the pen was predominantly used to establish the balance of the composition and the dramatic movements of the figures; in the other (124) wash was extensively added as Filippino investigated both the spatial relationships between the figures and the narrative emphases. These two sketches could later have been blended in the production of a more formal drawing like his *Triumph of St. Thomas Aquinas* (24). Sketching could also be used to study different aspects of a more-or-less fixed pictorial design, as shown by a series of three drawings of the *Expulsion of Joachim* by Piero di Cosimo (125–7). The first (125) is an exploratory design for the main figure group in which Piero di Cosimo moved his pen boldly around the forms, concentrating his attention on the crucial narrative movements of acceptance and rejection at the altar. In the second (126) he was more concerned with the context of the event and the relationships in scale between figures and setting, although he again worked hard to build the forms of the main figures with thick, repetitive hatching. He was preoccupied in the third drawing with the tonal range and contrast of the group and the setting: here he used the brush vigorously, laying on bold shadows and highlights to produce the effect of a grisaille painting in his close examination of the fall of light. This drawing is reminiscent of the precocious freedom of Filippo Lippi's brush drawing for *St. Stephen exorcising a Demon* (29), and may well have been used as a general guide for the underpainting of a panel.

None of these examples can match the flexible immediacy of Leonardo da Vinci's early ideas for a pictorial composition. In the little sketch for a *Maiden with a Unicorn* (128) he jotted down his thoughts with a characteristically lively pen in a confident, intuitively balanced sketch which delicately vibrates with life. As with his exploration of the *Madonna and Child with a Cat* group (110), Leonardo was able in compositional sketches to record ideas more freely and speedily than any other quattrocento draughtsman, and could work smoothly and lucidly towards an ideal solution for each compositional problem.

137

THE EVOLUTION OF A PICTORIAL DESIGN

North Italy

The more frequent use of paper for drawing in the last twenty or so years of the fifteenth century and the increasing number of drawings which survive allow us to trace the evolution of pictorial compositions in the work of several painters. Not only compositional drawings but also figure studies can be brought into such reconstructions of working method. In the drawings of Pisanello, Gentile Bellini, Carpaccio, Leonardo da Vinci and especially Domenico Ghirlandaio, the genesis and development of a composition can, with varying degrees of precision, be reconstructed through all stages from preliminary idea to contract drawing.

Even before Benozzo Gozzoli's experiments in compositional sketching on paper (121–2), Pisanello had been noting compositional ideas on paper with vigour and originality. On one side of a sketch-book sheet (129), a bewildering range of rapidly sketched thoughts for different compositions fills every spare inch of the paper. At the top are several suggestions for an Annunciation (sometimes associated with the fresco in S. Fermo, Verona), and at the bottom right-hand corner is a very brief sketch for a Crucifixion. The main sketch for a Madonna and Child with Saints altarpiece, worked

129. Pisanello, *Sheet of sketches*. Paris, Louvre, Vallardi 2631. Pen and ink on red-tinted paper; 25.3 × 37.7 cm.

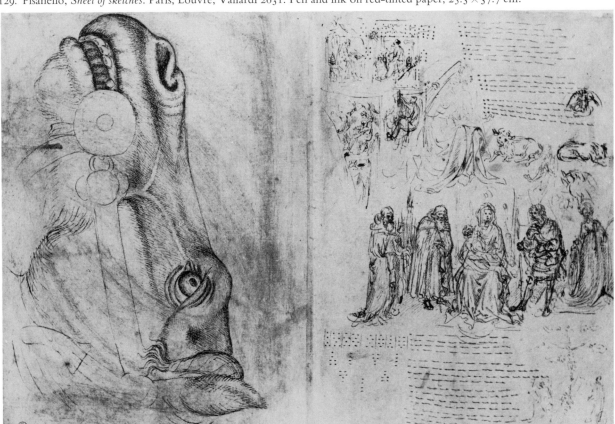

up in more detail than the others on the sheet, is an idea from which the London *Madonna and Child with SS. Anthony Abbot and George* may have evolved, after the incorporation of an alternative treatment of the Madonna and Child group shown in another drawing (96). No group of drawings survives, however, to show clearly Pisanello's procedure in compositional preparation, and his regular use and adaptation of model-book motifs is a further complicating issue.

Another intriguing experiment in Pisanello's drawing is his method of developing a general pattern for a composition of figures set within a landscape space. This may be akin to Jacopo Bellini's investigations of the relationship between narrative and landscape setting, but Pisanello's experiments show a more intuitive, less formal approach to the question. Two slight sketches of figures in a landscape (130), one set above the other as alternative, framed explorations of the idea, may have preceded the *Cavalcade* drawing (131) in Pisanello's thought process. The fluency of observation and freedom of handling and recording of landscape forms in these sketches show a mind more perceptive of the broad sweep of natural forms and topography than any before Leonardo's (1), a mind which anticipates the atmospheric landscape studies of Giorgione and Fra Bartolommeo early in the sixteenth century .

Working practice in later quattrocento compositional design becomes clearer. Gentile Bellini's preliminary sketches (132), which may have crystallised later into designs for

130. Pisanello, *Sketches for a landscape composition*. Paris, Louvre, Vallardi 2594 verso. Pen and ink on reddened paper; 24.2 × 17.9 cm.

131. Pisanello, *Cavalcade*. Paris, Louvre, Vallardi 2595. Pen and ink on reddened paper; 25.6 × 19.0 cm.

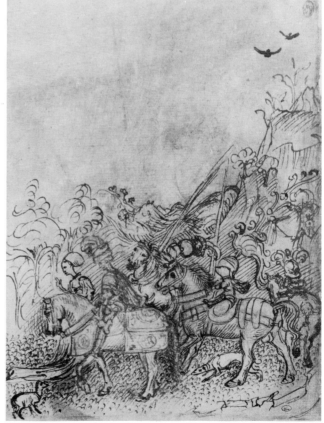

132. Gentile Bellini, *Sketch of an architectural interior with figures.* Munich, Staatliche Graphische Sammlung, 14648 verso. Pen and ink on paper; 7.0 × 11.0 cm.

133. Gentile Bellini, *Procession in Piazza S. Marco.* London, British Museum, 1933–8–3–12. Pen and ink, over preliminary sketch in red chalk, on paper; 13.0 × 19.6 cm.

narrative paintings in the Venetian *Scuole*, are analogous to the vivacious immediacy of Leonardo da Vinci's swift compositional doodles (128). The most generalised are very small sheets on which the pen was used broadly and aggressively to state the basic lines of the architectural forms. Over these were drawn the simplest indications of figures, a rapid loop in the shape of an inverted, elongated 'U' for the body and a brief, undifferentiated circle for the head. Descendants of the speedily drawn figures in Jacopo Bellini's *Crucifixion* (111), these cyphers suggest a swifter notation of a compositional idea even than Leonardo's first sketches, such as the early idea for the *Adoration* (166). Although spontaneously drawn, Leonardo's figures are clearly differentiated in pose and type. He was interested in the more complex problem of how to interrelate the figures in an intimate scene, whereas Gentile Bellini was concerned with the overall pictorial structure within which the crowd is a relatively subsidiary element. Even in the next stage of work, Gentile used a simplified formula for the figures. The earliest sketch for the great *Procession in Piazza S. Marco* (133) is similar in style to the first idea for a design (132) but is on a larger scale and includes more detail, though attention is still primarily paid to topographical accuracy. Preparation was more careful here: the pen-and-ink details were added over an initial sketch in red chalk which, in its brevity, reflects the first stage of design. Except in the use of red chalk (which became increasingly usual in Venice at the end of the century for this type of underdrawing) instead of charcoal, this procedure is a distant reflection of Cennino's advice about strengthening a brief sketch with stylus or pen.

In the last stage of Gentile Bellini's work on a composition, the brief sketches were redrawn in detail on sheets which have the laboured, impersonal appearance of contract drawings (135). The architectural structures are no longer summarily described with a few quick strokes of the pen but are precisely rendered topographical likenesses of Venetian buildings. The figures are carefully differentiated in costume and status and accurately placed on the perspectival chequer-board pavement. Figures introduced at this stage of the compositional design process were sometimes based on *simile* drawings, especially in the case of Orientals or other exotic types (65). A *Turkish woman* (134) is even provided with colour-notes to guide the painter in his transcription and to ensure a

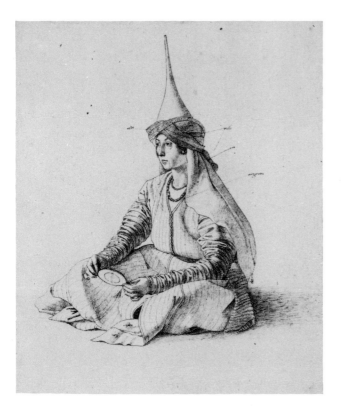

134. Gentile Bellini, *Turkish woman*. London, British Museum, Pp.1–20. Pen and ink on paper; 21.5 × 17.7 cm.

135. (below) Gentile Bellini, *Procession*. Florence, Uffizi, 1293 E. Pen and ink on paper; 44.2 × 59.1 cm.

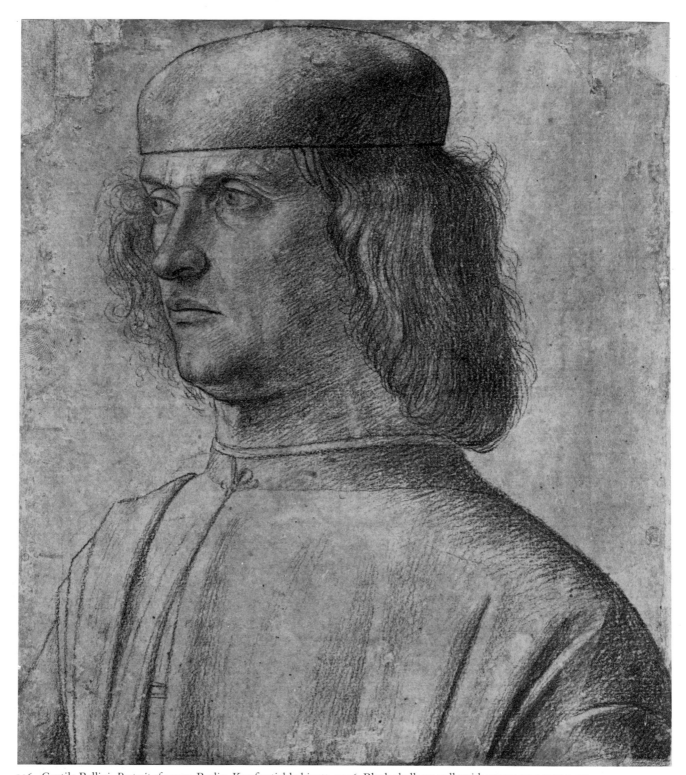

136. Gentile Bellini, *Portrait of a man*. Berlin, Kupferstichkabinett, 5136. Black chalk on yellowish paper; 22.7 × 19.5 cm.

142

137. (right) Vittore Carpaccio, *St. Augustine in his Study*. London, British Museum, 1934–12–8–1. Pen and ink, with light brown wash, on paper; 27.7 × 42.7 cm.

high degree of fidelity to the original type.[10] These *simile* drawings were clearly therefore used both in the final production of the contract drawing and as 'auxiliary cartoons' during the execution of the painting itself, to assist with details of pose and costume. Finally, portrait studies of individuals to be included in the painting were made: the sitter for a fine black chalk portrait drawing by Gentile Bellini (136) reappears in his *Procession of the Holy Cross* in the Venice Accademia.

Carpaccio's design procedure corresponds to Gentile Bellini's, but the evidence for it is better since more Carpaccio drawings survive than for any other Venetian quattrocento painter, with the exception of Jacopo Bellini. The contract drawing stage is best exemplified by the sheet showing *St. Augustine in his Study* (137), from which the painting in the Scuola di S. Giorgio degli Schiavoni differs only in the smallest details. This shows both the high degree of patronal approval for Carpaccio's composition and the faithfulness with which he transferred it to canvas. This sheet is a beautifully delicate pen-and-ink drawing with a light wash added to build up a gentle tonal range, and includes almost all the up-to-date furnishings and fittings of St. Augustine's study which make the painting such a valuable document of late quattrocento Venetian interior decoration.

Various grades of compositional pen drawings lie behind the production of Carpaccio's finished contract drawings.[11] Rough sketches like the early formulation of the *English Prince taking leave of his Father* (138), drawn with the pen over a rapid red chalk layout sketch, were elaborated into the stage shown in the *Triumph of St. George* design (139), in

138. Vittore Carpaccio,
*English Prince taking leave of
his Father*. Chatsworth,
Devonshire Collection, 740.
Pen and ink, over
preliminary sketch in black
chalk, on paper; 12.9 × 27.1
cm.

139. Vittore Carpaccio,
The Triumph of St. George.
Florence, Uffizi, 1287E. Pen
and ink, over preliminary
sketch in red chalk, on
paper; 23.5 × 41.9 cm.

140. Vittore Carpaccio,
The Funeral of St. Jerome.
Uppsala, Universitets-
biblioteket. Pen and ink,
with wash, on paper;
27.0 × 42.0 cm.

which the technique is the same but the finish is more careful and the composition is assembled within a measured-up frame, or in the small but exquisite study for the *Dream of St. Ursula* (141), in which Carpaccio studied tonal modulations in an interior by subtle applications of wash. In comparison with the almost destructive freedom of Gentile Bellini's pen in the initial stages of his work, Carpaccio's sketching was controlled and angular. Even in his earliest compositional experiments he defined the broad masses of the drapery around each of the main figures, and supplied simplified but clear features and limbs. This can be seen well in, for example, the two figures at the left-hand side of the Chatsworth sketch (138), which may be brief copies of standard *simile* drawings such as those copied onto the sheet in the Ashmolean Museum, Oxford (66). Figures on this sheet, drawn in the characteristic workshop technique of brush and pigment on blue paper, were indeed also used for subsidiary figures in the finished painting of the *English Prince taking leave*. A composition like this one was to some degree designed around the stock of types and poses available in the workshop portfolio of figure patterns. Another intriguing example of Carpaccio's practice is in the last stages of the evolution of the composition for the S. Giorgio degli Schiavoni *Funeral of St. Jerome*. The final compositional drawing (140), probably that submitted for patronal approval, shows the background in great detail, with the space and the architectural detail precisely and lovingly described; but many of the figures are contrastingly sketchy in finish. Some of these figures might have been transposed directly to the painting from appropriate *simile* drawings, but for at least one of them, the foremost monk holding a taper, a fresh preparatory study was made (142). This judgment results from the high quality of the drawing, distinctly superior to the normal workshop *simile* copies, although in technique and handling it could appear to be a portfolio prototype rather than a drawing made from life especially for this composition.

141. Vittore Carpaccio, *The Dream of St. Ursula*. Florence, Uffizi, 1689 F. Pen and ink, with light wash, on paper; 10.2 × 11.0 cm.

142. Vittore Carpaccio, *Kneeling monk*. Rotterdam, Museum Boymans-van Beuningen, inv MB 1940/T7. Brush and brown ink, with white heightening, on blue paper; 19.4 × 14.2 cm.

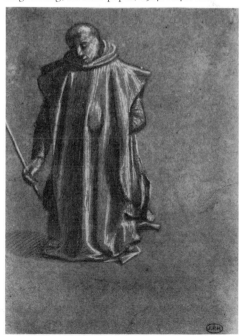

Domenico Ghirlandaio

In many respects Domenico Ghirlandaio's working procedure in the preparation of a painted composition was closely analogous to Carpaccio's. It is worth considering separately, however, for his drawings for frescoes provide the fullest and most instructive material for an assessment of the uses of drawing in the formulation of a late quattrocento pictorial composition. The number and range of the drawings which survive in preparation for the frescoes in the Sassetti Chapel in Sta. Trinita and the Tornabuoni Chapel in Sta. Maria Novella, Florence, may be due in part to the novel artistic problems facing Ghirlandaio in those fresco cycles, and in part to the unusually stringent requirements of the patrons as indicated by the terms of the Tornabuoni Chapel.contract. Ghirlandaio had not previously had to grapple with cycles as demanding and thematically as extensive as those of the lives of St. Francis, and of the Virgin and St. John the Baptist. Furthermore, the costliness and prestigiousness of the cycles exerted unusually strong pressures on the painter and his workshop, not least in the planning stages. The unmatched quantity and range of the surviving drawings allow us to reconstruct much more clearly the role of drawing in the Ghirlandaio workshop than is the case for any other quattrocento painter.

Compositional designs or sketches survive which are related to several of the Tornabuoni Chapel scenes, and to one in the Sassetti Chapel, the *St. Francis before Pope Honorious IV* (143). This drawing at once allows an insight into the relationship between painter and patron, and into the role of the contract drawing. It is a well worked-up design, but it differs in two important respects from the finished fresco (144). Two groups of portraits standing at the right and left sides of the fresco are absent from the compositional drawing, and the inclusion of these figures in the fresco creates blocks of immobile form which detract from the rhythmic flow of Ghirlandaio's design. They were presumably included at the patron's behest, after he had been offered the drawing for approval, a requirement which Ghirlandaio could not fulfil while preserving the narrative rhythm of his design. Secondly, it was probably on patronal demand that Ghirlandaio radically altered the architectural setting to include a long view of the Piazza della Signoria in Florence behind the main narrative group in the fresco.

Five compositional drawings for the Tornabuoni Chapel frescoes are extant. The *Annunciation to Zacharias* (145) was, like the Sassetti Chapel drawing (143), submitted to the patron for approval, according to the terms of the contract of September 1485, in which

> it is further agreed . . . that [Ghirlandaio] shall begin to paint one or other of the above-mentioned stories and paintings only after first doing a drawing of the said story which he must show to the said Giovanni [Tornabuoni]; and [he] may afterwards start this story, but painting and embellishing it with any additions and in whatever form or manner the said Giovanni may have declared.[12]

The *Annunciation to Zacharias* is the most fully finished of the Tornabuoni Chapel drawings. Although the figures were relatively freely sketched, the architectural setting was carefully drawn with ruled verticals and horizontals, and indications of the archi-

143. Domenico Ghirlandaio, *St. Francis before Pope Honorius IV*. Berlin, Kupferstichkabinett, 2368. Pen and ink, with light wash, on paper; 13.0 × 16.0 cm.

144. Domenico Ghirlandaio, *St. Francis before Pope Honorius IV*. Florence, Sta. Trinita, Sassetti Chapel.

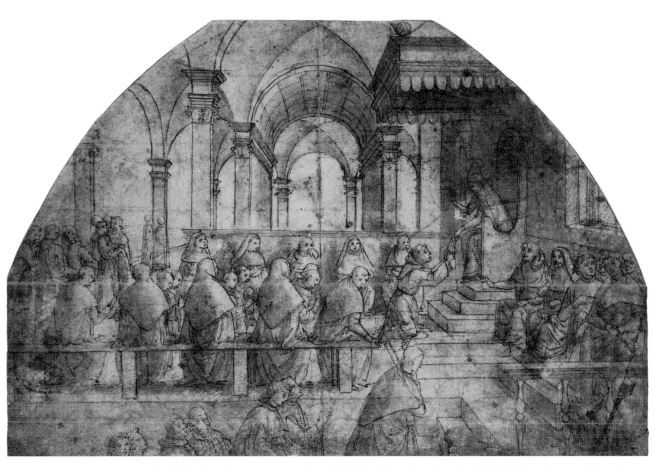

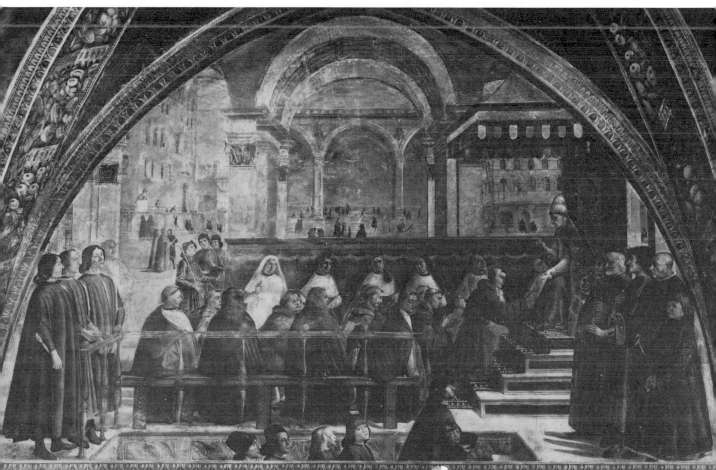

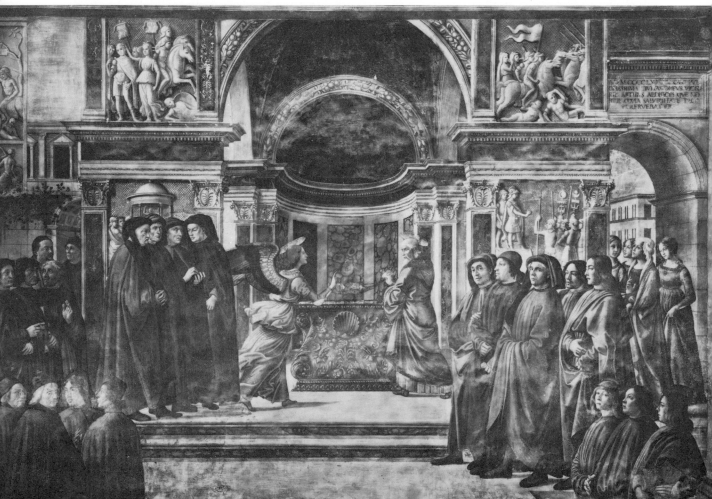

tectural decoration were added. Finally the whole scene was brought up into relief by the application of varying strengths of wash to indicate the fall of light, as though from the window of the chapel, and the recession of the planes of the space in which the figures are set. Because this scene was to be painted on the lowest register of the right-hand wall of the chapel, at a level where portraits could easily be recognised, the drawing is full of supernumerary figures, several of which are inscribed with the name of the member of the family whose portrait was to be represented there. As in the case of the Sassetti, it was with respect to the portraits that Giovanni Tornabuoni most clearly exercised his contractual right to require additions and changes. A comparison with the finished fresco (146) shows again that patronal demand caused Ghirlandaio much difficulty in re-organising the poses and placement of the figures. The result is a stodgy composition in which the narrative focus is all but overpowered by family portraits.

This drawing marks the culmination of the design stages for the composition, although interestingly, as in Carpaccio's *Funeral of St. Jerome* (140), the figures are fairly briefly indicated. The other four compositional drawings for the Tornabuoni frescoes represent two earlier design stages, in the second of which individual figures are more closely considered. The earliest surviving ideas for these compositions are seen in drawings for the *Visitation* and for the *Birth of the Virgin*. An even earlier phase in Ghirlandaio's working procedure may, however, be illustrated by a sheet of studies for the *Apparition of St. Francis at Arles*, originally probably to have been included in the Sassetti Chapel cycle. On the recto (147) the design is fairly well advanced: figure poses and drapery patterns are shown in some detail with hatching and fluent contours. The composition was then reconsidered on the verso (148) with a bold, abrupt pen remi-niscent of the brusque simplifications of Gentile Bellini's initial sketches (132), and alternatives to the architectural forms of the interior were tried out above and beneath. The abbreviations to form and composition in this brilliant sketch suggest a rapidity of transcription of thoughts akin to the fluent dynamic of Leonardo da Vinci's pen at about the same date.

A similar swift vigour, at a stage in designing which shows more certainty, charac-terises the *Visitation* (149) and *Birth of the Virgin* (150) drawings. In the first the basic lines and spaces of the composition are shown: the architectural setting is sparsely drawn in and the figures to right and left are added in bare outline with simple free-hand circles for the heads. The two main figures are more carefully considered, but were worked up to different extents. Elizabeth's drapery is only lightly indicated compared with the closer hatching which defines the fold patterns of the Virgin's robe. Her head is shown by a quickly drawn angular oval, whereas the Virgin's, at first drawn in the same way, was corrected and redrawn in more detail to define more precisely her pose and features. Here we can follow the development of the expressive idea in Ghirlandaio's mind; the amendments show how his thoughts crystallised about the relationship between the two women. At first they were placed almost symmetrically about a vertical axis, but on reconsideration Ghirlandaio made the Virgin a more reticent figure and, as in the final fresco, gave the expressive movement to Elizabeth. The informal nature of this sheet is emphasised by the design for a balustrade and distant landscape on the verso, which was pricked for transfer to another stage of preparatory work.

149

145. Domenico Ghirlandaio, *Annunciation to Zacharias*. Vienna, Albertina, inv. 4860. Pen and ink, with wash, on paper; 25.9 × 37.4 cm.

146. Domenico Ghirlandaio, *Annunciation to Zacharias*. Florence, Sta. Maria Novella, Tornabuoni Chapel.

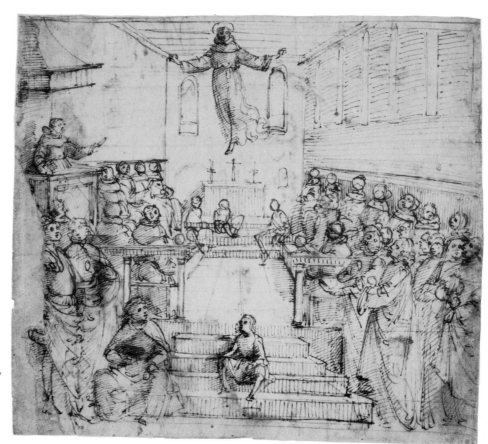

147. Domenico Ghirlandaio,
Apparition at Arles. Rome,
Gabinetto Nazionale delle
Stampe, F.C. 130495 recto.
Pen and ink on paper;
19.8 × 21.8 cm.

148. Domenico Ghirlandaio,
*Sketches for the Apparition at
Arles*. Rome, Gabinetto
Nazionale delle Stampe, F.C.
130495 verso. Pen and ink on
paper; 19.8 × 21.8 cm.

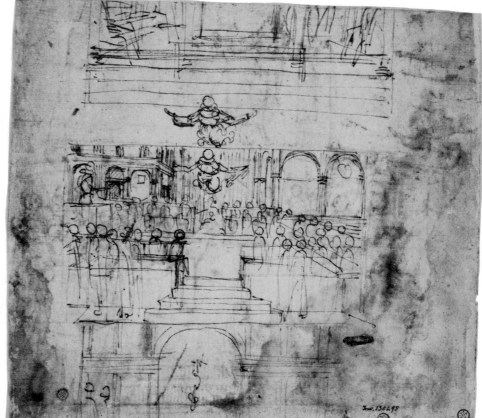

149. (facing page top)
Domenico Ghirlandaio,
Visitation. Florence, Uffizi,
291E. Pen and ink on paper;
26.0 × 39.0 cm.

150. (facing page bottom)
Domenico Ghirlandaio, *Birth
of the Virgin*. London, British
Museum, 1866–7–14–9.
Pen and ink on paper;
21.5 × 28.5 cm.

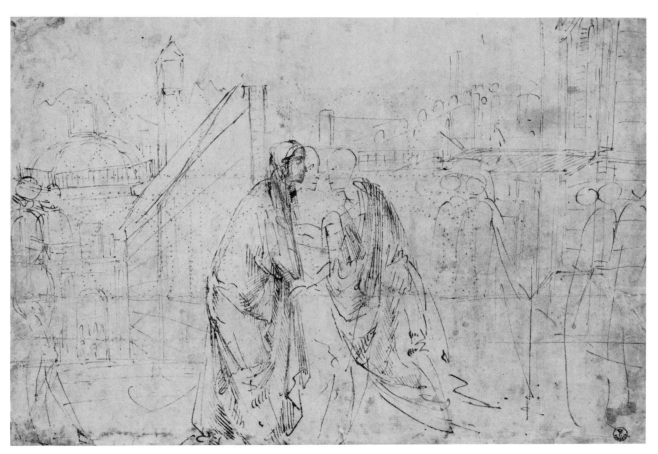

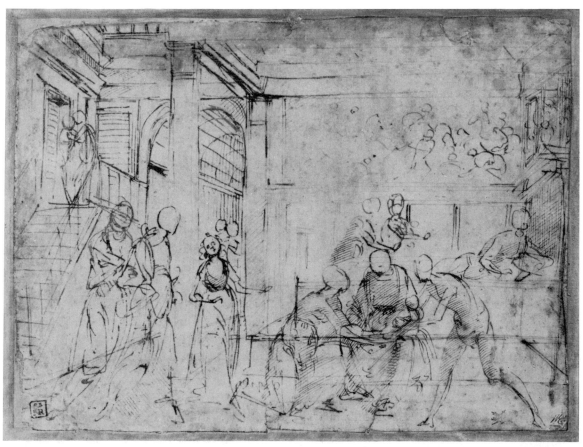

The architectural setting of the *Birth of the Virgin* (150) is more firmly built. Hatching indicates the fall of light and the extension of spaces beyond the main chamber. Although some areas are left ill-defined, the perspectival arrangement is more fully established than in the *Visitation* drawing. The figures behind St. Anne's bed are again shadowy, with mere touches of swift hatching to imply form. Those at the left are more clearly built, with emphasis given to the flowing lines of their draperies to indicate their forward movement. Like these, the main figures at the right foreground are superimposed on the lines of the architectural perspective, but they are more fully formed with extensive hatching. The figure furthest to the right, drawn with an eye especially to movement, is a transcription of a study from the nude, or perhaps from a lay-model, before drapery is added. The compositional drawing was used as the setting for a preliminary experiment on the pose and movement of this figure: her drapery was studied on a separate sheet at a later stage, once the pose was fixed (153).

Drawings for the *Marriage of the Virgin* and the *Naming of St. John the Baptist* show the next stage of compositional study. In the first (151) Ghirlandaio took the main figure

151. Domenico Ghirlandaio, *Marriage of the Virgin*. Florence, Uffizi, 292E. Pen and ink on paper; 20.1 × 26.3 cm.

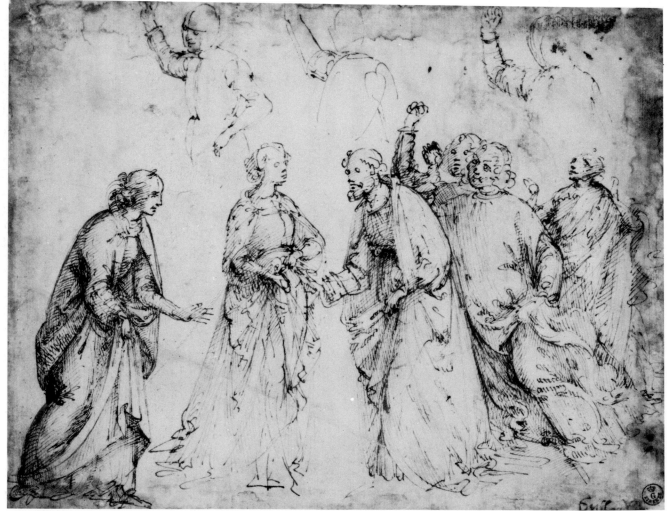

group out of its setting, which he had presumably already established in a compositional sketch like that for the *Birth of the Virgin*, and considered the interrelationship between the figures in movement and expression. As in the *Visitation* drawing (149), he used the paper immediately for further experiment, both with the grouping of the figures and with the pose and articulation of individual forms. The figures were first drawn in some detail, with elaborate hatching and cross-hatching to clarify forms and fold patterns, and with characteristic free-hand marks to establish the features, the hair, and to some degree the expressions on the faces. Ghirlandaio was dissatisfied, however, with the figures of the Virgin and of the angry suitor about to strike Joseph: these two were rethought in some detail. Two possible positions for the rejected suitor's striking arm were drawn in; not yet content, though, Ghirlandaio added three brief sketches from a studio model, seeking to clarify the anatomical form and movement so that the suitor's action would be convincing. The Virgin's position is totally reworked: instead of the poised, regal figure originally drawn, Ghirlandaio introduced a more anxious, energetic figure who moves tentatively towards Joseph, clasping her robe to her waist. This figure is defined in

152. Domenico Ghirlandaio, *Standing female figure*. London, British Museum, 1895–9–15–451. Pen and ink on paper; 24.1 × 11.7 cm.

153. Domenico Ghirlandaio, *Girl pouring water*. Florence, Uffizi, 289E. Pen and ink on paper; 21.9 × 16.8 cm.

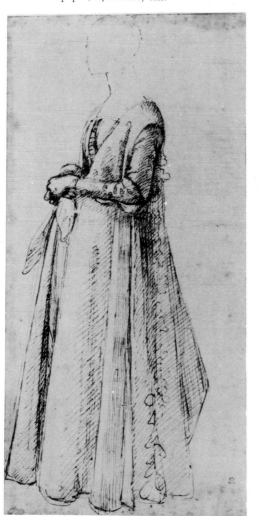

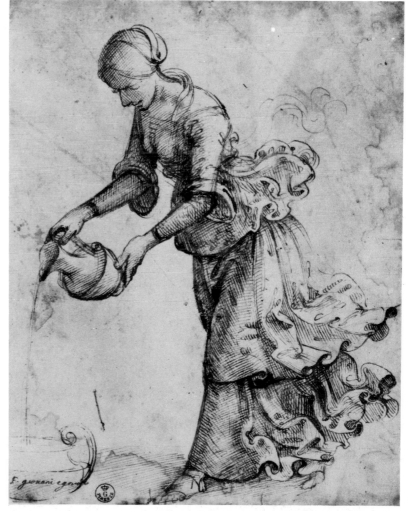

greater detail than any other in the drawing. She is an elaborated alternative to the earlier idea, with closer cross-hatching and more fully distinguished features and hair-style.

The main purpose of this working drawing was to study the movements and expressions of the principal figures, but it also included a detailed study of the Virgin's drapery. A group of independent drapery studies shows the next stage in the process of evolution of the compositions. Some of these studies were made for specific figures in the frescoes, but others were probably portfolio 'pattern' drawings reused for this occasion. A slight pen-and-ink drapery study for a female figure in the *Birth of St. John the Baptist* (152) could have served with only small adaptations for the leader of the women at the right-hand side of the *Visitation* and in reverse for the similar figure who leads the group of visitors in the *Birth of the Virgin* (154–5). Another study (156), this time in black chalk,

154. (facing page top) Domenico Ghirlandaio, *Birth of the Virgin*. Florence, Sta. Maria Novella, Tornabuoni Chapel.

155. (facing page bottom) Domenico Ghirlandaio, *Birth of the Virgin*, detail: female visitors. Florence, Sta. Maria Novella, Tornabuoni Chapel.

156. Domenico Ghirlandaio, *Standing female figure, and slight sketch of a face*. Chatsworth, Devonshire Collection, 885 verso. Black chalk on paper; 36.5 × 22.0 cm.

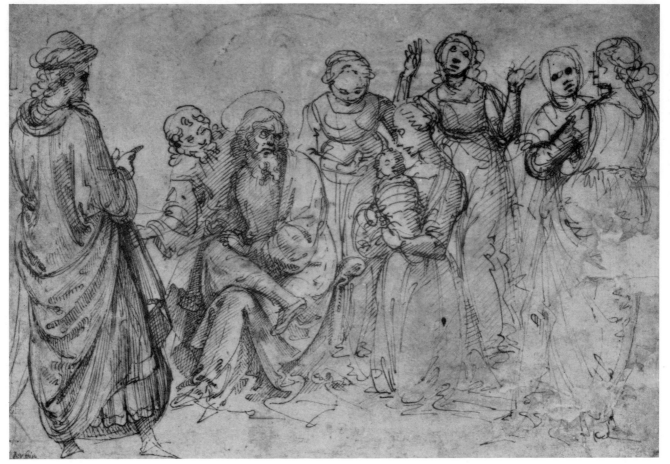

157. Domenico Ghirlandaio, *Naming of St. John the Baptist*. London, British Museum, 1895–9–15–452. Pen and ink on paper; 18.5 × 26.3 cm.

for the middle figure of the same group is on the verso of the Chatsworth cartoon (160). A beautifully fluent study for the woman pouring water in the same scene (153) follows up the indication of the sketchy figure's movement in the compositional drawing. The special problems raised by these figures needed to be considered from scratch. Because they were unusually important, being Tornabuoni portraits and a completely new and striking dramatic type, no established formulae existed which could be readily adapted for them. For many other figures, however, patterns already available in the workshop portfolio could be selected and slightly adapted as the need arose. One example of such sheets (158) reproduces two figures in Fra Filippo Lippi's *Miraculous Birth of St. Ambrogio* predella panel in Berlin. The wooden character of this and similar studies suggests that they were made by Ghirlandaio assistants copying from drawings in the workshop portfolio as part of their apprenticeship training. A large stock of drapery 'pattern' drawings was apparently kept in Ghirlandaio's workshop, serving not only as exemplars for copying but also as patterns which could be incorporated, in the same way as were Carpaccio's *simile* drawings, into compositional designs.[13]

The workshop exemplar copied by Ghirlandaio's apprentice (158) was also used, with

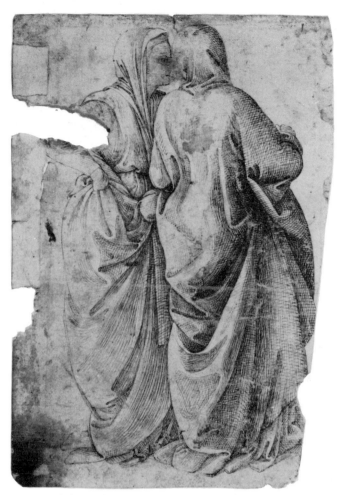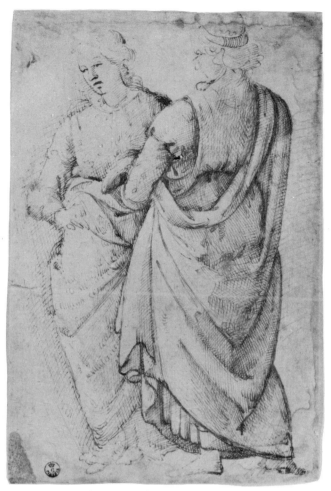

158. Workshop of Ghirlandaio, *Two female figures*. Whereabouts unknown. Pen and ink on paper; 22.0 × 15.0 cm.

159. Domenico Ghirlandaio, *Two female figures*. Florence, Uffizi, 294E. Pen and ink on paper; 22.7 × 14.2 cm.

some adaptation, in the figure group drawing for the *Naming of St. John the Baptist* (157), and the formula reappears in two or three other scenes in the fresco cycle. The drapery of the male figure at the left is well modelled with careful cross-hatching, indicating that the 'pattern' drawing was carefully transcribed into this sketch. On the other hand the two female figures at the right-hand end of the figure group are only lightly drawn. No suitable pattern was available for this pair of figures, and a fresh study was made (159) which, unlike the apprentice's 'pattern' drawing copy (158) shows the fresh brilliance of Ghirlandaio's draughtsmanship at its best.

These figure-group drawings and the new, detailed studies of particular figures were then drawn together into contract drawings like that for the *Annunciation to Zacharias* (145). The detailed studies also probably formed a base stock of drawings which guided work on the frescoes themselves, for the *Annunciation to Zacharias* drawing is insufficiently detailed to have provided more than a general indication of the composition. By analogy with the *sinopia* which has been uncovered beneath Ghirlandaio's *Last Supper* in the refectory of the church of Ognissanti in Florence, the Tornabuoni Chapel *sinopie* are probably outline drawings giving only the broadest indications of scale and form.

157

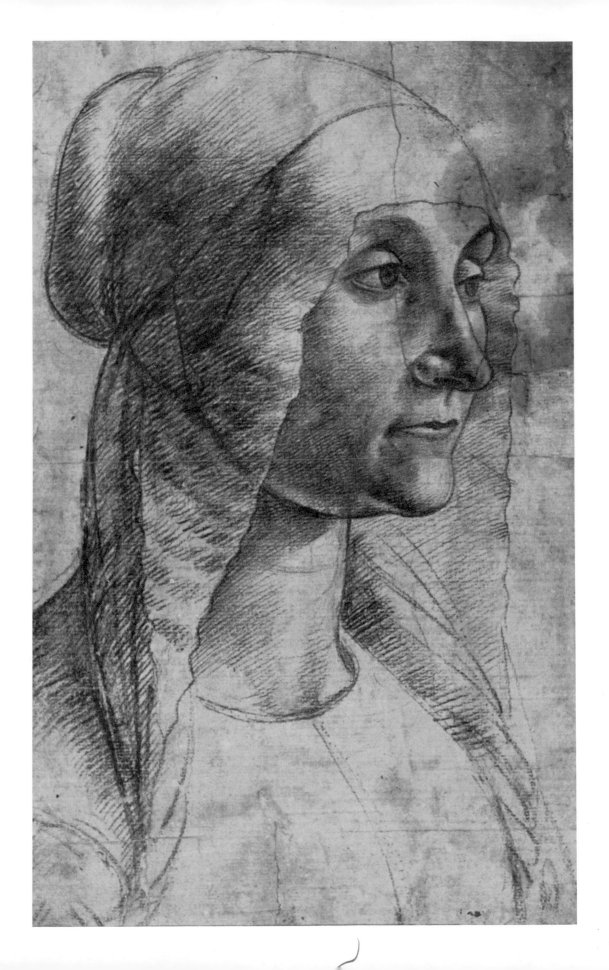

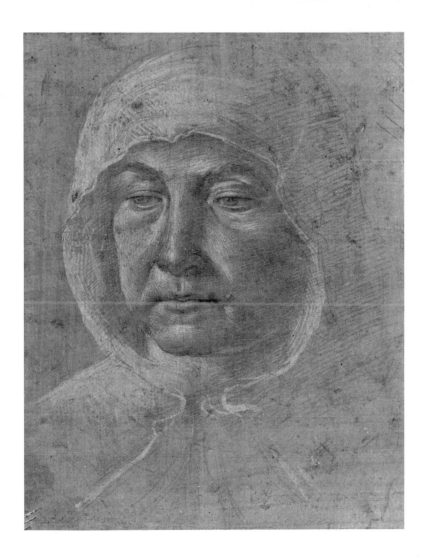

161. Domenico Ghirlandaio, *Portrait of an elderly lady*. Windsor, Royal Library, 12804. Silverpoint, with white heightening, on orange prepared paper; 23.2 × 18.5 cm.

Details of important figures were drawn up in full-scale cartoons, as was the case in Castagno's *Resurrection* fresco (18). The cartoon for the head of the last of the group of visitors in the *Birth of the Virgin* survives (160). This fine black chalk portrait drawing is pricked for transfer either directly to the wall surface or to an intermediate cartoon perhaps covering a larger area of the figure. It is not itself a fragment of a larger cartoon, since on the verso (156) is a black chalk drapery study superimposed over a light sketch of a face, perhaps the first attempt at the portrait for the second or third visitor (155). At this late stage of the working process Ghirlandaio used black chalk for both drapery and portrait studies. These drawings were probably associated with work done directly on the wall, and were used as 'auxiliary cartoons' to guide the painter's hand in laying in the tone-values in the fresco.

The portrait cartoon (160) was probably reworked up to scale from a portrait study in silverpoint. This is indicated by the survival of such a portrait (161), a delicate silverpoint drawing usually associated with the matronly looking figure in the same group of visitors in the *Birth of the Virgin* (155). Silverpoint is a suitable technique in which to encapsulate the precise details of physiognomy and character required of a portrait

160. Domenico Ghirlandaio, *Portrait of a lady*. Chatsworth, Devonshire Collection, 885 recto. Black chalk on paper, pricked for transfer; 36.5 × 22.0 cm.

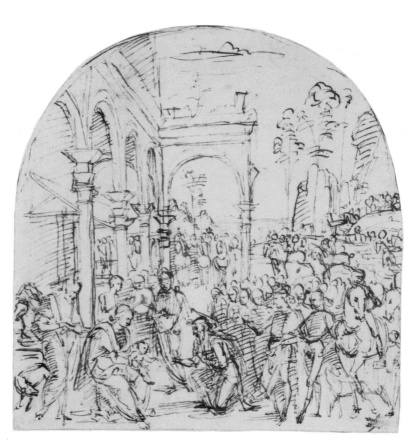

162. Pietro Perugino,
Adoration of the Magi.
London, British
Museum, 1853–10–8–1.
Pen and ink, over
preliminary sketch in
black chalk, on paper;
19.1 × 18.2 cm.

drawing. In Rogier van der Weyden's painting St. Luke draws the Virgin in silverpoint (20), and Jan van Eyck used the same technique for the so-called *Portrait of Cardinal Albergati* in Dresden.[14] Silverpoint portraits were presumably taken of all the members of the Tornabuoni family and retinue represented in the frescoes, and these were then scaled up in black chalk drawings ready for transfer to the wall. The Chatsworth cartoon (160) lacks the warmth and humanity of the silverpoint drawing (161), as though made at a remove from the model; but it is a fine early example of the possibilities of black chalk for exploring the undulations of the surface of the skin and the soft tonal gradations over the face.

The drawings for Ghirlandaio's two great Florentine fresco cycles, ranging from the first rapidly drawn ideas for the compositions to the exquisite and precise portrait drawings, provide us with a picture of the working procedure of the late quattrocento painter of unmatched clarity. The parallels between Ghirlandaio's procedure and that of Venetian contemporaries in the use of drawings in compositional preparation are also clear, indeed perhaps unexpectedly so. Ghirlandaio's pen-and-ink compositional sketches in various grades of finish are directly analogous to Gentile Bellini's. The workshop 'pattern' drawings are slightly different; for, whereas Ghirlandaio's are mostly cross-hatched pen-and-ink drapery studies, Venetian ones, especially those from Carpaccio's workshop, are usually brush drawings, closer in technique to the paintings for which they acted as auxiliary cartoons. The careful, methodical procedure followed by both Ghirlandaio and Carpaccio accounts to a significant extent for the generally undramatic nature of the large-scale narrative compositions of both painters.

Leonardo da Vinci

Features of Ghirlandaio's practice can also be identified in groups of drawings by his Central Italian contemporaries. Two sheets which can be associated with Perugino's lost *Adoration of the Magi* fresco in the cloister of the Florentine convent of the Gesuati, probably painted in the mid-1470s, indicate similar stages of preparation. A rapid and free compositional design (162), the equivalent of Ghirlandaio's *Birth of the Virgin* drawing (150), establishes the framework for more detailed studies. In a series of fine studies of heads drawn in silverpoint with white heightening (163), Perugino showed characteristically delicate precision in a random scattering of exploratory ideas over the sheet. This recalls the freedom of the use of paper in sketch-book drawings from Verrocchio's workshop (62–3). In vivid contrast, the black chalk study of three heads, probably for the central group of bystanders in the *Adoration*, on the verso of this sheet has a rough immediacy (164). Perugino used black chalk with an urgency and force reminiscent of Signorelli at his sketchiest (28), and anticipating the fluent, swinging line of the cartoon fragment of the *Head of an old man* (165). Black chalk is handled with remarkable freedom for so early a date, again perhaps indicative of the technical

163. Pietro Perugino, *Sheet of studies of figures and heads.* Düsseldorf, Kuntsmuseum, F.P. 9 recto. Silverpoint, with white heightening, on yellow prepared paper; 20.1 × 28.2 cm.

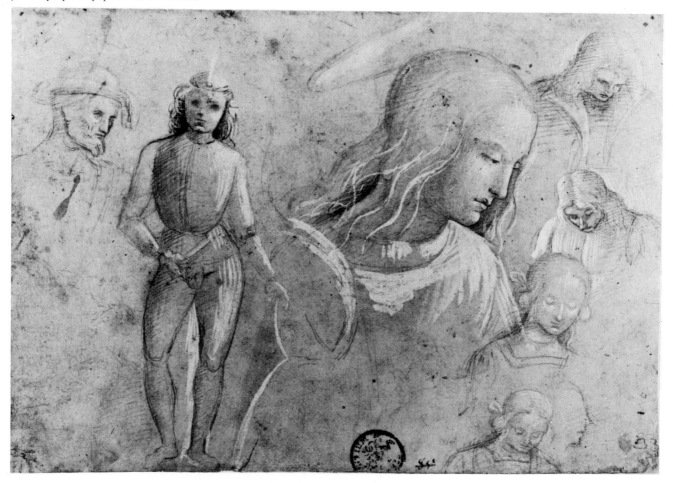

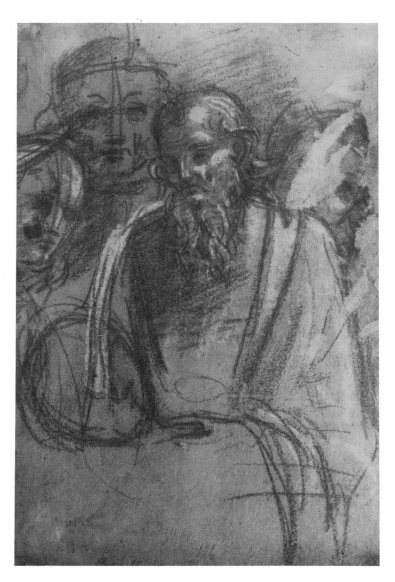

164. Pietro Perugino,
*Study for a group of
bystanders.* Düsseldorf,
Kunstmuseum, F.P.9
verso. Black chalk, with
white heightening, on
paper; 28.2 × 20.1 cm.

165. (facing page) Pietro
Perugino, *Head of an old
man.* Oxford, Christ
Church, JBS 8. Black
chalk on paper, pricked for
transfer; 27.0 × 25.0 cm.

inventiveness and fertility of graphic innovation of Verrocchio's Florentine workshop
from which Perugino had but recently emerged.

Some of the stages through which the imagination of Leonardo da Vinci, Verrocchio's
greatest apprentice, worked can also be seen in drawings for early compositions. It is,
however, more difficult to reconstruct the development of his compositions, and hence
of his drawing procedure, as clearly as in Ghirlandaio's case, principally because his
sketches are much freer and less evidently connected with any particular project. The
preparatory drawings for the Uffizi *Adoration of the Magi* follow a complex path, due in
part to the interweaving of two separate ideas, starting with an *Adoration of the Shepherds*
which seems to merge into the *Adoration of the Magi.* In part, too, the rapidity of
Leonardo's mental and imaginative activity led him to leap from problem to problem in

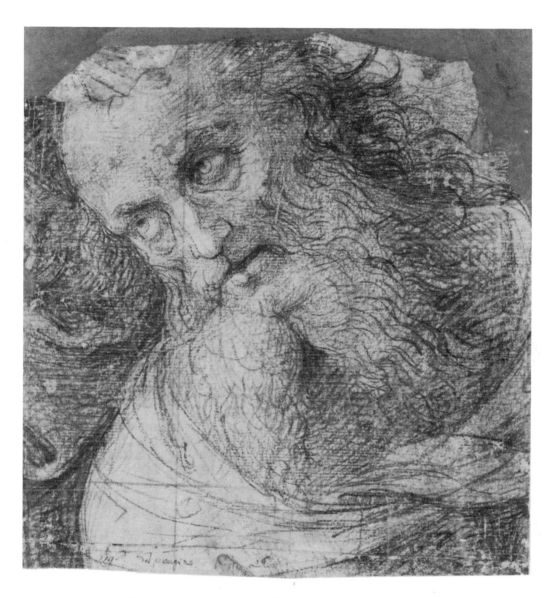

a manner apparently too inconsequential to be reconstructed. In general terms, however,
most of the drawings associated with the *Adoration* project emphasise the strength of the
Tuscan tradition, also followed by Ghirlandaio, of using the pen for exploratory
compositional and figure drawing, taking advantage of the quill's versatility of line.

The early compositional study in Bayonne (166) matured into the first *Adoration of the
Magi* design (167) by way of several sheets of marvellously spontaneous figure sketches
(89, 168–9) which experiment with the poses and expressions of the Magi and their
retinue. Detailed studies of single figures or heads for the *Adoration* do not survive:
the only other extant preparatory drawing is the extraordinary perspective study in the
Uffizi (170), in which Leonardo worked on the composition of the background of the
scene, using a complicated combination of pen and ink with occasional dabs of wash over

the perspectival lines drawn with a metalpoint and ruler. Leonardo's use of chalk to study the more painterly problems of tonal modulation, on the small scale of preparatory studies, is the most important technical development to be found in the drawings for the Milan *Last Supper*.

The initial idea for a Last Supper can be seen on one of the sheets of vivid figure studies for the *Adoration* some twelve years or so earlier (169). This brief sketch for a group of five figures seated at a table, with one or two further notes for associated figures, evolves from experimental forms elsewhere on the sheet through Leonardo's characteristic and extraordinarily imaginative pattern of thought association. He may have taken this and other sketches with him to Milan, but it is just as likely that the first major preparatory sketch for the 1494 *Last Supper* (171) developed from his memories of the earlier idea. In a more angular graphic style, clearly more mature in its eager, exploratory handling, Leonardo tested out the grouping of the Apostles in threes around the table, an arrangement already anticipated in the earlier sketch. This idea was next elaborated in red chalk (172): the forms of the Apostles are now built more firmly, and much thought has been given to the spatial positions and psychological intercommunication of the figures. Unfortunately, no compositional sketches tracing the further evolution towards the solution to Leonardo's pictorial problem survive. Later work consists only of detailed studies, especially of Apostles' heads, in which full consideration is given to the emotional responses to the event. A drawing in pen and ink over stylus (173) is usually associated

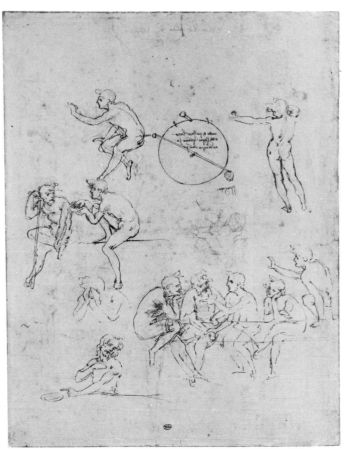

166. (far left) Leonardo da Vinci, *Study for an Adoration of the Shepherds*. Bayonne, Musée Bonnat, 658. Pen and ink on paper; 21.3 × 15.2 cm.

167. (left) Leonardo da Vinci, *Adoration of the Magi*. Paris, Louvre, 1978. Pen and ink on paper; 28.5 × 21.5 cm.

168. (above) Leonardo da Vinci, *Studies of figures*. London, British Museum, 1886–6–9–42. Pen and ink on paper; 16.3 × 26.3 cm.

169. (right) Leonardo da Vinci, *Studies of figures*. Paris, Louvre, 2258 recto. Pen and ink on paper; 27.8 × 20.8 cm.

170. (below) Leonardo da Vinci, *Perspective study for the Adoration of the Magi*. Florence, Uffizi, 436E. Pen and ink over metalpoint on paper, with wash and white heightening; 16.5 × 29.0 cm.

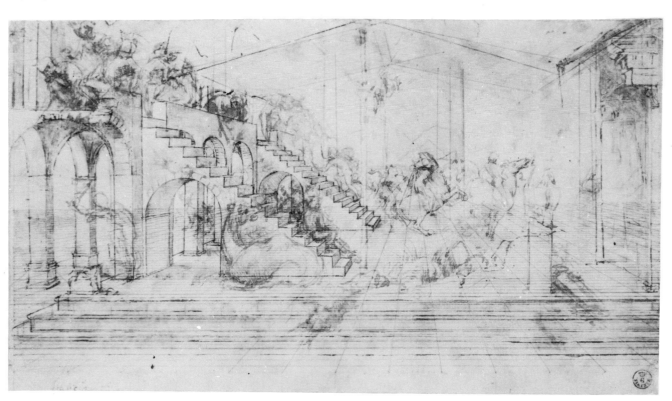

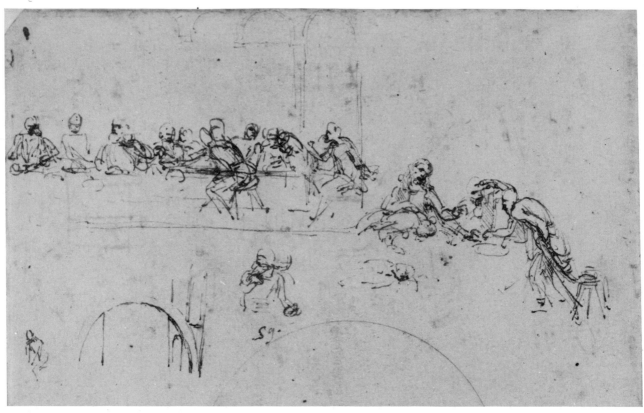

171. Leonardo da Vinci, *Study for the Last Supper*, detail. Windsor, Royal Library, 12542. Pen and ink on paper; 26.0 × 21.0 cm. (full page).

172. Leonardo da Vinci, *Studies for the Last Supper*. Venice, Accademia, 254. Red chalk on paper; 26.0 × 39.0 cm.

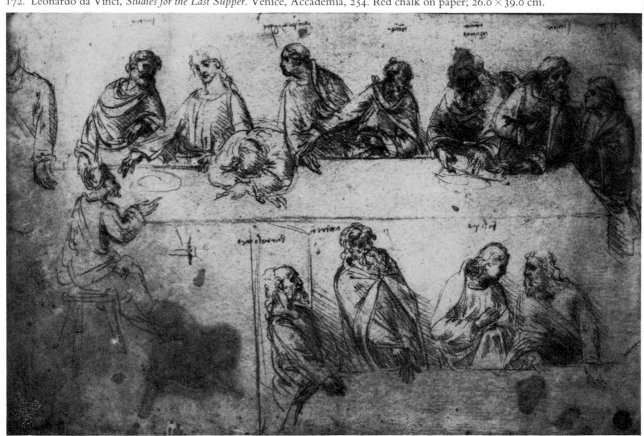

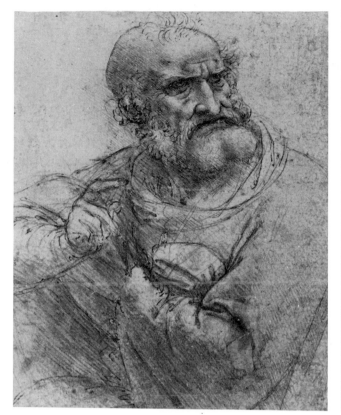

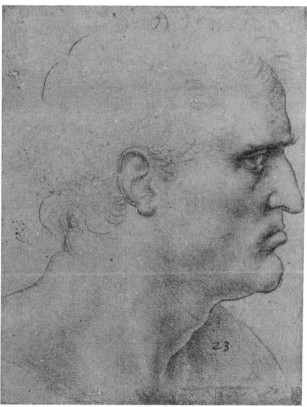

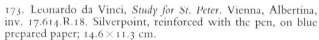

173. Leonardo da Vinci, *Study for St. Peter*. Vienna, Albertina, inv. 17.614.R.18. Silverpoint, reinforced with the pen, on blue prepared paper; 14.6 × 11.3 cm.

174. Leonardo da Vinci, *Study for St. Bartholomew (?)*. Windsor, Royal Library, 12548. Red chalk on reddened paper; 10.3 × 14.8 cm.

with the figure of St. Peter: this is a bold, forceful drawing with fluent and incisive contours and soft areas of hatched tone. But inevitably neither pen nor stylus could achieve such subtle tonal modulations as does the red chalk used for other studies of heads. In a group at Windsor, for example those showing the heads of *Judas* (colour plate VII) and *St. Bartholomew* (174), contour is scarcely indicated and form is generated by the gentle manipulation of a blunted chalk which creates the equivalent in tonal drawing to the *sfumato* produced by Leonardo's brush.

In his work on these detailed studies for the *Last Supper*, Leonardo exploited red chalk in completely novel ways, stretching its versatility and establishing it for the first time as a drawing technique of incomparable range. Leonardo's grasp of the potential of red and black chalk for experimenting with the tonal effects necessary to the High Renaissance painter was of profound importance for cinquecento practice. His experiments in Milan during the 1490s provided the precedent for such widely differing masters of chalk drawing as Fra Bartolommeo, Michelangelo, Raphael and Correggio. In chalk drawing as in pen drawing, Leonardo set the scene for the experimental drawing practice of the master draughtsmen of the High Renaissance.

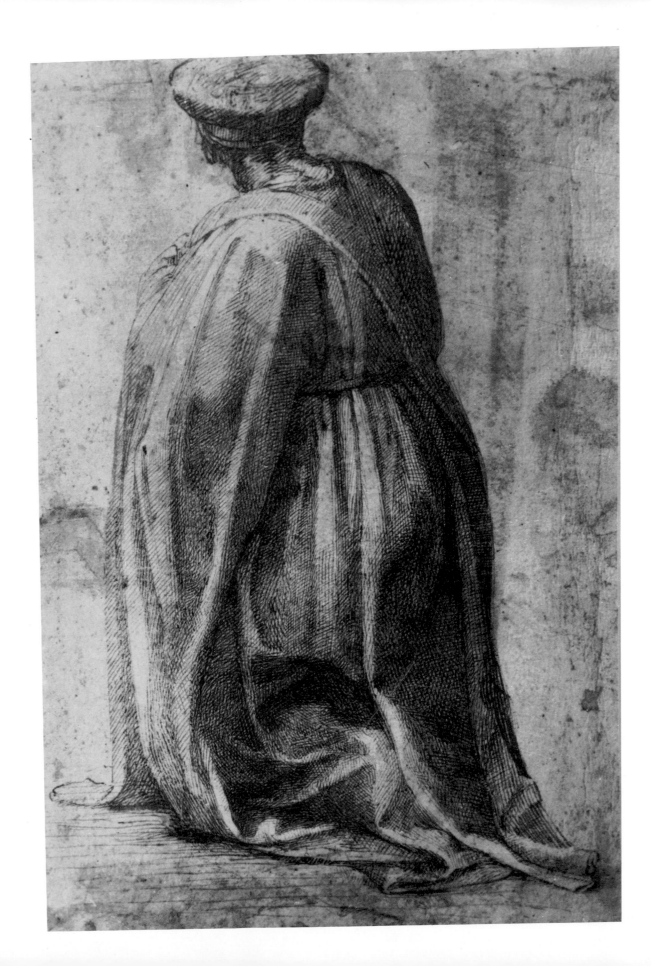

EPILOGUE

The Quattrocento Legacy

THE INNOVATIONS in the uses of drawing, sometimes tentative and experimental, some-times powerful and confident, which have been considered in the last chapters come to full maturity in Central Italy during the first decade of the sixteenth century. The crucial event which stimulated the High Renaissance draughtsman's new sense of purpose was Leonardo da Vinci's return from Milan to Florence, via Venice, in 1500. In his early Florentine works Leonardo had already significantly extended the possible range of silverpoint and pen drawing. This we have seen in the extraordinary subtlety of early drawings in Verrocchio's studio, like the *Bust of a warrior* (colour plate I), and in the freedom of his experimental handling of the pen for organising his thoughts about the *Madonna and Child with a Cat* composition (109) or in the preparatory work for the 1481 *Adoration* (166–9). But the possibilities hinted at by his lithe pen for exploring problems of form, grouping or compositional design were very seldom taken up during the last two decades of the fifteenth century in Florence. Leonardo's awareness of the potential of chalk for combining the pen's spontaneity of movement with smooth tonal modelling also remained unexamined in Central Italy until the last years of the century.

Shortly after Leonardo's departure for Milan, Verrocchio left for Venice and Pollai-uolo for Rome. By 1485 the two workshops most inventively active in experimental calligraphic draughtsmanship, and most deeply concerned with the use of the pen to represent sculptural form in movement, lost their creative centres. The major Florentine workshops of the last two decades of the quattrocento were those of Botticelli, Ghirlandaio and Filippino Lippi. All three were masters of silverpoint drawing and skilled in sketching with the pen, but their drawing generally followed conventional patterns and lacked the virtuoso brilliance and graphic excitement of drawing in the Verrocchio and Pollaiuolo workshops. Furthermore, the political instability of the 1490s, with its dampening effect on artistic patronage and productivity, probably tended to reinforce traditional values and practices.

Workshop conventions could exercise a powerful constraint on artistic individuality: so Michelangelo seems to have felt while apprenticed to Domenico Ghirlandaio. The reconstruction of Ghirlandaio's design procedure shows that he was a careful, thorough worker. He often based his ideas on traditional compositions or types, reorganised to include 'patterns' themselves derived from inventions of the mid-fifteenth century. Ghirlandaio, a traditionalist also in training his apprentices, expected Michelangelo

169

175. Michelangelo, *Kneeling figure*. Vienna, Albertina, inv. 116 verso. Pen and ink on paper; 29.0 × 19.7 cm.

to gain his knowledge of the workshop style and skills by the time-honoured system of copy-drawing. Every one of Michelangelo's earliest surviving drawings is in the technique current in Ghirlandaio's workshop, of deliberate and meticulous pen cross-hatching to develop a range of tone in the modelling.[1] Vasari wrote that before joining Ghirlandaio's shop Michelangelo made friends with one of the apprentices, Francesco Granacci, who 'saw that Michelangelo had a great aptitude for drawing, and as he was very fond of him he used to supply him every day with drawings by Ghirlandaio'.[2] Early drawings such as the *Kneeling figure* (175) may well derive from Ghirlandaio originals. Later on, moreover, Michelangelo was seen by Ghirlandaio

> not only surpassing his many other pupils but also very often rivalling the achievements of the master himself. On one occasion it happened that one of the young men studying with Domenico copied in ink some draped figures of women from Domenico's own work. Michelangelo took what he had drawn and, using a thicker pen, he went over the contours of one of the figures and brought it to perfection; and it is marvellous to see the difference between the two styles and the superior skill and judgement of a young man so spirited and confident that he had the courage to correct what his teacher had done.[3]

His training may have been traditional, but Michelangelo firmly rejected the silverpoint as too limited and inflexible. Ghirlandaio's training method probably followed Cenino's recommendations and started apprentices off with silverpoint drawing, but no Michelangelo silverpoint drawings have been identified. In an early sheet of studies (176), Michelangelo followed but improved on Ghirlandaio's handling of the pen (159) in changing the tone gradually by slight variations of spacing of hatching and cross-hatching. The contrasting spontaneity of his shorthand formulae for indicating the head and features of the draped figure is also closely comparable to Ghirlandaio's (151). Michelangelo's freer cross-hatching, however, articulates more convincingly the anatomical forms lying beneath the voluminous drapery folds.

When dealing with nude form, Michelangelo was severely hampered by the inherent limitations of the pen for constructing plastic form. This is made more noticeable by the fact that he seldom used the pen in the dynamic, form-implying manner associated with the modelling technique of the bronze sculptor or goldsmith. Michelangelo was a carver, concerned with paring away the marble to reveal the plastic undulations of the skin surface over the implied anatomical structure, rather than with the modeller's creation of three-dimensional form *ex novo*. The parallel scratches of his claw chisel working towards the final revealed surface of the marble are analogous to the system of hatching and cross-hatching that he developed in his pen drawings of nude form. Through the use of chisels, files and pumice-stone for the final smoothing, or of paint on panel or wall, Michelangelo could, however, achieve the completely smooth transitions from plane to plane denied him by the linear character of pen drawing. His copies after antique nude figure sculpture (176) demonstrate the paradox facing him: it looks as though he wished to describe surface plasticity in an almost painterly manner, but had ultimately to be content with a series of conjoined facets in lieu of imperceptible modulations between planes. His struggle is clear when one realises how much more fluent and form-revealing

is his cross-hatching than that of the mediocre Ghirlandaio workshop copyists of the Codex Escurialensis (48). His problem became more acute still when drawing from the nude model under muscular tension, in preparatory studies for the *Battle of Cascina* in 1504 (177).

It was at this point that Leonardo, who had returned to Florence three years earlier, came to Michelangelo's rescue. Working on the pendant to Michelangelo's planned fresco, Leonardo further exploited the chalk technique which he had developed in studies for his *Last Supper* (colour plate VII, 174). By this time his handling of chalk was fully mature, as can also be seen in his studies of the nude (68). Michelangelo's resulting awareness of the tonal potential of chalk can be seen in the contrast between two nude studies, associated with his battle scene, in which using different techniques he investigated the dynamic musculature of the model's shoulders and back. In the pen drawing (177) small areas of tonally varied cross-hatching suggest the undulations of the skin over the strained muscles. Michelangelo here pushed the possibilities of pen hatching to their utmost limits in his search for a fuller and more subtle tonal range. In spite of these efforts, however, and even though he was growing more conscious of the value of curvilinear hatching around the forms, his figure inevitably still has a faceted appearance. In the second drawing (178), black chalk produces more subtle transitions between tones than could possibly have been achieved by purely linear means. Furthermore, the tonal range

176. Michelangelo, *Studies after antique sculpture*. Chantilly, Musée Condé, 29. Pen and ink on paper; 26.3 × 38.7 cm.

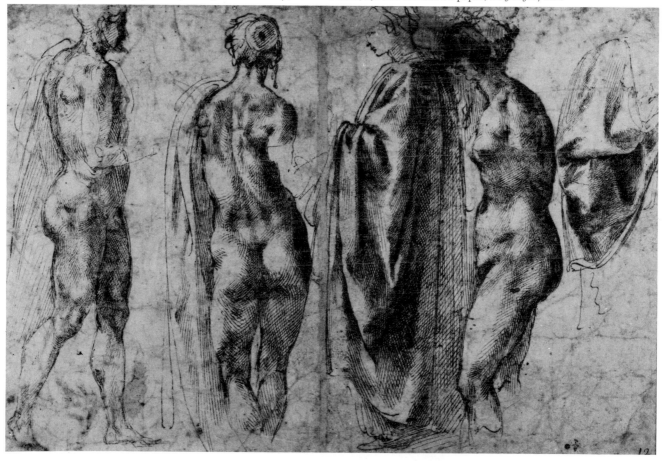

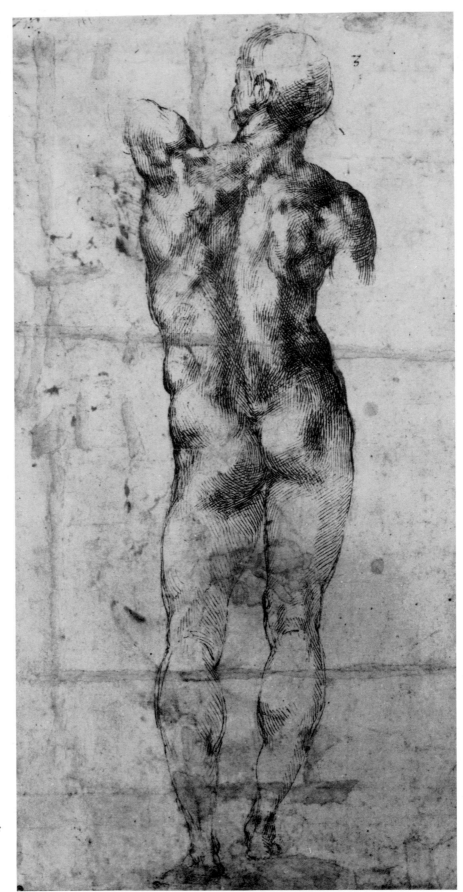

177. Michelangelo, *Nude man seen from behind*. Vienna, Albertina, inv. 118 verso. Pen and ink on paper; 37.9 × 18.7 cm.

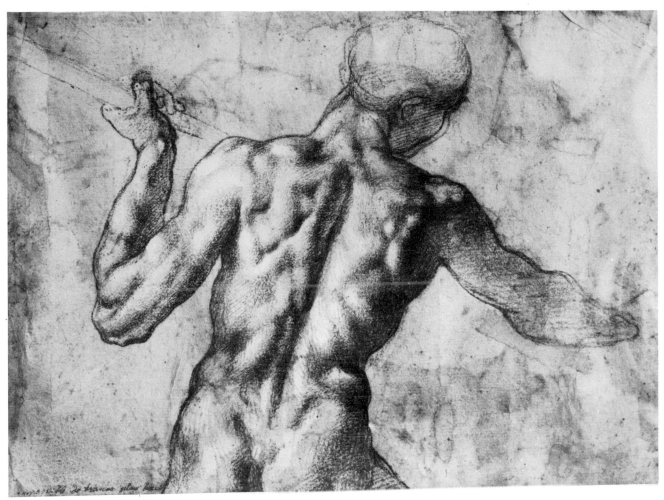

178. Michelangelo, *Nude torso seen from behind*. Vienna, Albertina, inv. 123 recto. Black chalk, with white heightening, on paper; 18.8 × 26.0 cm.

from the rich, heavily chalked blacks up to the white-heightened crests of form is greater than in the pen drawing and emphasises the tensions in the rippling musculature.

It seems surprising that it was not until Michelangelo experienced the competitive stimulus of Leonardo's draughtsmanship that he in turn began to examine the potential of chalk for figure drawing. Fifteen years earlier, in the very workshop in which Michelangelo was then apprenticed, Ghirlandaio used chalk in a similar, if relatively primitive, manner for his cartoon *Head of a lady* (160). In comparison with Michelangelo's immensely more sophisticated use of chalk to examine the modulating surface of form (178), there is an undeniably naïve contrast between Ghirlandaio's subtle treatment of the lady's chin and cheek and the rather harsh contour and sharp tonal contrasts on her brow and neck. None the less, it is clear from this drawing, and from others like Verrocchio's *Head of a woman* (colour plate VI), that by the 1480s draughtsmen were beginning to take advantage of chalk for modelling form. Both these drawings, however, were cartoons: the use of chalk seems to have been almost entirely restricted, by Florentine quattrocento workshop tradition, to the final stage of prepar-

173

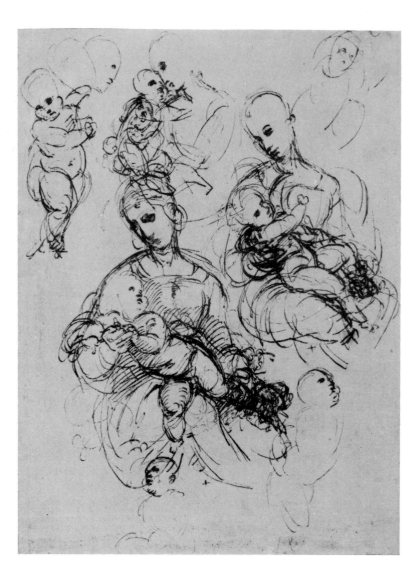

179. Raphael, *Studies of the Madonna and Child*. London, British Museum, Ff.1–36. Pen and ink, over slight sketch in red chalk, on paper; 25.4 × 18.4 cm.

ation for painting, and to have been considered an inappropriate medium for preliminary study.

Shortly before Leonardo's return to Florence, two Central Italian artists independently took new steps in investigating the possibilities of chalk for figure study. The drawings of nudes associated with his Orvieto frescoes of 1499–1502 (95) show Signorelli exploiting the speed of movement of chalk to emphasise the muscular vitality of his models in a vigorous flurry of lines. And in his early drawings (27) Fra Bartolommeo used the tonal subtleties of chalk to evoke an expressive atmosphere around monumental forms treated in broad, flowing planes. Neither of these important experiments had an immediate effect on Michelangelo, however, since neither provided a directly imitable solution to his difficulty with the precise representation of the plastic surface of forms; but both may have been important to him later, in conjunction with the greater impact of Leonardo's ideas. It is perhaps a sign of Michelangelo's traditionalism that he adopted chalk as a medium for figure study only in the context of the competitive project for the two great *Battle* scenes. On this ground Michelangelo soon equalled his rival; but Leonardo was the

initial stimulus in demonstrating the broad range of purposes for which chalk was invaluable, and it was his example which established chalk as the primary technique of the sixteenth-century draughtsman.

Given the impact of Leonardo da Vinci's chalk drawing in Florence after 1500, it is curious that his initial influence on Raphael, the third of the great High Renaissance draughtsmen, was in the handling of the pen.[4] Trained in the temperate, even rarefied, air of Perugino's workshop, Raphael had been accustomed before moving to Florence in 1504 to regarding drawing essentially as the means for carefully preparing a painting. Generally speaking, this suited well his rational, collected temperament. His early drawings have frequently been confused with Perugino's, so closely do they follow his master's considered approach to compositional design or to study from the workshop model. Not unexpectedly, therefore, silverpoint was a favoured technique in Raphael's Perugian drawings. Some fifteen years later, long after Leonardo had abandoned the technique and it had fallen into general disuse, Raphael still relished the control demanded by the stylus for making immaculately precise figure studies. When he arrived in Florence, however, Raphael was bowled over by the freedom of movement of Leonardo's pen. Few drawings survive from this period of his career which do not show his desire to emulate Leonardo's calligraphic verve and imaginative range. Just at the time when Michelangelo became aware of the potential of Leonardo's chalk drawing, Raphael discovered, and explored with characteristically single-minded fervour, Leonardo's innovatory handling of the pen.

It was the freedom and spontaneity of touch of Leonardo's drawings of the late 1470s and early 1480s, as much as those of the early sixteenth century, which stimulated Raphael's burst of creative energy. The way that Leonardo directly transferred his thoughts to paper, rapidly noting a series of ideas in search of the ideal solution to a problem of pose or grouping (109), is closely reflected in Raphael's new, experimental approach to drawing (179). A sense of formal discipline, the heritage of the restrained control of his initial training, survives, however, in the way that Raphael laid out his studies over the sheet, in contrast with the arbitrary placing of Leonardo's fertile, dynamic jottings. Raphael studied and re-studied his group, carefully recording each idea next to the last, to build up an orderly series of possible solutions from which he could synthesise the final version.

The same disciplined approach can be sensed in the gradual evolution of the final composition for the 1507 Borghese *Entombment*.[5] All the drawings which can be associated with this major dramatic work of Raphael's Florentine period are in pen and ink. This reflects both Leonardo's influence and the tradition represented by Ghirlandaio's procedure in preparation for the Tornabuoni Chapel frescoes. One fundamental difference between Raphael's and Ghirlandaio's methods of working out their compositions, however, is that Raphael never included precast motifs transferred from 'pattern' drawings. He studied each figure individually, thinking it out from scratch according to the demands created by its place within the entire composition. Ghirlandaio's and Carpaccio's use of 'pattern' and *simile* drawings still reflects the conventions of the model-book, established at a time when individuality was not an artistic prerequisite and when the difficulties of integrating established formulae into a new composition went

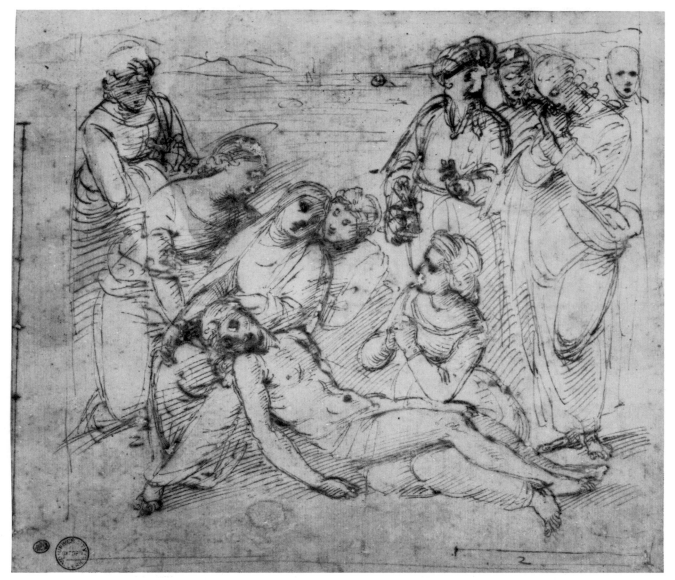

180. Raphael, *Study for the Lamentation*. Oxford, Ashmolean Museum, KP 529. Pen and ink on paper; 12.9 × 20.6 cm.

unheeded. The High Renaissance draughtsman was willing, indeed determined, to use as much paper as was necessary to ensure that his preparatory drawings produced a completely satisfactory solution to the compositional problem. The saving of time and paper by the use and reuse of 'pattern' drawings was ultimately no saving when the result looked stilted or inconsistent.

The preparation for the Borghese *Entombment* therefore probably reflected Leonardo's working method more closely than Ghirlandaio's. Just as Leonardo's graphic handling and technique were the precedent for Raphael's use of the pen in his Florentine works, so also the first *Lamentation* sketch (180) from which the *Entombment* evolved has strong resonances of Leonardo's *Adoration of the Shepherds* sketch (166). In both the figures are lightly drawn, mainly in terms of a fluent contour. For both draughtsmen the purpose of

181. Raphael, *Studies of nudes, for the Lamentation*. Oxford, Ashmolean Museum, KP 530 recto. Pen and ink on paper, pricked for transfer; 32.2 × 19.8 cm.

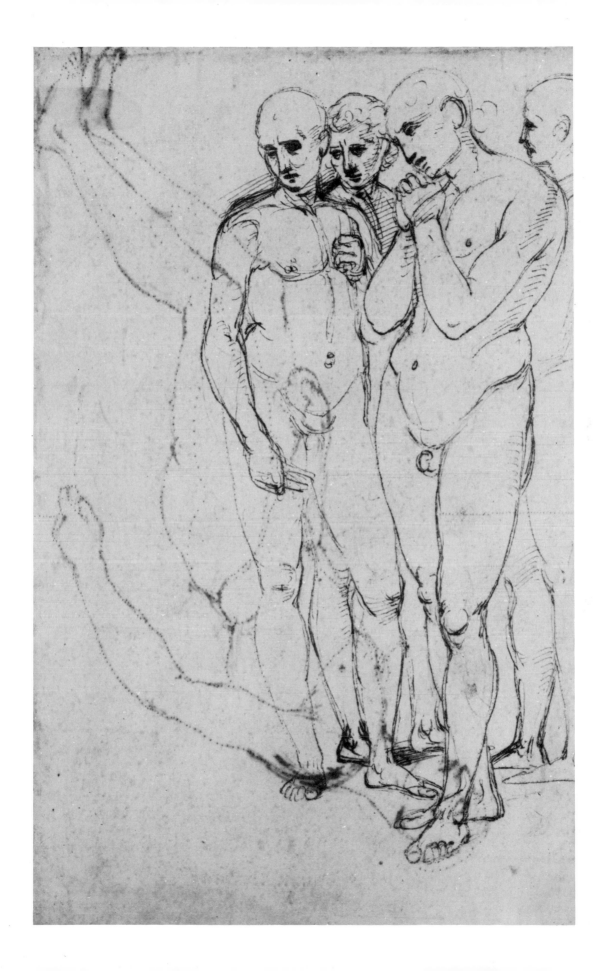

the preliminary sketch was firstly to establish the composition and, loosely, the poses of the figures, and secondly to stimulate more detailed consideration of the figures both independently and in groups. There are also parallels in the next stages of preparation, although they are less clear because of the difficulties of keeping pace with the ebullient fertility of Leonardo's mind. Allowing for Raphael's more controlled approach, the handling in his nude studies for the *Lamentation* (181) reflects Leonardo's (89, 169) in graphic style, and these sheets occupy the same place in the preparatory process.

No drawings from Raphael's Florentine period compare, however, with Leonardo's chalk studies for the *Last Supper*. The cartoon for the Borghese *Entombment* was presumably in chalk, like that (pricked for transfer) for the London *St. Catherine of Alexandria* of about the same date (182). This drawing reflects Fra Bartolommeo's broad atmospheric softness as much as Leonardo's and Michelangelo's rigorously detailed examination of the plastic surface of skin over bone and muscle. It was not until 1509, when he undertook his first monumental fresco cycle in the Stanza della Segnatura of the Vatican, that Raphael began to consider the potential of chalk drawing in figure study, perhaps because he was for the first time working on the same scale as the two *Battle* scenes intended for the Florentine Palazzo Vecchio. This new development in Raphael's chalk drawing was probably stimulated not by Leonardo but by drawings for the Sistine Chapel vault, in which Michelangelo showed his fully mature handling of red chalk. None the less, Leonardo was the vital stimulus for Raphael's development beyond the delicate formality of Perugino's workshop towards the brilliant achievements of his maturity in High Renaissance Rome.

In drawing, as in other fields, Leonardo da Vinci was therefore the pivotal figure between the quattrocento and the High Renaissance. His innovations in the practice of drawing with the pen and with chalk were the crucial catalyst in the development of new attitudes to drawing and a new awareness of the breadth of its potential. His work was also fundamental to the establishment of drawing as an art form in its own right, a form which merited preservation as an illustration of the spontaneous working of a creative imagination. In turn, however, Leonardo depended on the traditions established, sometimes laboriously, during the trecento and earlier in the quattrocento. His extraordinary achievements in delicate and immaculately beautiful silverpoint drawing (colour plate I, 88) had minimal consequences, since the technique was of its very nature inappropriate for exploring the preoccupations of the High Renaissance draughtsman. None the less, they were based on the traditional role played by silverpoint drawing in the training of workshop apprentices, and on the frequent use of the technique for many types of drawing throughout the quattrocento. His skilfully controlled yet vibratingly dynamic pen technique was the culmination of numerous earlier experiments using the pen to note ideas or observations swiftly, or to develop individual calligraphic styles. Underlying his achievements in this field were on the one hand the fluent experiments of Stefano da Verona (41), Parri Spinelli (57–9, 101–2) and especially Pisanello (51–3, 129–31) earlier in the century, and on the other hand the more deliberate investigations of Pollaiuolo (colour plate V, 80–1) and Verrocchio (86–7) into the 'sculptural' qualities and potential of the pen line. Finally, his use of chalk was based on the spasmodic struggles of earlier draughtsmen to achieve smooth plasticity of form by gradual and

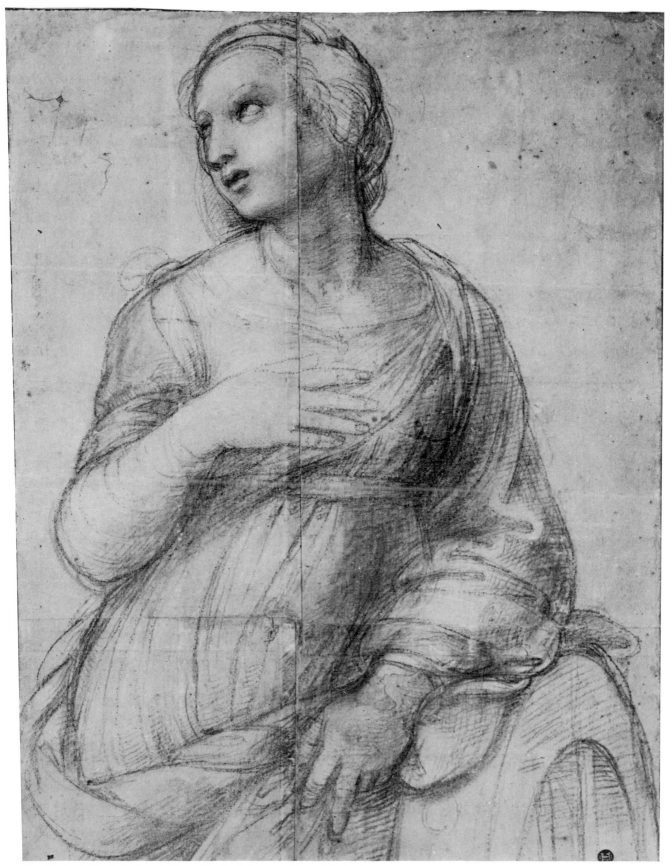

182. Raphael, *St. Catherine of Alexandria*. Paris, Louvre, F.207. Black chalk on paper, pricked for transfer; 58.4 × 43.5 cm.

imperceptible changes of tone. In this respect, Leonardo built on foundations made up of several different elements. These include the limited experiments in large-scale drawing in charcoal or sinoper in preparation for mural painting (12–14, 19), and experiments in brush drawing (especially in Venice) which closely emulated the technique of painting on panel (2, 30, 94). Perhaps the major element was, however, the slow but sure increase in the use of chalks for particular purposes, such as the initial sketches for compositional designs (in Venice and elsewhere), the full-scale cartoon, underdrawing on panel in preparation for painting, and the presentation portrait drawing in late quattrocento Venice (4). All these developments in chalk drawing contributed to the experimental stock from which Leonardo evolved his formative innovations.

The extraordinarily rapid changes and developments in the practice of drawing discussed in the earlier chapters were clearly indispensable to the heritage both of Leonardo and of the early cinquecento draughtsmen who benefitted from his example. The new theoretical preoccupations examined in detail by early Renaissance draughts-men, the increasing availability and use of paper, and the growing range and awareness of the possibilities of drawing techniques were all crucial to the achievements of the great masters of the High Renaissance. During the quattrocento drawing became more and more securely the foundation of artistic practice, for Ghiberti the 'fondamento e teorica' of sculpture and painting. Artists developed their ideas more and more often by drawing on paper: it is therefore in their drawings that we can best see their spontaneous responses to the influence of other artists' works, to theoretical innovations and to nature herself. Artists used drawings more frequently for the logical development of compositions, from the preliminary sketched idea to the fully formulated design. Through examin-ation of an artist's drawings we can begin to trace the way he considered a compositional problem in the light of new theoretical concerns with narrative design and with the natural, affective movements of the figures.

The paucity of extant drawings by many major quattrocento artists – none by Masaccio, for instance, and only some half-dozen by Verrocchio – has distracted us from fully appreciating the importance of drawing both for the artist and for our understand-ing of his activities. We have consequently developed an over-balanced preoccupation with the finished products which issued from his workshop. Pitifully few quattrocento drawings, to be sure, have survived the passage of five centuries. None the less, when considered as far as is possible in the context of the time, place and manner of their production, those that have survived can often be persuaded to reveal much more about the artists' interests and working practices than is generally realised. Just as drawing was the foundation of the training and activity of the Renaissance artist, so also the study of drawing is essential to a fuller understanding of early Renaissance art.

Notes to the Text

NOTES TO CHAPTER I

1. Ghiberti/Schlosser 1912, p. 23.
2. Cennini/Thompson 1954, ch. IIII, p. 3
3. For the most recent discussion of the date of Cennino's treatise, see C. Cennini, *Il Libro dell' Arte*, ed. L. Magagnato, Vicenza 1971, pp. v–vi.
4. Vasari/Maclehose 1907. The passage on drawing appears in chapters I–II of the section *On Painting*, pp. 212–15.
5. Leonardo/McMahon 1956 is the edition of Leonardo's *Trattato* from which all quotations are derived.
6. Alberti/Grayson 1972 is the translation of *de Pictura* used throughout this book.
7. Quotations from Vasari's *Vite* are normally taken from Vasari/Bull 1965.
8. 'Design, the parent of our three arts Architecture, Sculpture and Painting': Vasari/Maclehose 1907, p. 205.
9. Vasari's book of drawings has been reconstructed by L. Ragghianti Collobi, *Il Libro de' disegni del Vasari*, Florence 1974. See also O. Kurz, 'Giorgio Vasari's "Libro"', *Old Master Drawings* XII, 1938, pp. 1–15.
10. 'This work not only won the astonished admiration of all the artists but when finished for two days it attracted to the room where it was exhibited a crowd of men and women, young and old, who flocked there, as if they were attending a great festival, to gaze in amazement at the marvels he had created': Vasari/Bull 1965, pp. 265–6.
11. Quoted by L. Goldscheider, *Michelangelo Drawings*, London 1966, p. 17; and see also B. Cellini, *The Life of Benvenuto Cellini*, trans. J. A. Symonds, London 1889, p. 22.
12. K. Clark, *Leonardo da Vinci*, Harmondsworth 1967, pp. 119–20; see also Vasari/Bull 1965, p. 260: 'For his very close friend Antonio Segni, Leonardo drew on a sheet of paper a Neptune executed with such fine draughtsmanship and diligence that it was utterly convincing.' For Leonardo's drawings, see A. E. Popham, *The Drawings of Leonardo da Vinci*, London 1946; and K. Clark, *The Drawings of Leonardo da Vinci in the Collection of Her Majesty the Queen at Windsor Castle*, 2nd edition, revised with the assistance of C. Pedretti, London 1978–9.
13. For Signorelli's drawings, see B. Berenson, 'Les Dessins de Signorelli', *Gazette des Beaux-Arts* 6°, VII, 1932, pp. 173–210; and A. Martindale, 'Luca Signorelli and the Drawings connected with the Orvieto Frescoes', *Burlington Magazine* CIII, 1961, pp. 216–20.
14. Scheller 1963, pp. 142–54; van Schendel 1938, p. 60; and the facsimile reprint *Giovannino de' Grassi Taccuino di disegni: codice della Biblioteca Civica di Bergamo*, Monumenta Bergomensia V, Milan 1961.
15. See Tietze 1944, p. 102; and Gilbert 1980, pp. 35–6; and for Jacopo's books of drawings, see the facsimile reprints by C. Ricci, *Iacopo Bellini e i suoi libri di disegni*, Florence 1908; and V. Goboulew, *Les Dessins de Jacopo Bellini au Louvre et au British Museum*, Brussels 1912. Important studies of Jacopo Bellini's books of drawings are by M. Röthlisberger, 'Studi su Jacopo Bellini', *Saggi e memorie di storia dell'arte* II, 1958–9, pp. 43–89; and by C. Joost-Gaugier, 'The "Sketch-Books" of Jacopo Bellini Reconsidered', *Paragone* 297, 1974, pp. 24–41.
16. C. Mitchell, 'Felice Feliciano *Antiquarius*', *Proceedings of the British Academy* XLVII, 1961, pp. 199–200.
17. For the history of collecting, see Meder-Ames 1978, pp. 478–85; and de Tolnay 1943, ch. VIII, pp. 76–86.
18. B. Cellini, *Trattati dell'oreficeria e della scultura*, ed. L. De-Mauri, Milan 1927, pp. 4–5. The translation is quoted from J. White, 'Paragone: Aspects of the Relationship between Sculpture and Painting', in *Art, Science and History in the*

Renaissance, ed. C. Singleton, Baltimore 1968, p. 101: this article includes important and perceptive comments on quattrocento drawings. For Pollaiuolo's drawings, see Berenson 1938, I, pp. 17–29; and L. D. Ettlinger, *Antonio and Piero Pollaiuolo*, London 1978, pp. 159–62.

19. See A. Martindale, *The Triumphs of Caesar in the Collection of Her Majesty the Queen at Hampton Court*, London 1979, pp. 23 and 76, n.3.

20. See the letter from Raphael to Francia of 5 September 1508 in V. Golzio, *Raffaello nei documenti . . .*, Città di Vaticano 1936, pp. 19–20; and the inscription on the drawing sent to Dürer, *ibid.*, p. 36.

21. de Tolnay 1943, p. 76.

22. *ibid.*, p. 76.

23. The opposite sides of the case are discussed by E. Panofsky, 'Das erste Blatt aus dem "Libro" Giorgio Vasaris', *Städel-Jahrbuch* VI, 1930, pp. 25–72 (the abridged translation, 'The First Page of Giorgio Vasari's "*Libro*"', in *Meaning in the Visual Arts*, Harmondsworth 1970, pp. 206–76, omits the crucial section); and by R. Oertel, 'Wandmalerei und Zeichnung in Italien', *Mitteilungen des Kunsthistorischen Institutes in Florenz* V, 1940, pp. 217–314. See also B. Degenhart, 'Autonome Zeichnungen bei mittelalterlichen Künstlern', *Münchner Jahrbuch der Bildenden Kunst* I, 1950, pp. 93–158; and for general discussion, de Tolnay 1943, pp. 28–35; Evans 1969, pp. 16–17; and Meder-Ames 1978, pp. 5–15.

24. '[et] sacies bien q[u]'il fu contrefais al vif': see H. R. Hahnloser, *Villard de Honnecourt: Kritische Gesamtausgabe des Bauhüttenbuches ms. fr. 19093 der Pariser Nationalbibliothek*, Graz 1972, pp. 145–8; and Scheller 1963, pp. 88–93.

25. Cennini/Thompson 1954, ch. VIII, p. 5

26. *ibid.*, ch. XXVII, p. 15

27. *ibid.*, ch. II, p. 2.

28. *ibid.*, ch. XXVII, p. 15.

29. Ettlinger, *Pollaiuolo*, 1978, p. 161.

30. Leonardo/McMahon 1956, para. 61, p. 46.

31. *ibid.*, para. 59, p. 45.

32. Gilbert 1980, p. 163.

33. *ibid.*, p. 156.

NOTES TO CHAPTER II

1. Cennini/Thompson 1954, chs. V–VI, p. 4; see further, Meder-Ames 1978, pp. 135–7.

2. This discussion of paper is derived principally from L. Febvre and H.-J. Martin, *L'Apparition du livre*, Paris 1958 and 1971. Also useful are: A. Blum, *On the Origin of Paper*, New York 1934; R. H. Clapperton, *Paper: An Historical Account of its Making by Hand from the Earliest Times down to the Present Day*, Oxford 1934; T. L. de Vinne, *Notable Printers of Italy during the Fifteenth Century*, New York 1910; D. C. Mc-Murtie, *The Book: The Story of Printing and Bookmaking*, New York 1937; E Sutermeister, *The Story of Papermaking*, Boston 1954; D. Hunter, *Papermaking through Eighteen Centuries*, New York 1957; and C. F. Bühler, *The Fifteenth-Century Book*, Philadelphia 1960.

3. Cennini/Thompson 1954, p. 111.

4. Much of the material in the following pages is based on the discussion in U. Procacci, *Sinopie e affreschi*, Milan 1961; and L. Tintori and M. Meiss, *The Painting of the Life of St. Francis in Assisi*, New York 1967, especially pp. 3–42 and 200–7.

5. Cennini/Thompson 1954, chs. XXXVIII, p. 23, and LXVII, pp. 42–4.

6. *ibid.*, ch. LXVII, p. 43

7. Alberti/Grayson 1972, para. 31, p. 69; and cf. Leonardo/McMahon, para. 119, pp. 65–6: 'If you wish to become really accustomed to correct and good poses of figures, divide a frame or stretcher by threads into squares inside, and fasten it between your eye and the nude that you draw, and make those same squares lightly on the paper on which you wish to draw that nude', and Ghiberti's advice, Ghiberti/Schlosser 1912, p. 233.

8. Alberti/Grayson 1972, para. 61, p. 105.

9. Cennini/Thompson 1954, chs. LXVII–LXVIIII, pp. 42–8.

10. For these sinopie and frescoes, see F. Enaud, *Simone Martini à Avignon* (Les Monuments historiques de la France IX, 3), Paris 1963.

11. Cennini/Thompson 1954, ch. VIIII, p. 6.

12. *ibid.*, p. 37: 'Then you prepare your pounce patterns according to the clothes which you want to make; that is, first draw them on parchment; and then prick them carefully with a needle, holding a piece of canvas or cloth under the paper. Or do the pricking over a poplar or linden board; that is better than the canvas. When you have got them pricked, take dry colors according to the colors of the cloths upon which you have to pounce. If it is a white cloth, pounce with charcoal dust wrapped up in a bit of rag; if the cloth is black, pounce it with white lead, with the powder done up in a rag.'

NOTES TO CHAPTER III

1. Cennini/Thompson 1954, ch. V, p. 4. Much of the material in this chapter is derived from

Watrous 1957, a highly detailed and fascinating discussion of drawing techniques.

2. Watrous 1957, pp. 10–12.
3. Cennini/Thompson 1954, ch. XVI, pp. 9–10,
4. *ibid.*, ch. XV, p. 9.
5. *ibid.*, ch. XVI–XXII, pp. 9–12.
6. *ibid.*, ch. XIII, p. 8.
7. Watrous 1957, ch. IV, pp. 66–74.
8. Cennini/Thompson 1954, chs. XXX, p. 17, LXVII, pp. 42–3, and CXXII, p. 75.
9. *ibid.*, ch. XXXIIII, p. 20.
10. Watrous 1957, ch. V, pp. 91–106.

NOTES TO CHAPTER IV

1. Scheller 1963, pp. 1–7. Scheller's book is the primary source for this section. See also van Schendel 1938, pp. 57–70; and Evans 1969, pp. 14–15.
2. Scheller 1963, pp. 88–93; Hahnloser, *Villard de Honnecourt,* 1972, *passim.*
3. Cennini/Thompson 1954, ch. CXXII, p. 75.
4. Gilbert 1980, p. 163.
5. Scheller 1963, p. 17.
6. Cennini/Thompson 1954, ch. LXX, p. 49.
7. Scheller 1963, p. 144.
8. G. F. Hill, *Drawings by Pisanello*, New York 1965, pp. 17–18. Further on Pisanello's drawings, see M. Fossi Todorow, *I disegni del Pisanello e della sua cerchia*, Florence 1966.
9. B. Degenhart and A. Schmitt, 'Gentile da Fabriano in Rom und die Anfänge der Antikerstudiums', *Münchner Jahrbuch für Bildenden Kunst* XI, 1960, pp. 59–151. The description *taccuino di viaggi* is used by Fossi: Todorow, *Disegni del Pisanello*, pp. 47–8 and 121–40.
10. For the Palaeologus drawings, see M. Vickers, 'Some Preparatory Drawings for Pisanello's Medallion of John VIII Palaeologus', *Art Bulletin* LX, 1978, pp. 417–24.
11. Vasari/Bull 1965, p. 98.
12. *ibid.*, p. 103.
13. Scheller 1963, p. 17.
14. B. Degenhart, 'Domenico Veneziano als Zeichner', in *Festschrift Friedrich Winkler*, Berlin 1959, pp. 100–13.
15. F. Knapp, *Fra Bartolommeo della Porta und die Schule von San Marco*, Halle a.S. 1903, p. 275.
16. For this sketch-book, see G. Gronau, 'Über das sogennante Skizzenbuch des Verrocchio', *Jahrbuch der Königlich Preussischen Kunstsammlungen* XVII, 1896, pp. 65–72; and A. E. Popham and P. Pouncey, *Italian Drawings in . . . the British Museum: The Fourteenth and Fifteenth Centuries*, London 1950, I, pp. 38–40.

17. Leonardo/McMahon 1956, para. 249, p. 105; and further, para. 258, p. 107: 'Make a note . . . with a few lines in your little book which you should always take with you. Its pages should be of colored paper, so that you cannot rub your sketch out, but will have to change from an old page to a new when the old one is filled. For these are not things to be erased but preserved with great care, because these forms and actions are so infinite in number that the memory is not capable of retaining them, wherefore keep your sketches as your aids and teachers.'
18. *ibid.*, p. 104.
19. Cennini/Thompson 1954, ch. XXVIIII, p. 16.
20. O. Fischel, *Die Zeichnungen der Umbrer*, Berlin 1917, pp. 157–87.
21. F. Ames-Lewis, 'Drapery "Pattern"-Drawings in Ghirlandaio's Workshop; and Ghirlandaio's early Apprenticeship', *Art Bulletin* LXIII, 1981, pp. 49–62.
22. Tietze 1948, pp. 66–7.

NOTES TO CHAPTER V

1. Alberti/Grayson 1972, for example paras. 36–9, pp. 73–7, and paras. 42–4, pp. 81–5.
2. *ibid.*, para. 58, p. 101.
3. *ibid.*, para. 36, p. 75.
4. *ibid.*, para. 42, p. 81.
5. Leonardo/McMahon 1956, para. 124, p. 67.
6. Alberti/Grayson 1972, para. 46, p. 89.
7. *ibid.*, para. 46, p. 89.
8. Vasari/Bull 1965, p. 188: 'His draughtsmanship was strong and he made his designs so skilfully and boldly that they have no equal.' See also H. W. Janson, *The Sculpture of Donatello*, Princeton 1963, p. 217, quoting an anecdote about the speed of Donatello's drawing included in Pomponius Gauricus' *de Sculptura* and casting doubt on the validity of these sources. For attributions to Donatello, see the discussion in B. Degenhart and A. Schmitt, *Corpus der Italienischen Zeichnungen, 1300–1450: 1. Süd- und Mittelitalien*, Berlin 1968, 2, pp. 343–66.
9. J. Pope-Hennessy, *Luca della Robbia*, Oxford 1980, p. 233; and in the same year Luca was paid 'per sua fatica d'un disegno e d'un modello di terra fe' per fare la sepoltura d'Ughone', i.e. Count Hugo of Tuscany; *ibid.*, p. 234.
10. Vasari/Bull 1965, p. 243.
11. The attribution of drawings between Mantegna and Giovanni Bellini is particularly problematical. For recent discussion, see G. Robertson, *Giovanni Bellini*, London 1968, pp. 21–8, with many further bibliographical references.

12. Quoted by E. Gombrich, 'Leonardo's Method for Working out Compositions', in *Norm and Form*, London 1971, pp. 60 and 59 resp.; see Leonardo/McMahon 1956, para. 257, p. 107 and para. 261, p. 108.
13. Leonardo/McMahon 1956, para. 76, p. 51.
14. Gombrich, *Norm and Form*, 1971, p. 58.

NOTES TO CHAPTER VI

1. Alberti/Grayson 1972, p. 83: 'They also praise in Rome the boat in which our Tuscan painter Giotto represented the eleven disciples struck with fear and wonder at the sight of their colleague walking on the water, each showing such clear signs of his agitation in his face and entire body that their individual emotions are discernible in every one of them.'
2. A. C. Hanson, *Jacopo della Quercia's Fonte Gaia*, Oxford 1965, pp. 11–13, and Document 4, pp. 89–90.
3. G. Vasari, *Lives of the Painters, Sculptors and Architects*, ed. W. Gaunt, London 1927, I, p. 214.
4. Tietze 1948, p. 13.
5. D. Chambers, *Patrons and Artists in the Italian Renaissance*, London 1970, pp. 172–5, and see below, p. 146. Further examples of contracts are given in H. Glasser, *Artists' Contracts of the Early Renaissance*, Ann Arbor 1968, especially pp. 115–49.
6. Cennini/Thompson 1954, ch. CXXII, p. 75.
7. *ibid.*, ch. CXXII, p. 75.
8. *ibid.*, ch. LXVII, pp. 42–3.
9. Alberti/Grayson 1972, para. 61, p. 103.
10. A. E. Popham and P. Pouncey, *Italian Drawings in the . . . British Museum: The Fourteenth and Fifteenth Centuries*, London 1950, p. 5; and cf. Pisanello's sheet of studies of Emperor John VIII Palaeologus (52), which is inscribed: 'The hat of the Emperor should be white on top and red underneath, the profile black all round. The

doublet of green damask and the mantle on top crimson. A black beard on a pale face, hair and eyebrows alike. The eyes between gray and green, and the stooped shoulders of a small person. The boots of pale yellow leather; the sheath of the bow brown and grained, and also that of the quiver and of the scimitar'; see Vickers, *Art Bulletin* 1978, p. 419.
11. On Carpaccio's drawings, see J. Lauts, *Carpaccio*, London 1962, pp. 41–3 and 265–84; and M. Muraro, *I disegni di Vittore Carpaccio*, Florence 1977.
12. Chambers, *Patrons and Artists*, p. 175.
13. Ames-Lewis, *Art Bulletin* 1981, pp. 49–62.
14. For this drawing, see E. Panofsky, *Early Netherlandish Painting*, Cambridge, Mass. 1953, p. 200. The drawing has colour-notes to the drapery ('yellowish and whitish-blue', 'purplish red') and to the features ('the lips very whitish', 'the nose a little sanguineous').

NOTES TO THE EPILOGUE

1. For Michelangelo's early drawings, see Goldscheider, *Michelangelo Drawings*, 1966; L. Dussler, *Die Zeichnungen des Michelangelo*, Berlin 1959; and C. de Tolnay, *Corpus dei disegni di Michelangelo* I, Florence 1978.
2. Vasari/Bull 1965, p. 327.
3. *ibid.*, p. 328.
4. For Raphael's drawings, see O. Fischel, *Raffaels Zeichnungen*, Berlin 1913–41; U. Middeldorf, *Raphael's Drawings*, New York 1945; and R. Cocke, *The Drawings of Raphael*, London 1969.
5. For the development of the Borghese *Entombment*, see J. Pope-Hennessy, *Raphael*, London n.d., pp. 50–8; and I. Richter, 'A Contribution to the Understanding of Raphael's Art: The Drawings for the *Entombment*', *Gazette des Beaux-Arts* 6°, XXVIII, 1945, pp. 335–56.

Bibliography

WORKS ABBREVIATED IN THE NOTES TO THE TEXT

Sources

Alberti/Grayson 1972 Leon Battista Alberti, *On Painting and On Sculpture*, trans. and ed. C. Grayson, London 1972.

Cennini/Thompson 1954 Cennino Cennini, *The Craftsman's Handbook 'Il Libro dell'Arte'*, trans. D. V. Thompson Jr., New Haven 1933 and New York 1954.

Ghiberti/Schlosser 1912 Lorenzo Ghiberti, *Commentarii*, ed. J. Schlosser, Berlin 1912.

Gilbert 1980 C. Gilbert, *Italian Art, 1400–1500* (Sources and Documents in the History of Art series), Englewood Cliffs, N.J. 1980.

Leonardo/McMahon 1956 Leonardo da Vinci, *Treatise on Painting*, trans. and annot. A. P. McMahon, 2 vols., Princeton 1956.

Vasari/Bull 1965 G. Vasari, *Lives of the Artists*, trans. G. Bull, Harmondsworth 1965.

Vasari/Maclehose 1907 G. Vasari, *On Technique*, trans. L. S. Maclehose, London 1907.

General

Berenson 1938 B. Berenson, *The Drawings of the Florentine Painters*, 3 vols., Chicago 1938.

Evans 1969 M. W. Evans, *Medieval Drawings*, London 1969.

Meder-Ames 1978 J. Meder and W. Ames, *The Mastery of Drawing*, 2 vols., New York 1978 (an augmented translation of J. Meder, *Die Handzeichnung*, Vienna 1919)

Scheller 1963 R. W. Scheller, *A Survey of Medieval Model Books*, Haarlem 1963.

van Schendel 1938 A. van Schendel, *Le Dessin en Lombardie jusqu'à la fin du XV siècle*, Brussels 1938.

Tietze 1944 H. Tietze and E. Tietze-Conrat, *The Drawings of the Venetian Painters in the 15th and 16th Centuries*, 2 vols., New York 1944.

de Tolnay 1943 C. de Tolnay, *History and Technique of Old Master Drawings*, New York 1943.

Watrous 1957 J. Watrous, *The Craft of Old-Master Drawings*, Madison, Wis. 1957.

WORKS ON DRAWING AND DRAWINGS

General

L. Collobi Ragghianti *Il Libro de' disegni del Vasari*, Florence 1974.

B. Degenhart 'Autonome Zeichnung bei mittelalterliche Kunstlern', *Münchner Jahrbuch der Bildenden Kunst* 1, 1950, pp. 93–158.

BIBLIOGRAPHY

B. Degenhart and A. Schmitt	*Corpus der Italienischen Zeichnungen, 1300–1450, I: Sud- und Mittelitalien,* 4 vols., Berlin 1968.

I Disegni dei maestri: L'Italia dalle origini a Pisanello, ed. M. Fossi Todorow, Milan 1970.

H. S. Ede	*Florentine Drawings of the Quattrocento,* London 1926.
O. Fischel	*Die Zeichnungen der Umbrer,* Berlin 1917.
A. Forlani Tempesti	*I grandi disegni degli Uffizi,* Milan n.d.
P. Goldman	*Looking at Drawings: A Guide to Technical Terms,* London 1979.
L. Grassi	*Il disegno italiano dal trecento al seicento,* Rome 1956.
L. Grassi	*Storia del disegno: Svolgimento del pensiero critico e un catalogo,* Rome 1957.
D. von Hadeln	*Venezianische Zeichnungen der Quattrocento,* Berlin 1925.
O. Kurz	'Giorgio Vasari's "Libro"', *Old Master Drawings* XII, 1938, pp. 1–15.
R. Oertel	'Wandmalerei und Zeichnung in Italien', *Mitteilungen des Kunsthistorischen Institutes in Florenz* V, 1940, pp. 217–314.
E. Panofsky	'Das erste Blatt aus dem "Libro" Giorgio Vasaris', *Städel-Jahrbuch* VI, 1930, pp. 25–72.
U. Procacci	*Sinopie e affreschi,* Milan 1961.
C. Ragghianti and G. Dalli Regoli	*Firenze, 1470–1480: Disegni dal Modello,* Pisa 1975.
P. Rawson	*Drawing,* London 1969.

Museum and Exhibition Catalogues

I. Budde	*Beschreibender Katalog der Handzeichnungen in der Staatliche Kunstakademie Düsseldorf,* Düsseldorf 1930.
J. Byam-Shaw	*Drawings by Old Masters at Christ Church Oxford,* 2 vols., Oxford 1976.
K. Clark and C. Pedretti	*The Drawings of Leonardo da Vinci in the Collection of Her Majesty the Queen at Windsor Castle,* 3 vols., London 1978–9.
London 1981	*Drawing: Technique & Purpose,* ed. S. Lambert, London 1981
Munich 1966	*Italienische Zeichnungen der Früh-Renaissance,* ed. B. Degenhart, Munich 1966.
New York 1968	*Great Drawings of the Louvre Museum: The Italian Drawings,* ed. R. Bacou, New York 1968.
K. Parker	*Catalogue of the Collection of Drawings in the Ashmolean Museum, II: Italian School,* 2 vols., Oxford 1956.
A. E. Popham and P. Pouncey	*Italian Drawings in the Department of Prints and Drawings of the British Museum: The Fourteenth and Fifteenth Centuries,* 2 vols., London 1950.
A. E. Popham and J. Wilde	*The Italian Drawings of the XV and XVI centuries in the Collection of H.M. the King at Windsor Castle,* London 1949.
P. Pouncey and J. Gere	*Italian Drawings in the Department of Prints and Drawings of the British Museum: Raphael and his Circle,* 2 vols., London 1962.
Rome 1979	*Disegni toscani e umbri del primo Rinascimento dalle collezioni del Gabinetto Nazionale delle Stampe,* ed. E. Beltrame Quattrocchi, Rome 1979.
A. Stix	*Beschreibender Katalog der Handzeichnungen in der Graphischen Sammlung Albertina,* 6 vols., Vienna 1926–41.
Uffizi 1978	*I disegni antichi degli Uffizi: I tempi del Ghiberti,* ed. L. Bellosi, Florence 1978.
J. Wilde	*Italian Drawings in the Department of Prints and Drawings of the British Museum: Michelangelo and his Studio,* London 1953.

Individual Draughtsmen

F. Ames-Lewis	'Drapery "Pattern"-Drawings in Ghirlandaio's Workshop; and Ghirlandaio's early Apprenticeship', *Art Bulletin* LXIII, 1981, pp. 49–62.

BIBLIOGRAPHY

B. Berenson 'Les dessins de Signorelli', *Gazette des Beaux-Arts* 6°, VII, 1932, pp. 173–210.

R. Cocke *The Drawings of Raphael*, London 1969.

B. Degenhart 'Domenico Veneziano als Zeichner', *Festschrift Friedrich Winkler*, Berlin 1959, pp. 100–13.

B. Degenhart and A. Schmitt 'Gentile da Fabriano in Rom und die Anfänge der Antikerstudiums', *Münchner Jahrbuch für Bildenden Kunst* XI, 1960, pp. 59–151.

L. Dussler *Die Zeichnungen des Michelangelo*, Berlin 1959.

H. Egger *Codex Escurialensis: Ein Skizzenbuch aus der Werkstatt Domenico Ghirlandaios*, 2 vols., Vienna 1906.

G. Fiocco 'Disegni di Stefano da Zevio', *Proporzioni* III, 1950, pp. 56–64.

O. Fischel *Raffaels Zeichnungen*, 8 vols., Berlin 1913–41.

M. Fossi Todorow *I disegni del Pisanello e della sua cerchia*, Florence 1966.

Giovannino de' Grassi. Taccuino di disegni: codice della Biblioteca Civica di Bergamo, Monumenta Bergomensia V, Milan 1961.

V. Goboulew *Les Dessins de Jacopo Bellini au Louvre et au British Museum*, 2 vols., Brussels 1912.

L. Goldscheider *Michelangelo Drawings*, London 1966.

E. Gombrich 'Leonardo's Method for Working out Compositions', in *Norm and Form*, London 1971, pp. 58–63.

G. Gronau 'Uber das sogennante Skizzenbuch des Verrocchio', *Jahrbuch der Königlich Preussischen Kunstsammlungen* XVII, 1896, pp. 65–72.

H. R. Hahnloser *Villard de Honnecourt: Kritische Gesamtausgabe des Bauhüttenbuches ms. fr. 19093 der Pariser Nationalbibliothek*, Graz 1972.

G. F. Hill *Drawings by Pisanello*, Paris 1929 and New York 1965.

C. Joost-Gaugier 'The "Sketch-Books" of Jacopo Bellini Reconsidered', *Paragone* 297, 1974, pp. 24–41.

A. Martindale 'Luca Signorelli and the Drawings connected with the Orvieto Frescoes', *Burlington Magazine* CIII, 1961, pp. 216–20.

U. Middeldorf *Raphael's Drawings*, New York 1945.

M. Muraro *I disegni di Vittore Carpaccio*, Florence 1977.

A. E. Popham *The Drawings of Leonardo da Vinci*, London 1946.

C. Ricci *Iacopo Bellini e i suoi libri di disegni*, 2 vols., Florence 1908.

I. Richter 'A Contribution to the Understanding of Raphael's Art: The Drawings for the *Entombment*', *Gazette des Beaux-Arts* 6°, XXVIII, 1945, pp. 335–56.

M. Röthlisberger 'Studi su Jacopo Bellini', *Saggi e memorie di storia dell'arte* II, 1958–9, pp. 43–89.

C. de Tolnay *Corpus dei disegni di Michelangelo*, 3 vols. (so far), Florence 1978– .

M. Vickers 'Some Preparatory Drawings for Pisanello's Medallion of John VIII Palaeologus', *Art Bulletin* LX, 1978, pp. 417–24.

OTHER WORKS CITED

A. Blum *On the Origin of Paper*, New York 1934.

C. F. Bühler *The Fifteenth-Century Book*, Philadelphia 1960.

B. Cellini *Trattati dell'oreficeria e della scultura*, ed. L. De-Mauri, Milan 1927.

C. Cennini *Il Libro dell'Arte*, ed. L. Magagnato, Vicenza 1971.

D. S. Chambers *Patrons and Artists in the Italian Renaissance*, London 1970.

BIBLIOGRAPHY

R. H. Clapperton	*Paper: An Historical Account of its Making by Hand from the Earliest Times down to the Present Day*, Oxford 1934.
K. Clark	*Leonardo da Vinci*, Harmondsworth 1959.
F. Enaud	*Simone Martini à Avignon*, Paris 1963.
L. Ettlinger	*Antonio and Piero Pollaiuolo*, London 1978.
L. Febvre and H.-J. Martin	*L'Apparition du livre*, Paris 1971.
H. Glasser	*Artists' Contracts of the Early Renaissance*, Ann Arbor 1968.
V. Golzio	*Raffaello nei documenti . . .*, Città di Vaticano 1936.
A. C. Hanson	*Jacopo della Quercia's Fonte Gaia*, Oxford 1965.
D. Hunter	*Papermaking through Eighteen Centuries*, New York 1957.
H. W. Janson	*The Sculpture of Donatello*, Princeton 1963.
F. Knapp	*Fra Bartolommeo della Porta und die Schule von San Marco*, Halle a.S. 1903.
J. Lauts	*Carpaccio*, London 1962.
D. C. McMurtie	*The Book: The Story of Printing and Bookmaking*, New York 1937.
A. Martindale	*The Triumphs of Caesar in the Collection of Her Majesty the Queen at Hampton Court*, London 1979.
C. Mitchell	'Felice Feliciano *Antiquarius*', *Proceedings of the British Academy* XLVII, 1961, pp. 197–221.
E. Panofsky	*Early Netherlandish Painting*, Cambridge, Mass. 1953.
J. Pope-Hennessy	*Luca della Robbia*, Oxford 1980.
J. Pope-Hennessy	*Raphael*, London n.d.
G. Robertson	*Giovanni Bellini*, Oxford 1968.
E. Sutermeister	*The Story of Papermaking*, Boston 1954.
L. Tintori and M. Meiss	*The Painting of the Life of St. Francis in Assisi*, New York 1967.
T. L. de Vinne	*Notable Printers of Italy during the Fifteenth Century*, New York 1910.
J. White	'Paragone: Aspects of the Relationship between Sculpture and Painting', in *Art, Science and History in the Renaissance*, ed. C. Singleton, Baltimore 1968.

Glossary

TECHNICAL terms in italics are discussed in detail elsewhere in the Glossary.

auxiliary cartoon	see *cartoon*
black chalk	A carbonaceous shale, referred to by Cennini (Thompson 1954, XXXIIII, p. 20) as coming from Piedmont, or according to Vasari (Maclehose 1907, p. 213) 'from the hills of France', which adheres strongly and indelibly to paper. Sufficiently cohesive to be sawn and cut into sticks, it had also to be friable and fine-textured enough to make strong, dense black marks on *paper*.
bodycolour	Opaque paint prepared by mixing a pigment and lead white with a binding medium, sometimes applied with a brush to a drawing, especially one in a *model-book*.
boxwood tablets	Thin panels of the very close-grained boxwood (for which fig-wood may be substituted; Cennini/Thompson 1954, V–VI, p. 4), surfaced as for *prepared paper* and used for experimental drawing. After the usefulness of the drawing is through, the preparation can be scraped off and reapplied: boxwood tablets are therefore reusable almost indefinitely.
bozzetto	Small model, in wax or clay, made in preparation for sculpture.
brush drawing	Drawing made by applying a water-soluble pigment (or diluted ink) to *paper* with a fine brush, normally of sable or miniver (fur from the tail normally of a stoat, weasel or squirrel; Cennini/Thompson 1954, LXIIII, pp. 40–1).
cartoon	Full-scale drawing, normally in *black chalk*, made at the final stage of preparation of a painting. During the fifteenth century cartoons were normally used only for important details, in wall painting in conjunction with a *sinopia*. The fifteenth-century cartoon was a 'spolvero', i.e. the drawing was transferred to the surface to be painted by pricking small holes in the paper along the outlines of the forms and 'pouncing' charcoal dust through the holes from a muslin bag, to leave dotted lines on the surface (Cennini/Thompson 1954, p. 87 on the use of 'pounce patterns', and p. 111 on the use of cartoons for stained-glass). In the execution of the painting the cartoon could also function as an 'auxiliary cartoon' (a term applied by Oskar Fischel originally to independent studies made by Raphael from *stylus* tracings from cartoons), closely guiding the painter's detailed work on the forms being painted.
chalk	see *black chalk*; *red chalk*
charcoal	Drawing material prepared by roasting sticks of willow in an air-tight pot (Cennini/Thompson 1954 XXXIII, p. 19), and used for broad preliminary sketching on paper, wall or panel. Charcoal has the technical advantage that it can easily be erased with a bunch of feathers (Cennini/Thompson 1954, CXXII, p. 75); but for this reason, and because it smudges very easily, charcoal drawings seldom survive.
contract drawing	Detailed compositional drawing approved by patron, on the basis of which an artist was legally obliged by his contract of commission to produce the finished work. Here used as distinct from *presentation drawing*.
heightening	A light-toned pigment, usually 'white lead well worked up with gum arabic' (Cennini/Thompson 1954, XXXI, p. 18; cf. Vasari/Maclehose 1907, p. 213)

GLOSSARY

	applied to a drawing with a fine minever brush (q.v. under *brush drawing*) to represent highlights.
ink	Drawing material prepared by binding a pigment – normally in the fifteenth century carbon particles (e.g. lampblack), or ferrous sulphate (copperas) in gall-extract for iron-gall ink – in gum and water.
leadpoint	*Stylus* of lead, or lead-tin alloy, which will mark un-*prepared paper* but is too soft to be satisfactory for fine *stylus* drawing. Leadpoint has the advantage that it can be erased with 'the crumb of some bread' (Cennini/Thompson 1954, XII, p. 8), and was sometimes used to sketch briefly the outlines of a form to be studied in detail with the *silverpoint* or the *pen*.
metalpoint	see *stylus*
minever	see *brush drawing*
model-book	Bound book, often of parchment sheets, containing highly finished drawings, often coloured in *bodycolour* or *watercolour*, of natural forms, especially animals or plants. It was intended primarily as a stock of motifs to be used in a painter's workshop for direct copying into a painting or manuscript decoration.
paper	Surface for drawing manufactured by soaking and pulping cloth (linen for good quality paper, but normally rags) and rolling the pulp thinly over a woven wire grill to dry.
parchment	A very durable surface for drawing prepared from the skins of sheep, goats or (for the finer, higher quality vellum) calves. Parchment is highly absorbent and has a smooth-textured, ivory-coloured surface, although one side may be marked with hair follicles.
pastels	Fabricated chalks prepared from dry pigments mixed with a binding medium such as gum arabic and rolled into a stick.
pattern-book	A bound collection of random motifs copied into a book by a medieval artist, generally during his travels.
'pattern' drawing	Detailed study, usually of drapery, used as an exemplar in the workshop both for apprentice copying and for direct transfer into paintings.
pen	Drawing instrument prepared from feathers, preferably of the goose (Cennini/Thompson 1954, XIII, p. 8) and ideally from the leading edge of the wing. These quills can be cut with a knife to any width or angle, allowing a wide range of different types of line.
prepared paper (and prepared parchment)	For *silverpoint* drawing a sheet of *paper* or *parchment* had to be prepared by coating it with a surface of white lead and ground bone, often tinted with a pigment such as *terra verde*, tempered with glue. This preparation was applied in several layers with a thick brush (Cennini/Thompson 1954, XVI, pp. 9–10, and for parchment X, pp. 6–7 and XVII, pp. 10–11). A simpler preparation, also recommended for use on *boxwood tablets* (Cennini/Thompson 1954, V, p. 4) was of ground bone applied with spittle.
presentation drawing	A carefully finished drawing given by the draughtsman to a friend, patron or potential patron. Here used as distinct from *contract drawing*.
recto	In a bound book of drawings, the right-hand page of an opening. For a loose, double-sided sheet, the side which is considered to have the more important drawing or drawings. This may be either side of a sheet of *parchment*, but is generally the prepared side of a sheet of *prepared paper* (or prepared parchment); cf. *verso*.
red chalk	A red ochre variety of haematite (iron oxide) diffused in clay, 'a stone coming from the mountains of Germany, soft enough to be easily sawn and reduced to a fine point suitable for marking on leaves of paper' (Vasari/Maclehose 1907, p. 213).
silverpoint	A *stylus* frequently used by fifteenth-century draughtsmen for fine, delicate studies on *prepared paper*, often with white *heightening* added.
simile drawing	A figure drawing, often of an exotic type, used in Venetian workshops as a prototype for figures in the middle and backgrounds of narrative paintings.

sinopia (plural: *sinopie*)	The *underdrawing* for a fresco painting, made with the red-earth pigment sinoper (red iron oxide) applied with the brush to the plastered wall, and over which the fresh plaster was laid before painting.
sketch-book	A bound volume of sheets of *paper*, sometimes *prepared paper* for *silverpoint* sketching, for informal recording of forms and motifs, perhaps for later reconsideration.
'snapping'	The process by which a wall surface is subdivided with major verticals, horizontals and diagonals by holding a taut string soaked in sinoper between two points and snapping it like a bow against the wall (Cennini/Thompson 1954, LXVII, p. 43).
squared drawing	A drawing of a composition or form covered by a fine grid of vertical and horizontal lines which serve as a guide to copying the subject onto a larger surface (such as a panel or wall) which is in turn squared with an enlarged grid.
stylus	Drawing instrument normally of cast metal with a point often at each end. For fine drawing the point was generally of silver, although other metals (gold, copper, lead, tin, lead-tin alloy etc.) were sometimes used. An iron stylus could be used to produce colourless, indented lines on paper as an initial guide to drawing; or in the sixteenth century for tracing a *cartoon* onto the surface to be painted (Vasari/Maclehose 1907, p. 215), or onto a 'spolvero' (q.v. under *cartoon*), thus preserving the cartoon.
taccuino di viaggi	Bound volume, used by an itinerant draughtsman or workshop over a period of time, in which copies were made of works of art in diverse locations.
terra verde	A natural clay coloured by small amounts of iron and manganese, producing a dull green pigment of extremely low colouristic strength, which can easily be covered and concealed. It was therefore frequently used for underpainting on panel and in colouring the preparation of paper for *silverpoint* drawing.
'three-tone' drawing	A drawing normally in *silverpoint* on pigmented *prepared paper*, with white *heightening*, in which the range of tone-values of the lines, the preparation and the heightening is exploited in the study of a three-dimensional form. The same effect can be achieved in a *brush drawing* with pigment and white heightening on a coloured paper.
underdrawing	A preliminary drawing, often in *charcoal* (Cennini/Thompson 1954, XXX, p. 17), *metalpoint*, or *chalk* on paper, or in *charcoal* on panel or wall (Cennini/Thompson 1954, CXXII, p. 75, and LXVII, p. 42–3 respectively), in which the outlines of forms or composition are sketched in preparation for detailed work in other techniques.
vellum	see *parchment*
verso	In a bound book of drawings, the left-hand page of an opening; or the less important side of a loose, double-sided sheet; cf *recto*.
wash	Diluted *ink* applied with the brush to a line drawing to indicate briefly the modelling of the forms, or the direction and intensity of the light.
watercolour	Water-soluble, translucent pigment, occasionaly applied with a brush to a drawing, especially in a *model-book*.
white heightening	see *heightening*

Index

INDEX